Kurt Trampedach

Mikael Wivel

Kurt Trampedach

Aschehoug

Contents

Exile – an introduction

Kurt Trampedach was born in Denmark, but does not live there any more. More than twenty years ago he went into exile in Sare in the French Basque Country, and he has never returned. He flourishes abroad, languishes in his native soil. True, his pictures come here from time to time, a kind of deputies, but he himself only passes through. This has nothing to do with either restlessness or rootlessness. Kurt Trampedach has simply put down roots somewhere else. So much so that one is tempted to think that this has been the idea all along; that he was only born in Hillerød by mistake; and that the years he spent in Copenhagen and its environs should only be seen as a wearisome if necessary roundabout path to the goal. He himself says that he only really began to feel at home when he moved into his house in Sare and could close the door behind him. Only then did he settle – if not 'down', then at least 'into place' somewhere in the world where he wanted to stay for the rest of his life.

That was in 1979 – and ever since he has remodeled and expanded and added on with persistence, drive and optimism, as if he knows deep within himself that his time here on earth is of a different and more intense substance than that of most others. When he went into exile he at last took matters into his own hands – now it was no longer a matter of his pictures alone, but of his life. And in the most literal sense. For the same reason he staked everything – totally and determinedly. Stone has been laid on stone and the buildings have risen on the mountainside with a weight and inevitability suggesting he will be there for several centuries to come. Of course he will not, and throughout the process there has been something conjuratory about his activities – as if Trampedach wanted to spellbind both past and future. As if he has been blazing paths in both directions as far as they can reach.

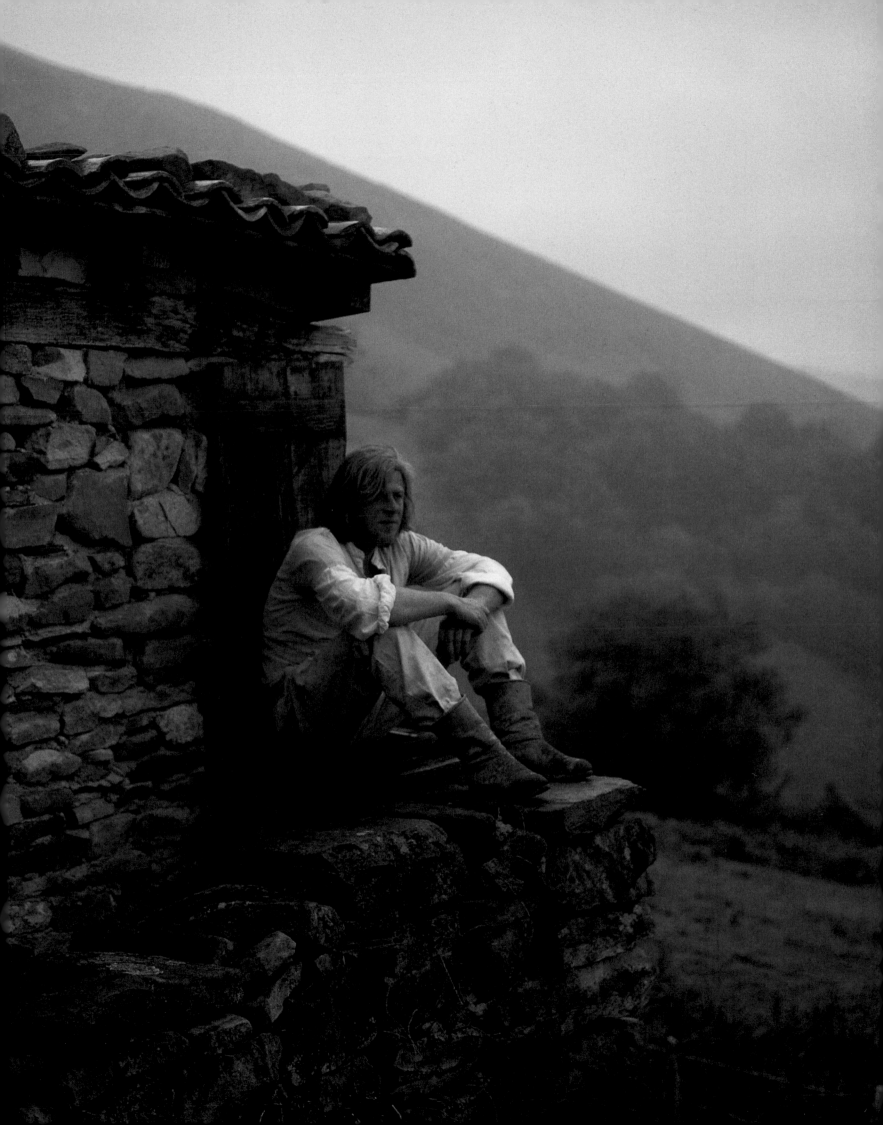

The past is present in the stones, while the future lies in the rooms surrounded by them. So it is quite literally, so the scene is set – and now it is up to him to forge the links between what once was and what will come now or soon. His mind is the filter through which the past must pass to leave its traces on the present, through the works he turns out. And therefore it is a matter of great urgency for him to give the place itself an aura of timelessness, incising the long lines backward and downward. For only thus is he able to tear his pictures free of the temporal and fire them off at an unknown target.

Kurt Trampedach is building his houses as the Basques have built them for centuries. And that is why they look as if they have always been there. But it is not just a dream he is realizing here, not just a nostalgic trip back to the roots he never had himself. There is more to it than that. What he is building up is not just pretty scenery – it is something else, something much more tangible and imperishable, something that will ease his way along the path he more or less consciously laid out for himself when he became aware of his abilities and his destiny, back in the years of his youth in Hillerød.

The buildings down there on the mountainside, with their unmistakable marks of time, connect back beautifully with the imaginings he had then about human history and his own place in it. The world he has built up around him now with his own strength and his own hands should thus be seen as a kind of monumental insistence on these youthful imaginings, a historical space that enables him at last to have the impact he intends.

The voluntary exile in Sare has thus been of crucial importance to Kurt Trampedach. By placing himself on a mountainside far from Denmark he has put a considerable distance not only between himself and his native country and all that goes with it, but also between himself and his own life as it was until he made his decision. Exile is in other words the very axis upon which the whole turns – life and work, and all that these two concepts can entail. There is a before and there is an after; the cut-off points are clear – there are pictures that lead up to the exile, and there are pictures that come out of it, and in many ways they represent two utterly different processes; but also two interrelated phenomena that serve to illuminate each other and suggest the epic nature of the processes.

For the man who has created the many pictures is at bottom the same man, even though he has undergone a development. And since Kurt Trampedach has at all times, both before and after his exile, taken his point of departure in his own psyche, his own mind, and – not least – in his own physiognomy, when painting his pictures, a consistent strand runs through them, a lifeline, simply, that is never abandoned but held tight, painful as it may have been for him to keep it from slackening. And so the work lies there like an open book to be read by anyone who knows a little about the codes.

It is in this book that I now want to turn the pages – and I do so not dispassionately or from a distance, but with empathy and to a certain extent also involvement. Because I have now for many years been one of Kurt Trampedach's closest friends and have followed his work with more than ordinary interest. My approach is therefore not one-sidedly that of the art historian, although the art history aspect is precisely the main point of the text; it is also that of the biographer – the life-historian – inasmuch as his life and mine have been interwoven, as those of good

friends are. The text therefore alternates between overall analyses of the individual works and glimpse-like flashes from the tumultuous life that has always been the direct precondition of these works.

I do this in the conviction that in the particular case of Kurt Trampedach, the work and the life cannot be separated – the works have arisen as a result of the lived life and the ever-increasing insight into his own psyche that this life has given the painter. This is a continuing series of figurations and an increasingly comprehensive manifestation of the path of a human being through the world; a world that is fundamentally unsympathetic, where it is entirely up to the individual to find a path and a meaning – on the basis of the premises nature has provided in the form of abilities and opportunities. And it is my view that Kurt Trampedach, by relating so literally and personally to this human condition, has become an exemplary representative of it; that by virtue of his quite uncompromising attitude to his metier as a means toward self-expression and visibility, he has been able to express something universal, not only about life as such, in these modern times, but also about the indispensability of art at all times.

Time and Space

For Kurt Trampedach concepts like Time and Space play a crucial role. Time is now and it is scarce – in every sense. Space, on the other hand, is the great, long haul back. That is why it is also what one should first and foremost relate to and express oneself in as a painter. For in a way one is contemporary with the old masters – their pictures are still here, we have them not only in the museums and in the books, but also inside our heads, and the painter constantly paints against them and thus into the tradition. Of course one also paints against Time here and now, because one exists amidst it and has it as one's immediate precondition. But if one only relates to it, one remains within it and never leaves the spot, and one thus slides into the great oblivion. Time is therefore a dangerous thing to relate to, although it can be both pleasurable and propitious, as long as it lasts. Space, on the other hand, is infinitely rich in possibilities.

Thus in Trampedach's universe two types of artist exist: those who fall into step with Time and become one with it, but who also disappear with it, as unnoticed as they came; and then there are those who fall out of Time, even as it passes, because they relate to something else, something greater, and are awkward and uncompromising. So fundamentally, Time will have nothing to do with them. The former never surface again as anything more than curious examples of something that once was. There are no traces of them, the wind passes over, the dust settles and the crust hardens. The others, however, return when one least expects it, like the fresh green shoots that burst so wonderfully from the scarred stumps of centuries-old olive trees. In short, it is the latter who have the last laugh, and it is clear that Kurt Trampedach counts himself among these.

And he knows what he is talking about, because for long periods he has himself tried to relate simplistically to Time and like Icarus has burnt his wings. There is thus nothing holier-than-thou about the attitude – and nothing moral in the

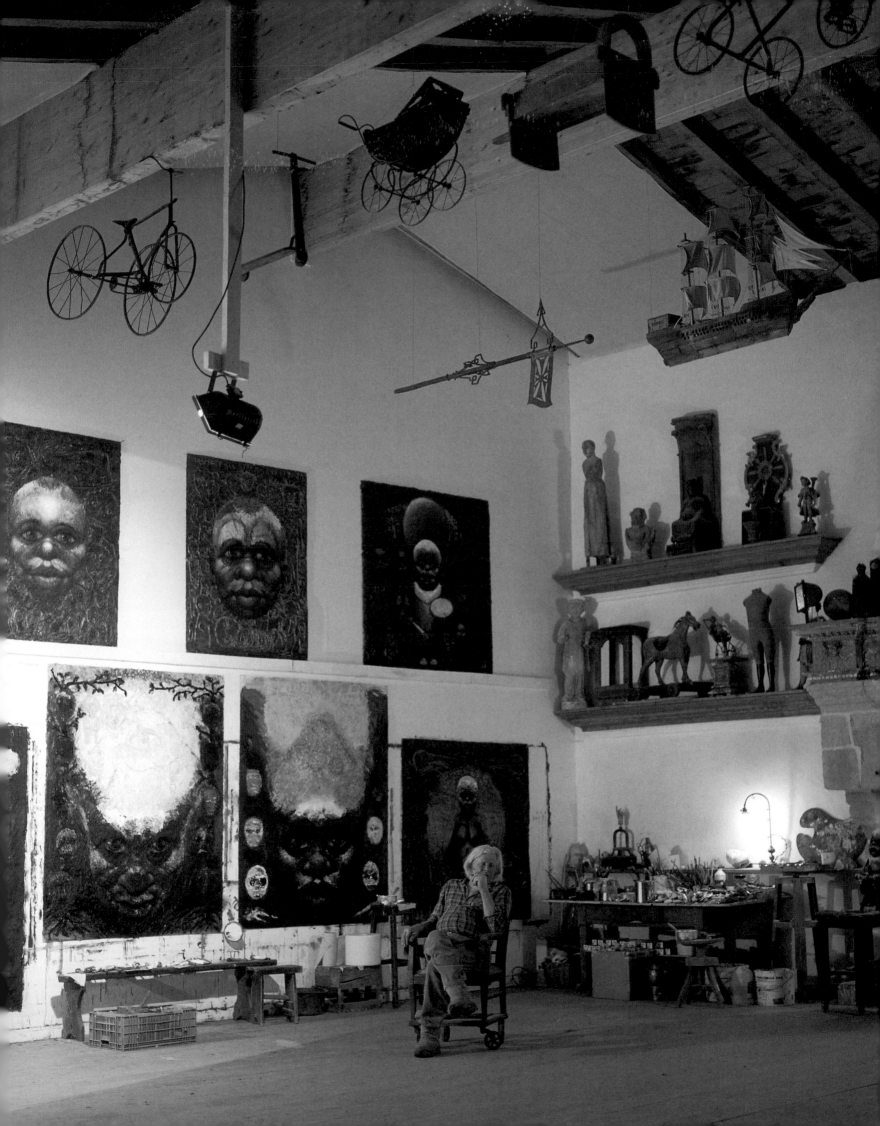

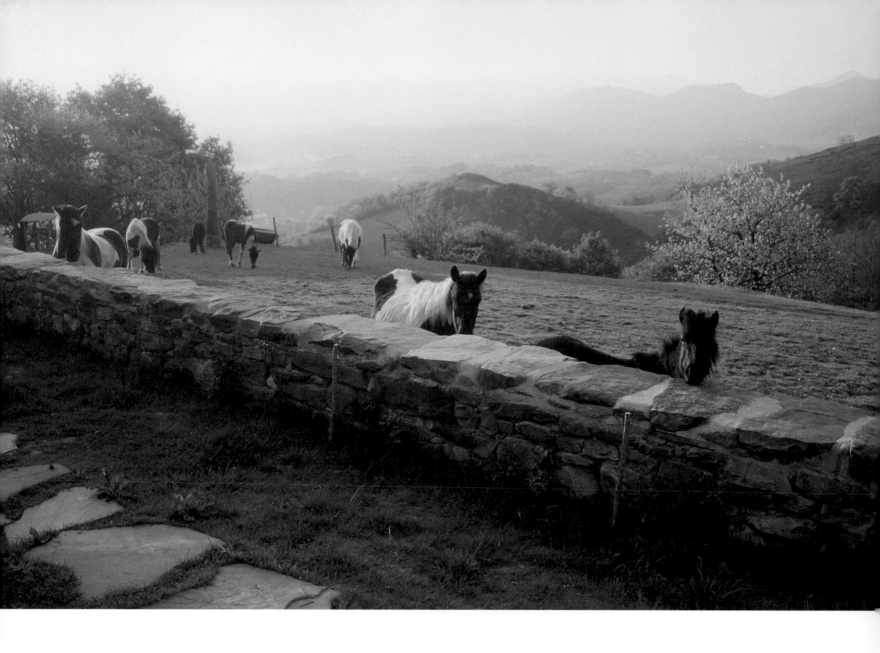

judgmental sense. The attitude is only the logical result of hard-won experience. Experience that has been sharpened by exile on the mountainside. From there Trampedach sees things more clearly than before. In the most literal sense he has distanced himself and cleared a space where he can work freely – outside Time and its many distractions, but inside Space and whirled along by the dizzying perspective it reveals.

There is Goya, who died in Bordeaux, not too far away – and there are Caravaggio, Zurbarán and Rembrandt, a little farther back. And then there is Munch, high up in the Nordic space, and the heroes from the formative years in Copenhagen, Giacometti and Bacon and fellow players and opponents from the environnment then, like Per Kirkeby. They are all there at some point on the line – as sparring partners or questioners. For Kurt Trampedach has realized that only with this visual ballast can he penetrate to the real – to the nature of art and perhaps also to his own nature. That, at least, is the object of the exercise. There are precursors who correspond to something in yourself, and who mean something for one reason or another, and the dialog with them is therefore crucial to an understanding of your own nature and origins. Only if you enter into this with raw and relentless energy, unburdened by your time, can you arrive at an understanding and fall into place somewhere in the line of succession. It has something to do with finding your way back to

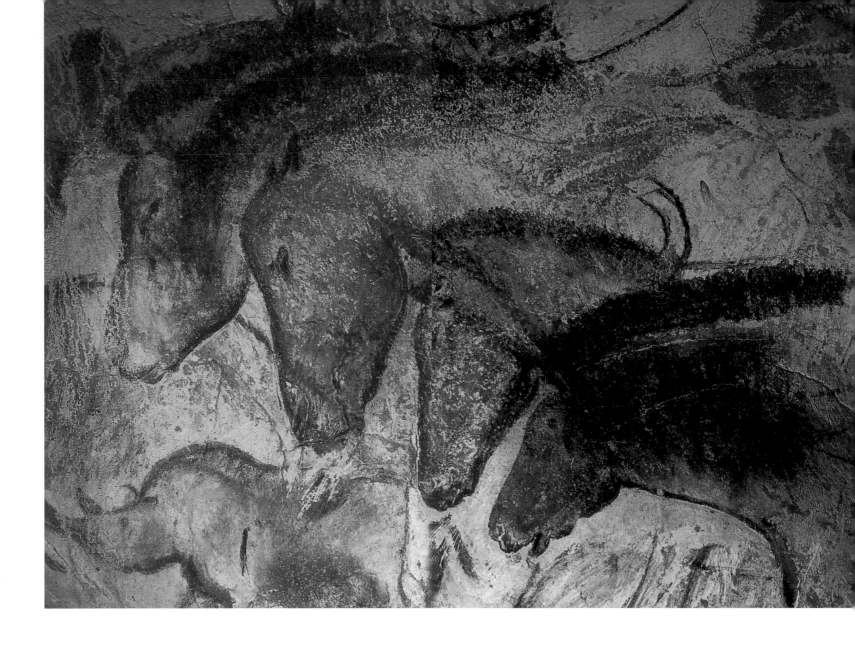

a truth beyond the here and now or to a primal force – within yourself of course, but also within the shared creative space of the tradition.

It is not only the western masters whose spirit is felt, but also much other flotsam from the history of civilization, from other and more remote cultures – the Egyptian and the Precolumbian, for example, or the prehistoric; the last of these is not least a presence in the Basque Country, where caves deep within the mountains are decorated with signs and images from the first age. It is thus magic ground Trampedach has beneath his feet – and he knows it. For the landscape has hardly changed since the days of Cro-Magnon man, nor have the animals. The half-wild horses that he has grazing himself, and for which he builds stables and outhouses, bear a striking resemblance to those that were painted in the Chauvet cave more than 30,000 years ago. He only needs to stretch out his hand and touch their friendly muzzles and their warm dusty skins to make the contact back in time.

Sare lies as far to the south west as one can get in France, right down in the corner of the Basque Country and at the bottom of a valley that stretches far into Spain. It is a very small town consisting of a nucleus of houses lying close around the church, and a number of large or small farms scattered around the landscape. But it is neither in the town nor out on the farms that Trampedach lives. Here too he has distanced himself.

Cro-Magnon: Wild horses and a hairy rhinoceros. Chauvet Cave, Vallon-Pont-d'Arc, France. Charcoal on rock, *ca.* 35,000 BC.

His house is a so-called *borda* and as such belongs to one of the farms. A *borda* is a smallish farm that lies some way up the mountainside at a place where as a rule some pastures have been cleared and some fruit trees have been planted. Here a family could be tenants and earn their living by taking care of the animals that grazed in the area – mainly sheep, goats and the above-mentioned half-wild horses. Trampedach's *borda* is on the mountain La Rhune, which is the highest point in this part of the Pyrenées Atlantiques, and it is the last occupied house before the wilderness. When one stands up there, one can see a long way around – on the right down along the valley toward the snow-clad peaks in Spain, and on the left toward the town and on over the open country toward Biarritz and Bayonne in the distance.

Since time immemorial the house has been called *Chilardico Borda* by the local people. The words are Basque and mean something like "the house that shines like silver", and this may be because it lies so high above the town that in the morning it is the first thing to be hit by the rays of the sun. But to start with Trampedach would not be content with this natural explanation. In his view there had to be a silver treasure hidden somewhere in the area, perhaps buried during the Napoleonic Wars. And as the amateur archaeologist that he also is, of course he has tried to find it. But so far with no luck – the old coins he has in fact excavated from the soil are few, and very few of them are silver. So he has also long since got used to the idea that it really is the sun that makes the place shine.

So every morning he gets up before it – and with a cup of coffee in his hand and a pack of Marlboros in his pocket he walks to a place he has cleared and where he can sit watching the sun rising over the mountains. And he is never alone – two delighted sheepdogs of indeterminate race go along, as well as a couple of cackling geese that regard him as their true parent because their mother was taken by a fox, so it was he who took them out of the incubator and gave them their first animal heat. So there they sit, all five, around a table and look out over the valley and wait for the coming of the sun. An hour of reflection before the day begins. As a rule the valley lies hidden below the cover of morning mist – one cannot even see the church tower down in Sare. And if the mist is thick and looks like clouds against the sky, the weather will be fine, but if it is thin and airy and the sun is white when it comes, it will rain.

The rest of the day is spent in the studio, where Trampedach paints with great intensity – working on several pictures at once. They are tacked up on the long wall, in the best light, and they can be years in the making. But when at last they are finished, they move up into the second tier, high up on the wall, where they hang as signposts to the continued work, as stages on the path and as prompts to saying the same thing but saying it even better. The fuel is coffee, cigarettes and loud music from the stereo – Pink Floyd, Van Morrison, Neil Young and other icons from the good times. The best sessions are in the forenoon and the late afternoon and onward far beyond the coming of the darkness.

The studio has been rebuilt and expanded several times and is now large and high-ceilinged as a church interior. There is lots of room – room too for the many things Trampedach has collected over the years as cues to inspiration and as confirmation of its endurance. They are generously scattered around on shelves and windowsills – fossilized sea urchins and dinosaur eggs, Romanesque and Gothic sculpture in wood or stone, winding columns of the Baroque, statuettes in fired clay

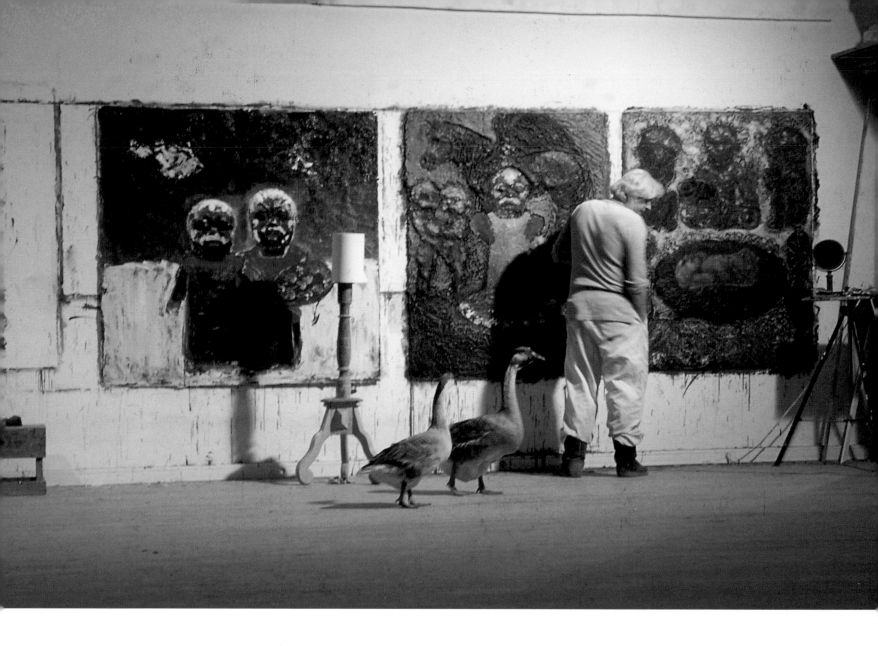

from remote and long-vanished cultures, finds from the Danish Stone Age and souvenirs of the Viking Era, Catholic holy pictures, holy men and women, but also mannequins and milliners' block heads from the nineteenth century and old toys and dolls with heads of china or ivory. A real jumble of figurations testifying to mankind's eternal urge to make images of himself and his surroundings and thus give existence fixed form – not necessarily a form created with virtuosity and life-like imitation; just as often the simple and primitive, with traces of the awkward hand that had to realize this urge.

In recent decades in particular the old toys have played a crucial role for this constant dialog with the past. From the rafters of the ceiling hangs a confusion of hand-carpentered or hand-forged baby carriages, rocking-horses, bicycles, soapbox carts and scooters – all wheeled vehicles childlike in nature, bearing witness to forward motion and the beginning of life. A single full-rigged ship with bellying sails has also found a place up there, as has a weather vane of wrought iron that can indicate direction and the way to go.

And down in the bottom of the studio, on shelves against the back wall, these memorial exchanges with the imaginative world of childhood continue in a collection of dolls' houses, mainly rural in nature, especially animal sheds with stalls and hand-carved horses of wood, in varying sizes and of widely differing kinds, all

individualized and marked by the creator's earnest attempt to bring out the animal as form. They are memories, of course, but they also stand there as an echo of what is happening just outside the studio, where Trampedach himself builds stables for his horses from dressed stones, with immense troughs that are filled with the clear water of the stream that runs down the mountain through his land. "I'll build myself a farm", says the Danish children's song – and Trampedach has quite evidently not forgotten its deeper meaning.

He builds the stables and the other buildings with the Basque farmer and bricklayer Joakim – or "Gorkin", as Trampedach calls him with a Basque accent. He comes up the mountain three times a week, either on foot or in a tractor, depending on the type of work, and on those days the painting is put off until the evening. This is clearly a give-and-take that suits Trampedach fine – the constructive work in the open air and the more contemplative in the studio. Everything is built up by hand and with stones that are either wrenched free of the mountain and dressed on the spot or bought from market-places or stone-masons' yards in places around the region.

The objects of these 'raids' down in the valley are mainly old window frames, portals and water-troughs. And Trampedach knows the stones – both those that lie on his own land and those that lie at the stone yards, overgrown with moss and hidden under brambles and bindweed. As a rule he has long since looked out the best and has only been waiting for an occasion when they could be fitted into some ongoing building work. Often they are in huge formats – foundation stones, ashlars, sills and receptacles that are worn down and bear witness to an earlier existence where they had some useful function in long-demolished buildings; stones – in brief – that are now given a new life, a new chance, but whose marks of wear and patina at the same time speak of what has gone before.

Everything is important – the stones, the fossils, the sculptures, the toys. They are all involved in a constant head-on dialog with the work as such, with the artist's creative work. These things keep Trampedach not only on track, but also on his toes. His pictures should be seen as answers to the questions they ask him, across time. Answers in the same spirit. Therefore the concreteness of the pictures, the hand-formed, the imaginative, the content-saturated – and the showing-forth of mankind as the actual track backward, as both starting-point and destination. There is neither naivete nor nostalgia here, rather courage and the will to adopt both a narrative and interpretative attitude to reality by putting it in pictures of a recognizable nature, without obscuring filters, straight from the shoulder. Here it will not do to stop at the mere suggestion, or to escape into the soothing realm of abstraction. Mankind must be present in the pictures not only as figuration, but also as their precondition.

Trampedach has seen that in this serious and at bottom existential work one must necessarily draw on a tradition that is as long as man's own history; while at the same time one must take one's point of departure in one's own brief life and in the mind that this life has been able to form. There is a crucial interaction here that is fruitful when one's concentration is intense, but barren when one switches to automatic pilot. There are two kinds of farmers, he says himself – those who go by the weather forecast and those who go by the clouds in the sky. The latter are the wisest – and the most courageous. because they trust their own gaze and take their own responsibility. For life and progress.

Out of Hillerød

Kurt Trampedach was born in Hillerød, a town north of Copenhagen dominated by Frederiksborg Castle, on May 13 1943. His father was a printer and his mother a housewife, and Kurt was the second of seven children – four sisters and three brothers. Their apartment was in the street Østergade with two rooms and a kitchen where Trampedach painted his first pictures while his mother cooked. In short there was not much room, nor was the atmosphere always the most desirable. His father was depressive and fundamentally taciturn. He did not say a word when they were out on walks together – he was just there, like a weight on the mind, a dark and negative force. The depression was regularly relieved with alcohol both during and after working hours. The course of events is classic but also a reality – not least for Kurt Trampedach himself, who never forgets how hard it was for his mother to make ends meet and how hard it was for him to say no when he began to earn money and his father stood with his hand out. Pettiness has never been one of his character traits.

Without warning the depression could turn into violence when the husband came home, full of drink and embittered powerlessness. The confrontations were legion, and Kurt had to defend not only himself but his mother from the abuse – so little by little he took over his father's role in the household and became a kind of protector for his smaller siblings. At that time he did not understand his father's mentality and psyche and perhaps did not think too much about such things – silence and aggression were simply there as a condition of life. But now, so long afterward, when he has experienced all too frequently what the mental weight of an endogenous depression means, he understands his father better, although he certainly does not sympathize with his violence. For the same reason he regards depression

as a family curse, something one cannot shrug off but must live with and try to get over; unlike his father, who did not have the strength to stand up against it but succumbed to it on a particularly violent day when a cerebral hemorrhage put him out of circulation and doomed him to slow death in a nursing home.

Trampedach went to school like everyone else, but he was bad at most things. Left-handed, innumerate and poor at spelling. Dictation was particularly bad. He simply could not see the point – what had to be written was already written, so why do it again? His essays, on the other hand, were sprawling and imaginative and were always read out to the class even though they were full of formal errors.

History lessons were his favorite – they struck a chord, and sent him out into the surroundings to track down settlements from the time before Hillerød became Hillerød. On the quiet he conducted his own excavation of one of them and found arrowheads, stone axes, flint cores and skulls of beaver and aurochs, which he took home to his workshop in the bicycle cellar. But since he couldn't keep his knowledge to himself, his teacher at first put a stop to the excavations by informing the National Museum, and later even persuaded him to donate his collection to the school. But of course that didn't stop Kurt digging on and building up a new collection – which he has had with him ever since, at his own shifting settlements.

But the drawing lessons were the only ones he really loved – and he drew more or less all the time; when he was off school of course, but also in the periods that bored him and when he simply went off and sat down by the Castle with his block. Or when he visited his grandmother, who had been married to an engineer and who supplied him with some strong inspiring paper from her late husband's drawers, which he then fondly filled up with herds of horses. Gradually his mother's kitchen was superseded by the above-mentioned bicycle cellar, where he established himself with chair and table and books and radio and space for his prehistoric finds, his sea urchin fossils and his first humble antiques. And it was there in this sanctuary that he slowly began to glimpse the contours of a future as a painter.

But at the moment leisure time was scarce – after school he was employed as a warehouse boy by a firm that traded in skins and leather. It was hard work, but in an odd sort of way it seemed to be a direct extension of the things into which he had gained insight by digging down through the strata, out there at the settlement site. The stiff dried skins came on a lorry in bundles along with the salt that was to be used to soften them, and it was Kurt's job to fetch them all out of the lorries into the workshop, cut the strings and spread the skins out on the floor and strew salt on them. The smell was staggering, but it was also animal and stretched directly back to the Stone Age, when similar skins had been prepared in similar ways and with similar purposes in mind.

Leaving school, he was apprenticed to a house-painter and it was something for which he had a decided talent. He very quickly mastered most of the work, was soon able to paint as fast as the journeymen, and gradually received the same wages. And he had a good, understanding boss – when he refused to paint radiators because it was repetitive and bored him, he was simply given other jobs, and when he begged off overtime and extra work because he had to paint pictures, that was accepted without further ado. "There has to be time for that too," said the masterpainter, and there was time – after work and on Sundays, when he started with a ritual stroll around the Castle to get in the right mood. At this time he was painting

small, compact pictures of a determined type, self-portraits and nude studies bearing witness to the seriousness of his intent.

While he was an apprentice he attended the Hillerød Technical School – and that was where things suddenly picked up speed. An alert teacher had found out that he was more than just good at drawing, and when he heard that he also painted pictures, he asked to see them – and was clearly impressed. "Who are your models?", he asked, and expected to hear the names of some of the local painters with whom Trampedach had already begun to exhibit. "Rembrandt", answered Trampedach with his characteristic presumptuousness, but it was no more than the truth.

That was in the fall of 1962, and the teacher immediately called the annual Artists' Fall Exhibition to find out about the submission deadline. It was several days too late; nevertheless Trampedach was still allowed to send four pictures in. Two of them were accepted, but three were hung – so the teacher sent him on to Dan Sterup-Hansen, professor at the Royal Academy of Fine Arts to ask when he could make a presentation. But the professor had already seen the pictures at the exhibition, so Trampedach was admitted with no further fuss. That was in 1963, and the next year he exhibited again at the Fall Exhibition and sold his first picture to Statens Museum for Kunst. This was when Jørn Rubow was director of the museum, and with characteristic consistency Rubow followed this up with several others over the next few years. A flying start, in short, and at the Academy they in fact had their doubts about this, both Sterup-Hansen and his fellow students – very few people could cope with such quick acceptance, they all agreed.

Among the pictures Trampedach submitted in 1962 – and had accepted – were a couple of self-portraits of strangely intense precision. They are small and meticulous in the details, there is no panache or youthful hubris to be traced, only a quite overwhelming interest in getting everything in place. They are not searching for a style, only searching. They are conventional in execution, but not in expression. The gaze is strong and piercing and an account is given of things with care and accuracy (Figs. 1 and 3). The interest is unceasing, and both pictures bear an amazing resemblance to Edvard Munch's earliest self-portraits, painted in 1882 when the Norwegian master was nineteen years old and thus the same age as Trampedach when *he* painted his. What ties the self-portraits together across time is the strong gaze and the great care – the painter's careful approach to the authentic, that is the Self and the forces through which this self is now to unfold.

Viewed from the point where the pictures had their genesis it is hard to imagine what was to come; but viewed with the insight of distance, it seems clear that the two painters had to start precisely so, with intense caution. Not that I will claim that Kurt Trampedach is a new Edvard Munch – such a painter we will never see again; only that their efforts are related and that Munch's example has much of the way been a guiding light for him. Rembrandt was thus not the only painter who stood as a model in these young years – Munch was also in there somewhere, as was Goya.

Trampedach tracked down their pictures in the library and in bookshops, but at the same time he was also confirmed in his ideal aspirations through his friendship with a talented contemporary called Kaj Jørgensen. He had heard of him through his drawing teacher, who told him there was another young man in Hillerød who

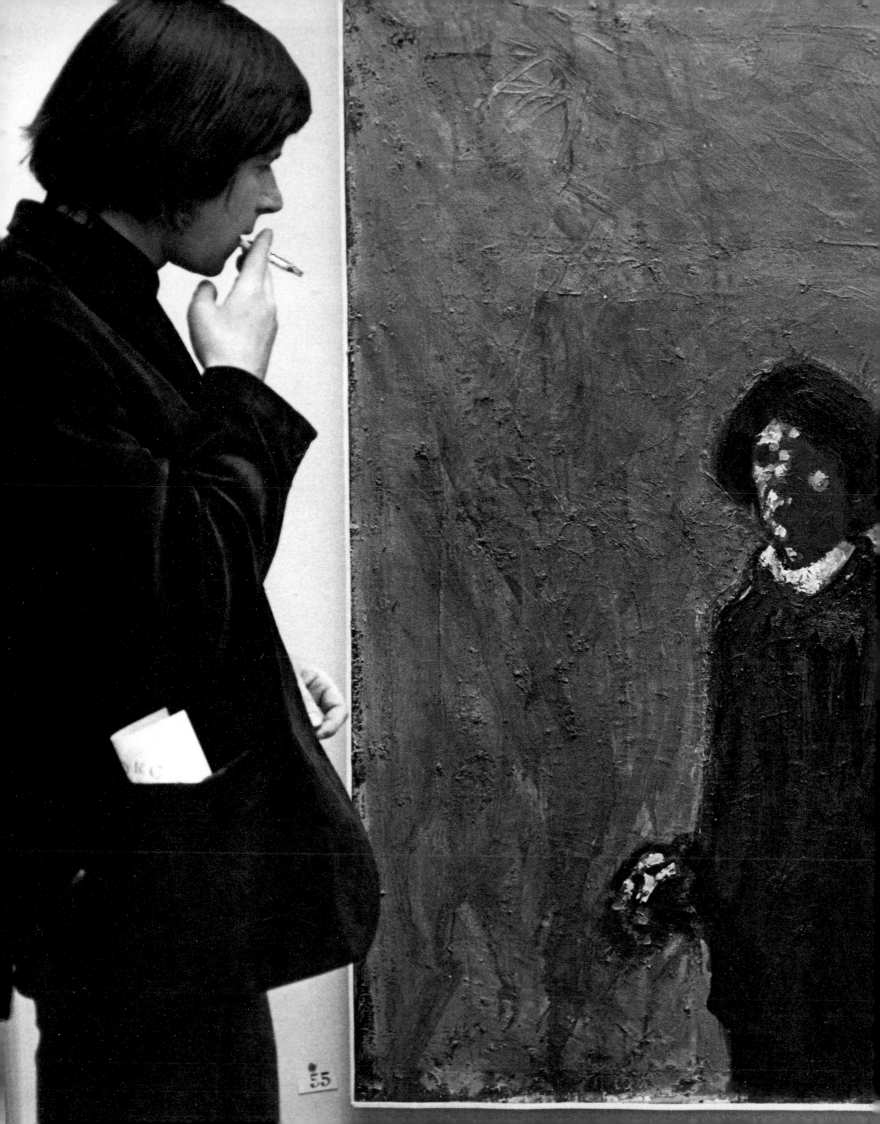

painted pictures in his leisure time – and with his usual energy he immediately went there and rang the doorbell to see what they looked like. In the event it was not so much Jørgensen's pictures that had a stimulating effect but what he could tell him about literature and art. Kaj Jørgensen was the son of a local smith, but had broken out of the environment to paint and to educate himself along more academic lines. He was – and is – a wonderful and inspiring raconteur with great knowledge and a striking, sensitive feeling for the essence of artistic creation. The friendship was an extraordinarily enhancing experience for Trampedach, and it continued unabated through all the formative years, although Kaj Jørgensen eventually gave up painting to become a schoolteacher. Kaj was the giver, Kurt was the listener, but he was also the much more determined talent.

The inspiration and the outlook can be traced in the pictures Trampedach submitted to the Artists' Fall Exhibition in 1964. They were far more impasto-like in execution than the earlier ones, more stylistically questing, and more saturated with meaning. This was when Jørn Rubow acquired his first Trampedach – a smallish picture entitled *Bowed Down*, showing a naked figure seated on the ground with his arms wrapped tightly around his head; a youthful work meant to represent sorrow and despair and perhaps fear of the future: an existential situation, in short, and as such quite in the spirit of Munch, although certainly not painted in his style (Fig. 4).

Trampedach himself remembers that it was the painter Niels Lergaard who had inspired him, but the picture is influenced rather by the *Zeitgeist* itself, by the Cold War and fear of the Bomb and the Hard Rain. In Denmark this latent fear was most strongly expressed in the art of Svend Wiig Hansen and Palle Nielsen, with which Trampedach was already then familiar. And precisely in this death-fixated context it is instructive to note the odd resemblance between the little picture and one of the casts that archaeologists have made of the cavities the dead left in the lava that covered Pompeii (p. 86). It is unlikely that Trampedach would not have known about these casts – they are reproduced in the history books and make an indelible impression on anyone who sees them. And for the youth who had gone around digging up the past in his surroundings they must have struck a chord. Far later too, they were to be of great importance to his work.

Into Copenhagen

When Trampedach got into the Academy, he was taught for a while by Sterup-Hansen, who had after all admitted him – but he quickly gravitated to Søren Hjorth-Nielsen, whose teaching suited his temperament better. Hjorth-Nielsen was greatly loved by his pupils, because he took an interest in each one of them and was open-minded and on the whole let them paint whatever they wanted. He did not say much, but what he said was concise and went right to the heart of the matter, and his peculiar diction and whole succinct form of expression consequently gave him an almost legendary status in the milieu. Normally, and very willingly, he would continue the lessons in the bars, especially *Kahytten* ("The Cabin") in Nyhavn just opposite Charlottenborg, the former palace where the Academy is now housed, but also further along the so-called "death route", the traditional Copenhagen nocturnal pub-crawling circuit, throughout the night. He himself had the constitution and character to carry off this offbeat practice as the ever-present professor, but the constant, drawn-out nightly treks along the route were certainly not without costs for the pupils. Some of them fell by the wayside – others actually died of it.

It is characteristic that the pupils who sought out Hjorth-Nielsen were all individualists and worked with some form of figurative expressionism, unlike those who sought out his colleague Richard Mortensen, and who all willingly allowed themselves to be browbeaten into abstraction, with a loss of personality as the result. The milieu into which Trampedach was drawn via Hjorth included a great variety of personalities who only had the figurative in common. They made up Trampedach's immediate circle of acquaintances, but then, as we have seen, he already had Rembrandt and Goya and Munch in his mental baggage, so one can hardly say that his Academy friends meant so much to him as sparring partners.

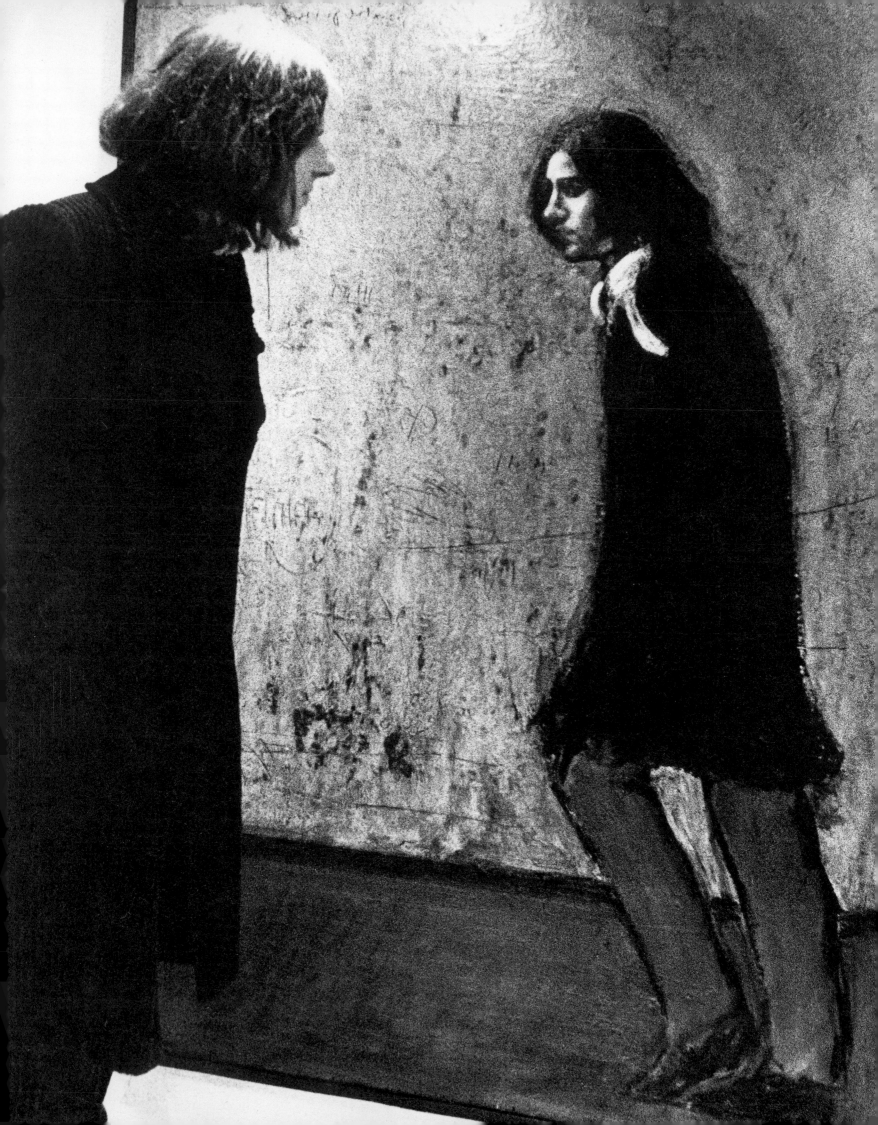

In general, in fact, he kept to himself, painted at home and only got together with others to be sociable as the evening drew on, and when the opinions flew back and forth across the table, among the bottles and glasses and dicing cups. The real passage of arms came at the adjudicated exhibitions, at the Artists' Fall Exhibition and the Charlottenborg Spring Exhibition, where Trampedach on the whole had several pictures accepted every time – and sold them, as a rule to spectacular and prestigious customers like Statens Museum for Kunst, the Ny Carlsberg Foundation and the National Arts Foundation. His success was conspicuous, as was his development toward a strongly personal idiom. Within very few years, at the end of the sixties, he had managed to make a name as one of the most interesting and relevant of the young Danish painters.

These were the years when Trampedach really fixed upon the somber color scale that was to typify his painting right up to the beginning of the eighties, showing a quite rare degree of consistency in his use of color and an intense immersion in the material that was closely related to what he wanted to bring out in his pictures. He made exclusive use of earth-colors and gray tones and of black and white, applied into the bargain with a heaviness as if the paint was mortar. It seemed almost impossible for him to handle bright colors like red and yellow, blue and green – as if they never crossed his mind's eye.

Perhaps this was due to his not yet fully acknowledged depressive psyche, but it was also a choice rooted in his view of life – and a strategy rooted in his stubborn will to be wholly himself. The primary colors had to wait until he was ready, until he could see them mentally and thus make them work in the pictures as something more than cheap effects. There was something almost scary about his consistency, but also something logical. Trampedach simply marked out an area in those years where only he felt at home. In the most literal sense.

For what preoccupied him exclusively in the pictures was himself and the world he had built up around him – both factually and mentally. Anything else had been omitted as irrelevant. Trampedach lived at the time in a small apartment in Vanløse on the outskirts of Copenhagen with his wife Ella and his daughter Lotte. There was not much room and he painted in the living-room, which was oblong and dark and ended in a balcony where the traffic rumbled by below and where the view was limited by the housing project opposite. He painted at the light end and down in the dark stood the gramophone with the Rolling Stones whipping out of the grooves – and around it on the shelves lay the fossilized sea urchin, the skulls and the flint implements from the excavations up in Hillerød. And it was there among these prehistoric objects that Kurt found his color and his depth, it was there the dark tone was struck.

The pictures were pitch-dark. They were self-portraits where Trampedach's own dark head seemed to have been twisted free of the paint and pulled into the light – and assemblages where a couple of fossils or a skull lay quivering on a dresser while the dark arched above them (Figs. 10-13). Heavy things and elementary materiality. A scanning of the territory. This was in the mid-sixties, when Danish painting was in a transitional phase and when the past was represented by compelling figures of a decidedly textural persuasion such as Oluf Høst, Erik Hoppe, Immanuel Ibsen and Niels Lergaard, and the present by younger and more questioning people like Svend Wiig Hansen and Palle Nielsen – and when the so-called

Ex-School, with Poul Gernes, Per Kirkeby and Bjørn Nørgaard at its head had not yet made its mark as the true avant-garde.

Trampedach tried to operate somewhere midway between these two tendencies. He was far from unaffected by the Romantic tradition represented by the older painters, but at the same time he was aware that it was the questioners who had renewal and time on their side. And it is characteristic that in a way he rejected both options, in order to choose himself instead – he took what he could use, the materiality and weightiness of the old and the questioning, symbolic figuration of the young, but only as things on which he could build further, on the basis of his own insight, his own unique psyche. And so his pictures came to appear as dark reflections of an inner life whose contours he himself still only obscurely grasped.

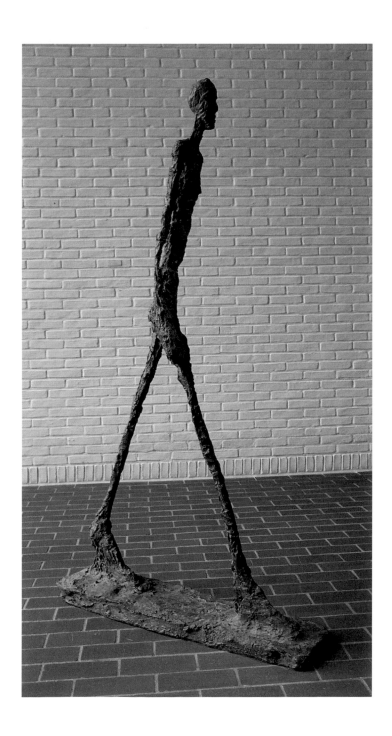

Alberto Giacometti:
Walking man. 1960.
Bronze. Height 182 cm.
Louisiana Museum of
Modern Art, Humlebæk.

The Self and the City

These religious paraphrases were painted in the apartment on Åboulevarden, where Trampedach lived for three years from 1967. It was on a corner and was dark and narrow, and not particularly encouraging, since most of the windows faced the light-starved tunnel of a side street. But there were three rooms in a row where he could sleep in one and work in the other two – with both painting and sculpture. In short, Trampedach had more space than before to work in, and he did in fact undergo rapid development in the years when he lived there, and initiated many of the themes on which he has rung changes ever since.

Self-representation and self-observation now took over in earnest in his pictures: partly in a series where he appears to have stood up from the chairs and begun moving, forward and out into the open, and partly in a group where he serially analysed his own face, field by field, row after row and layer upon layer. The second series was undoubtedly inspired by Andy Warhol and his serial versions of modern icons like Marilyn Monroe and Jacqueline Kennedy – pictures that had been shown in 1964 at the big Louisiana exhibition of American Pop Art and which one also came across everywhere in the art publications of the period.

But this did not make Trampedach's work Pop Art; it was more a unique, highly personally colored cross between Warhol and Giacometti. The ambivalent distance that typifies Warhol's images, for example, is completely absent – only the form has been taken over and given the existential element one finds in Giacometti. This is the point of departure and the essence of the works. Trampedach brings his head out into the light, again and again, in twelve stages where he gives an account of his own features, wondering, listening, exploring. He is thus still working with the number of the disciples, but he has now isolated them from one another, each in

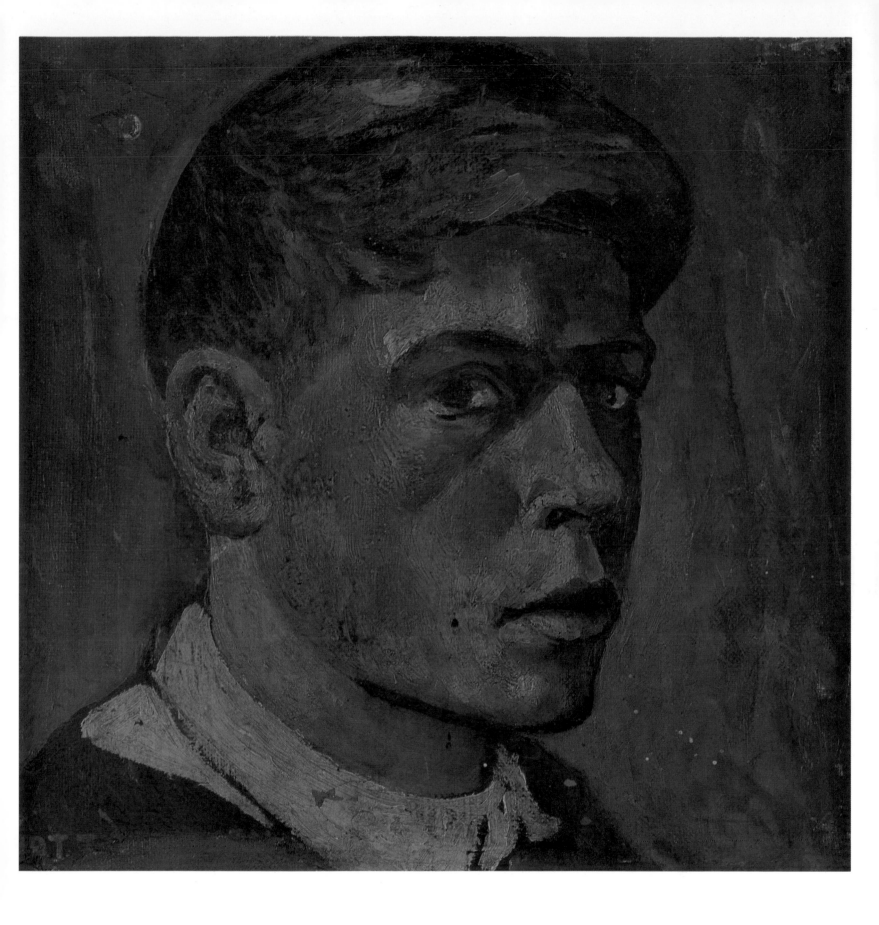

1
Self-portrait. 1962
Oil on canvas.
23 x 23 cm.

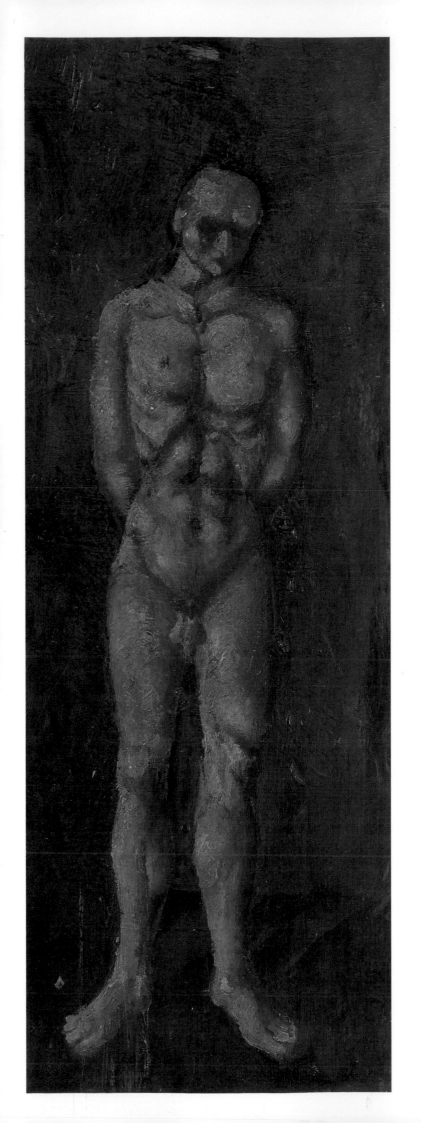

2
Male nude. 1962
Oil on canvas.
63 x 23 cm.
3
Self-portrait. 1962
Oil on masonite.
25 x 19 cm.

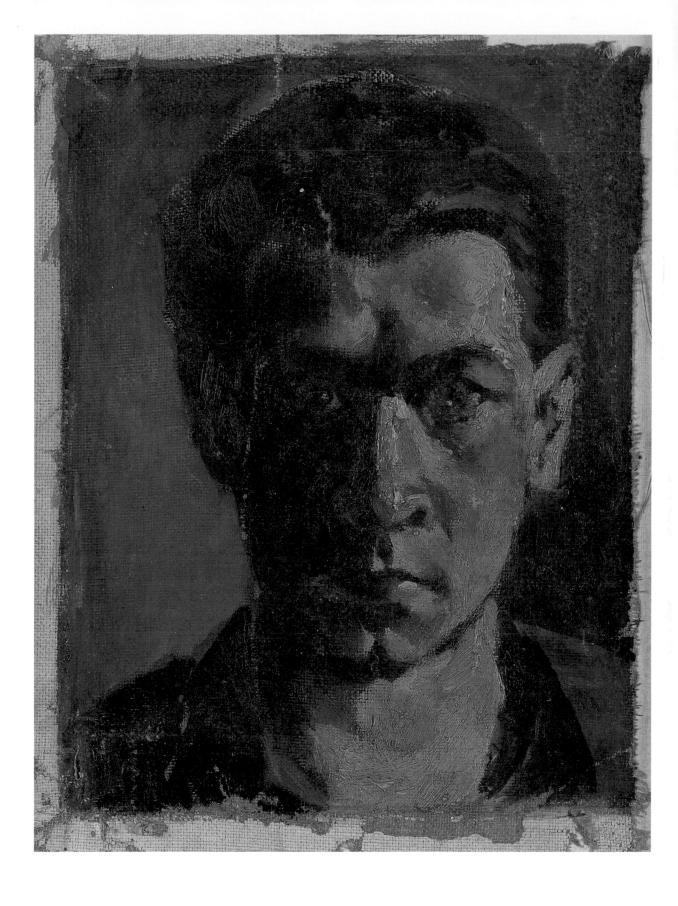

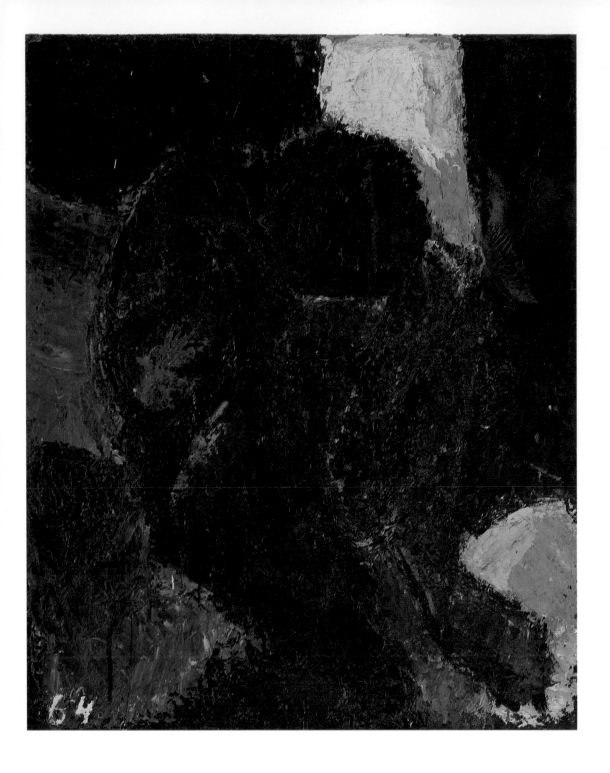

4
Bowed Down. Seated figure. 1964
Oil on canvas.
68 x 55 cm.
5
Self-portrait. 1965
Oil on canvas.
50 x 35 cm.

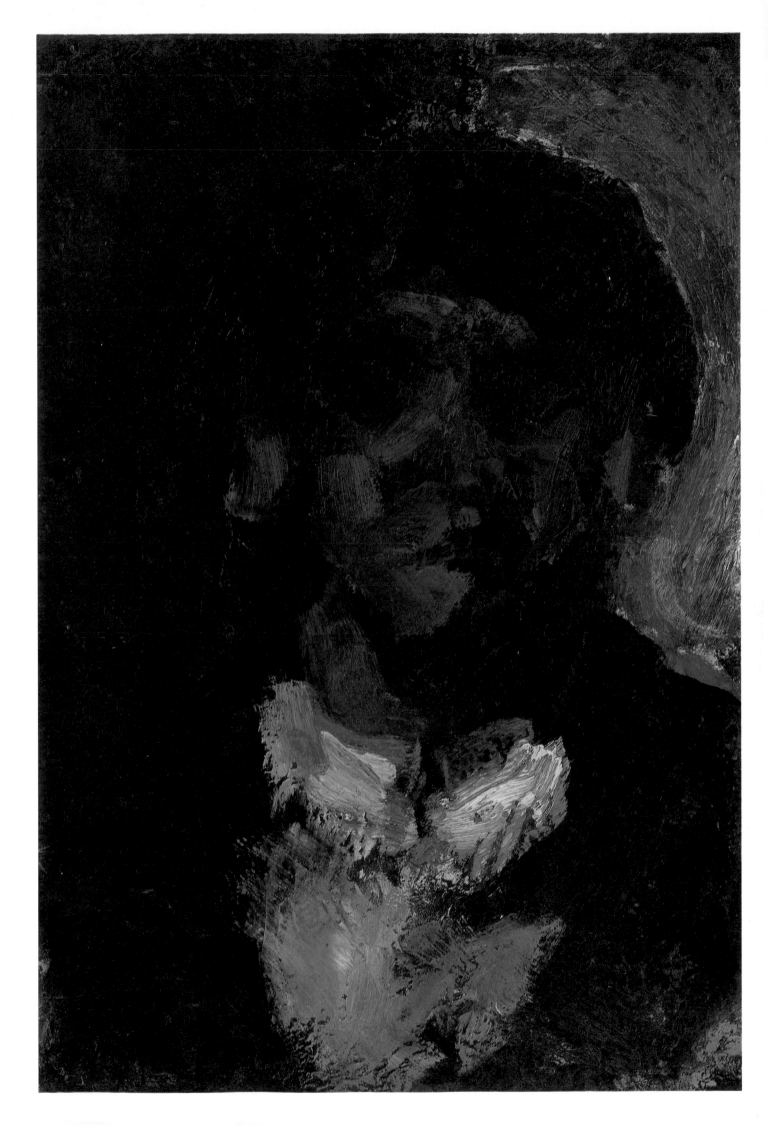

10
Self-portrait II. 1966
Oil on canvas.
59 x 85 cm.
11
Self-portrait. 1966
Oil and collage on canvas.
70 x 85 cm.

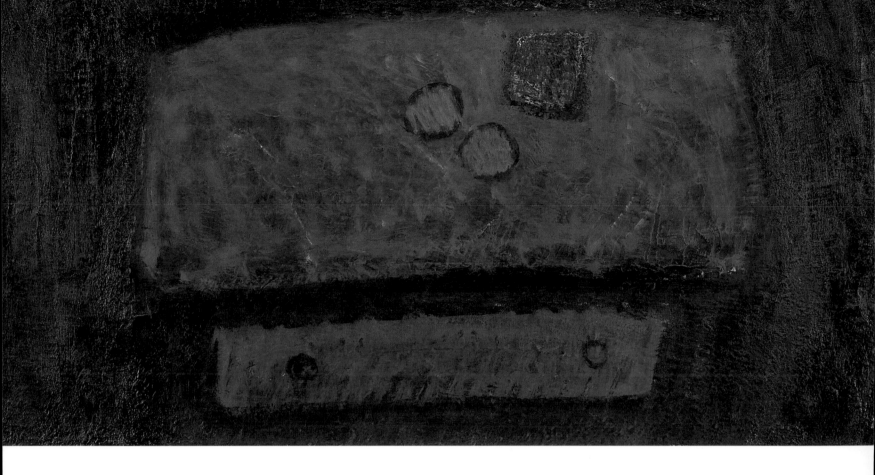

12
Still life on dresser. 1966/67
Oil on canvas
80 x 100 cm
13
Still life. 1967
Oil on canvas
37 x 53 cm.

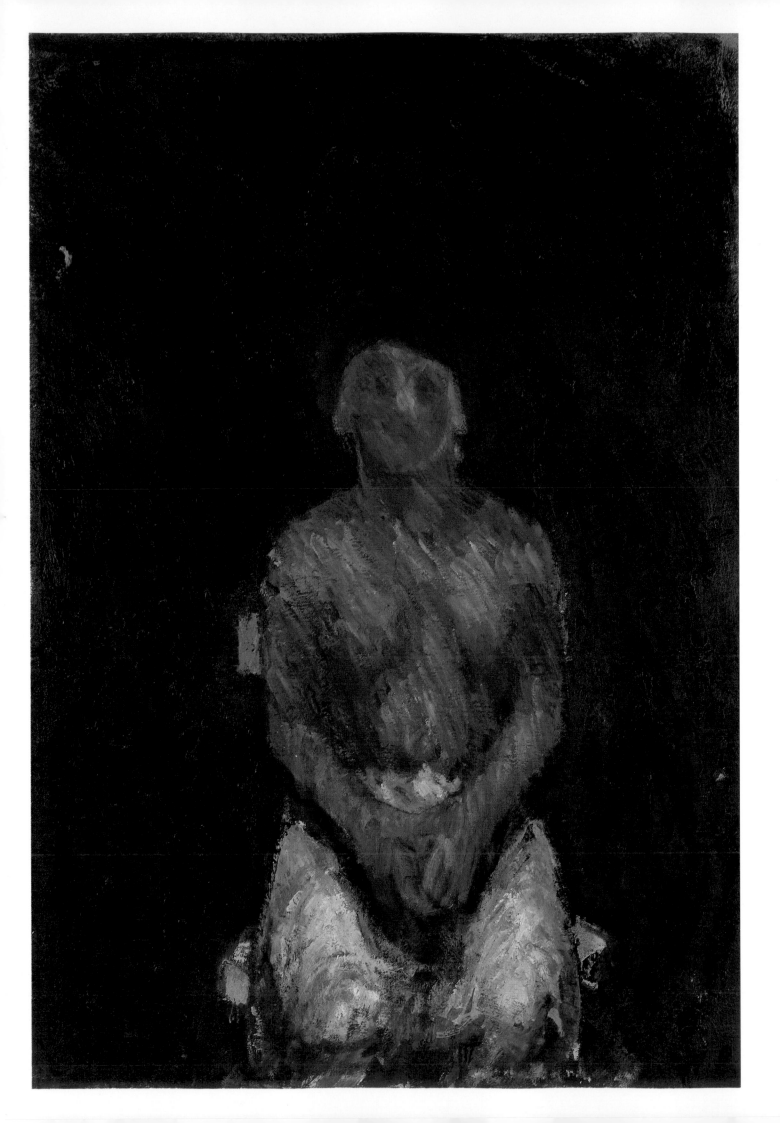

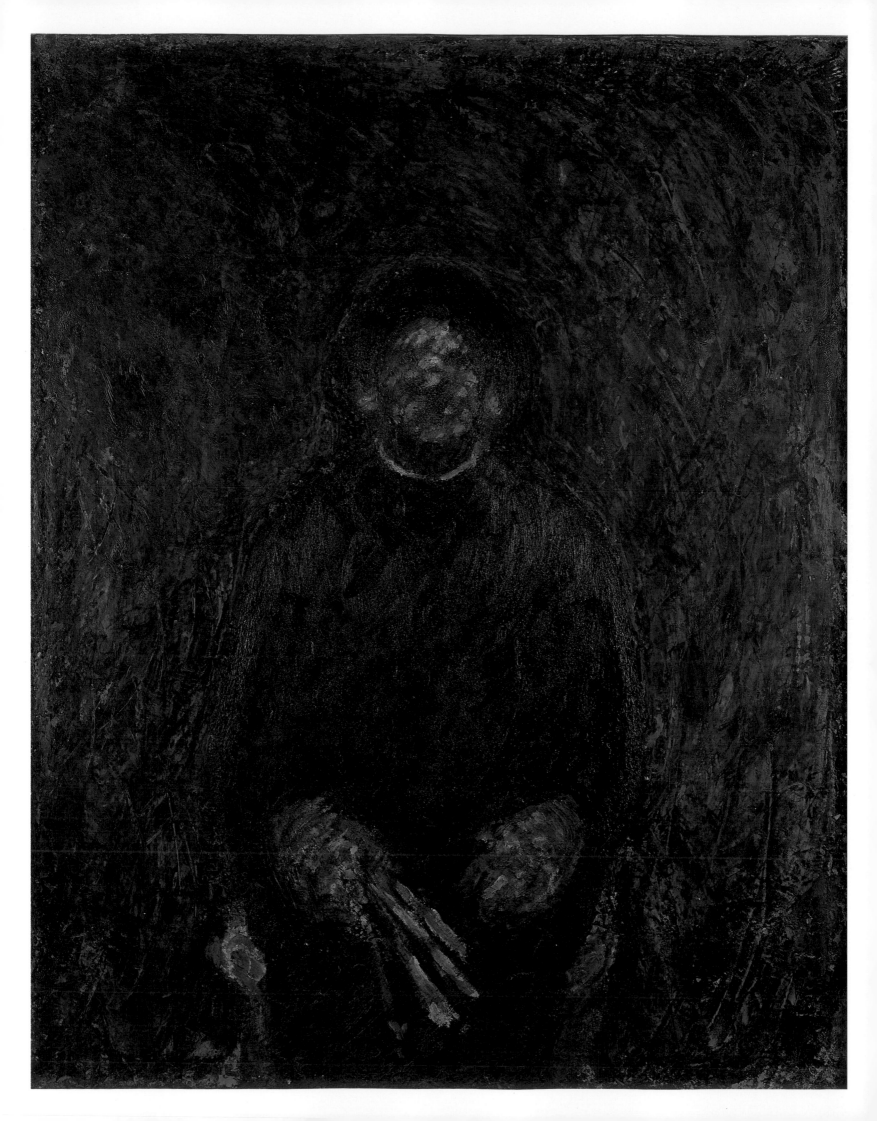

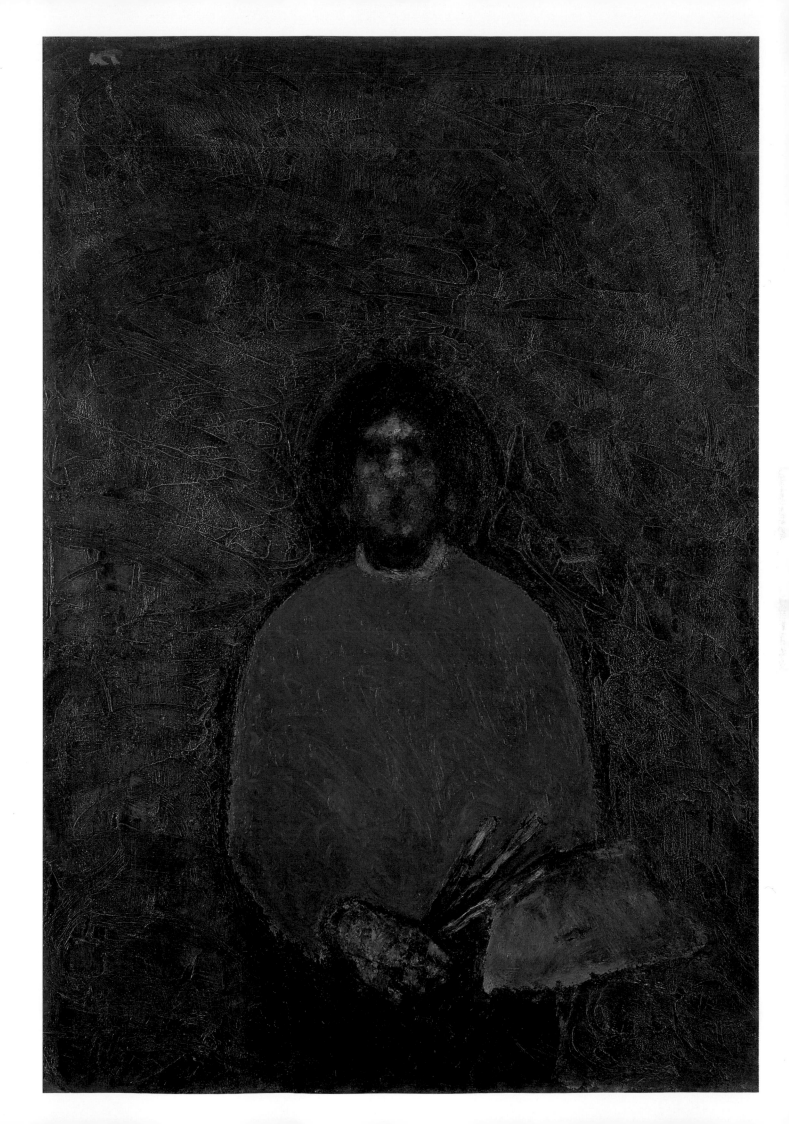

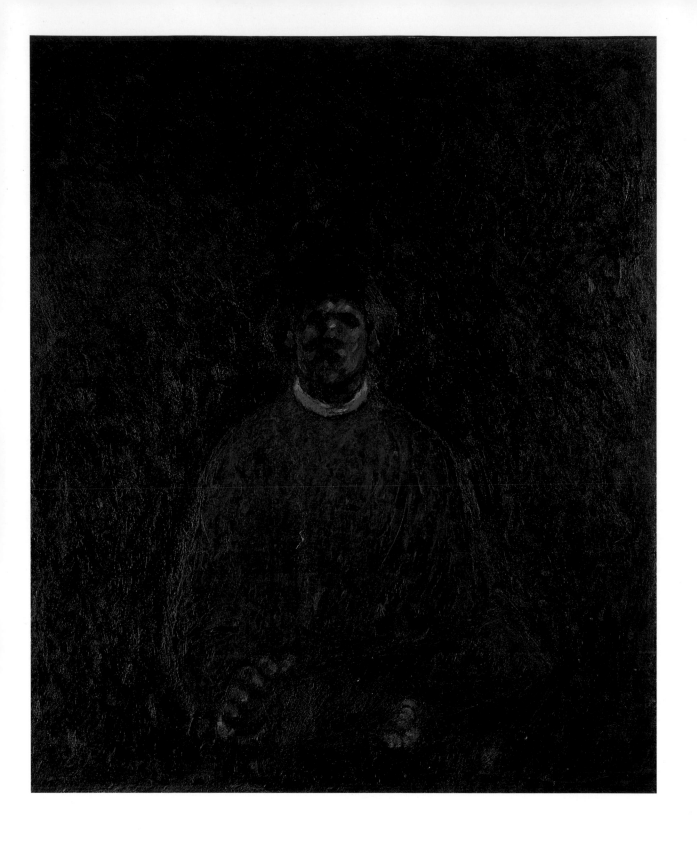

18
Self-portrait. 1968
Oil on canvas.
130 x 110 cm.
19
Picture I. 1968
Oil on canvas.
180 x 110 cm.

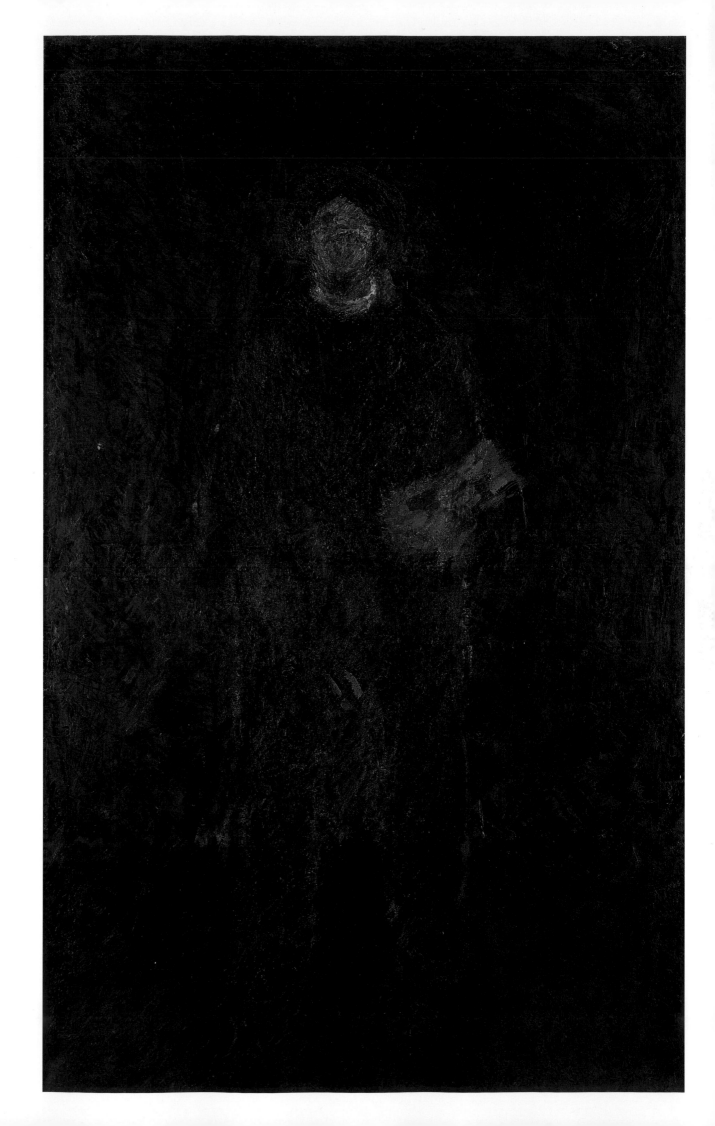

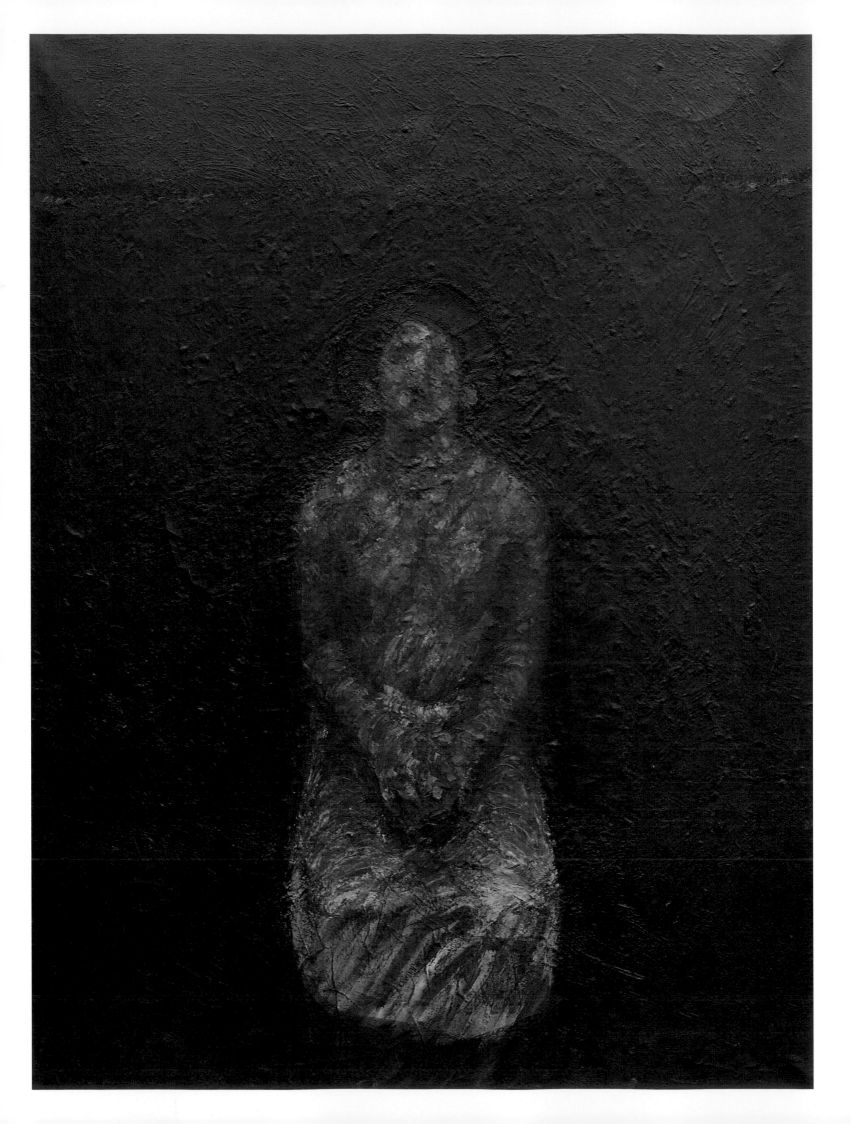

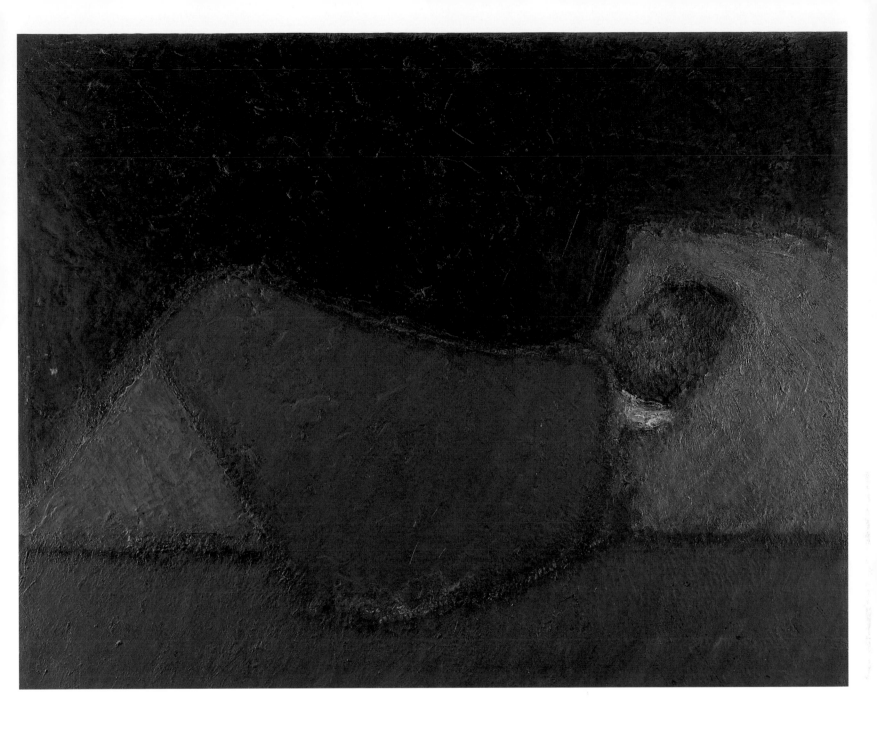

20
Picture IV. 1968
Oil on canvas.
190 x 110 cm.
21
Picture II. 1968
Oil on canvas.
115 x 140 cm.

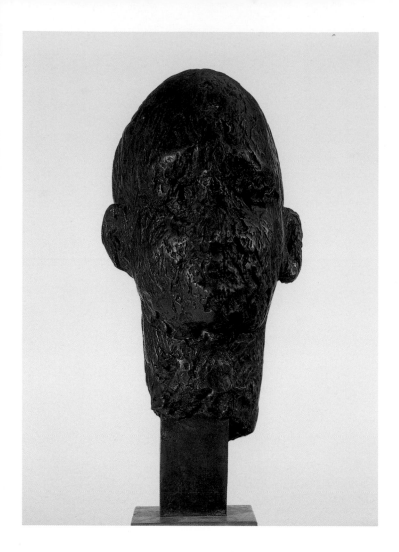

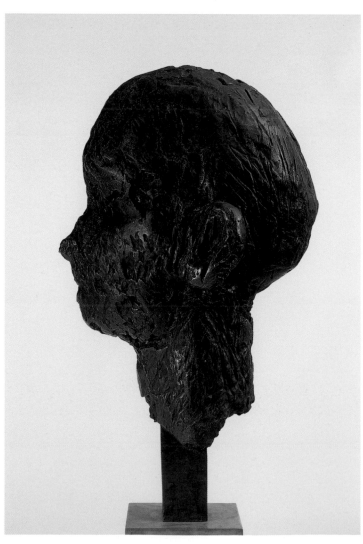

22
Portrait. Man. 1968
Bronze.
Height: 47 cm.
23
Model. 1969
Oil on canvas.
160 x 116 cm.

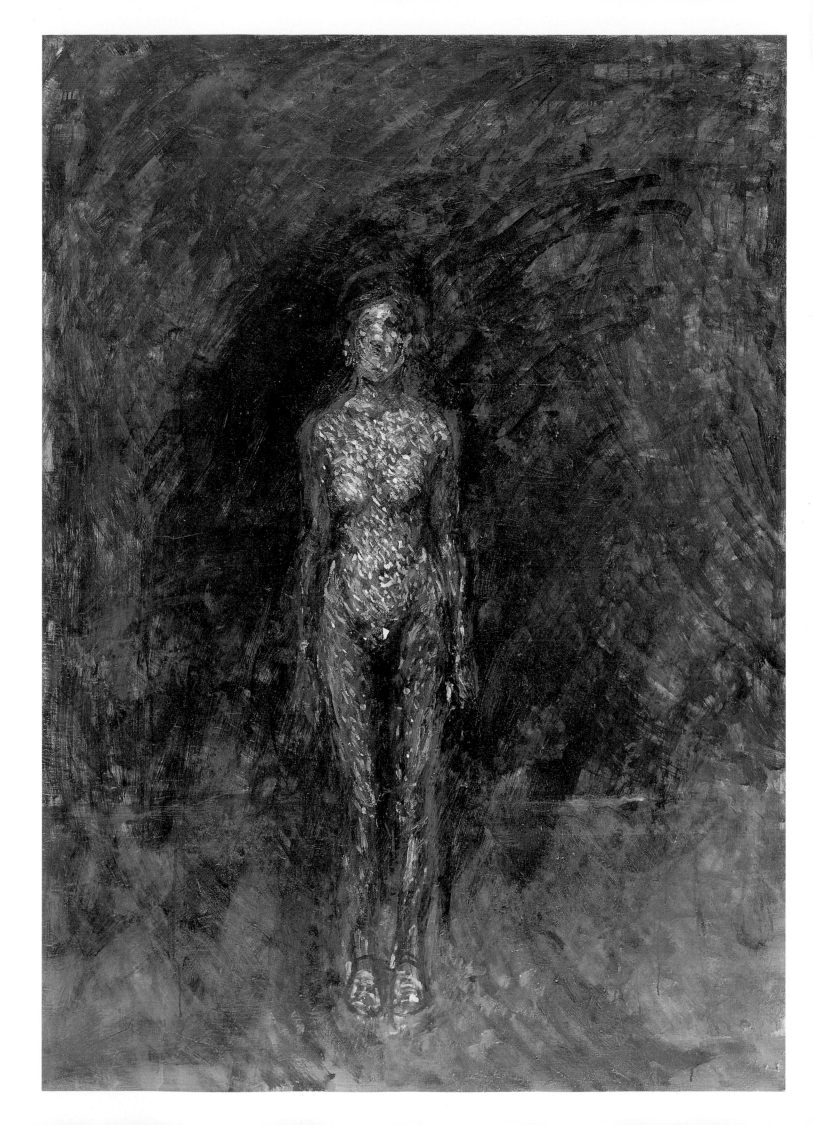

24
Self-portrait.
Standing. 1968/69
Oil on canvas.
140 x 100 cm.

following pages:

25
Self-portrait.
Walking. 1968/69
Oil on canvas.
121 x 170 cm.
26
Self-portrait.
Walking. 1968/69
Oil on canvas.
130 x 200 cm.

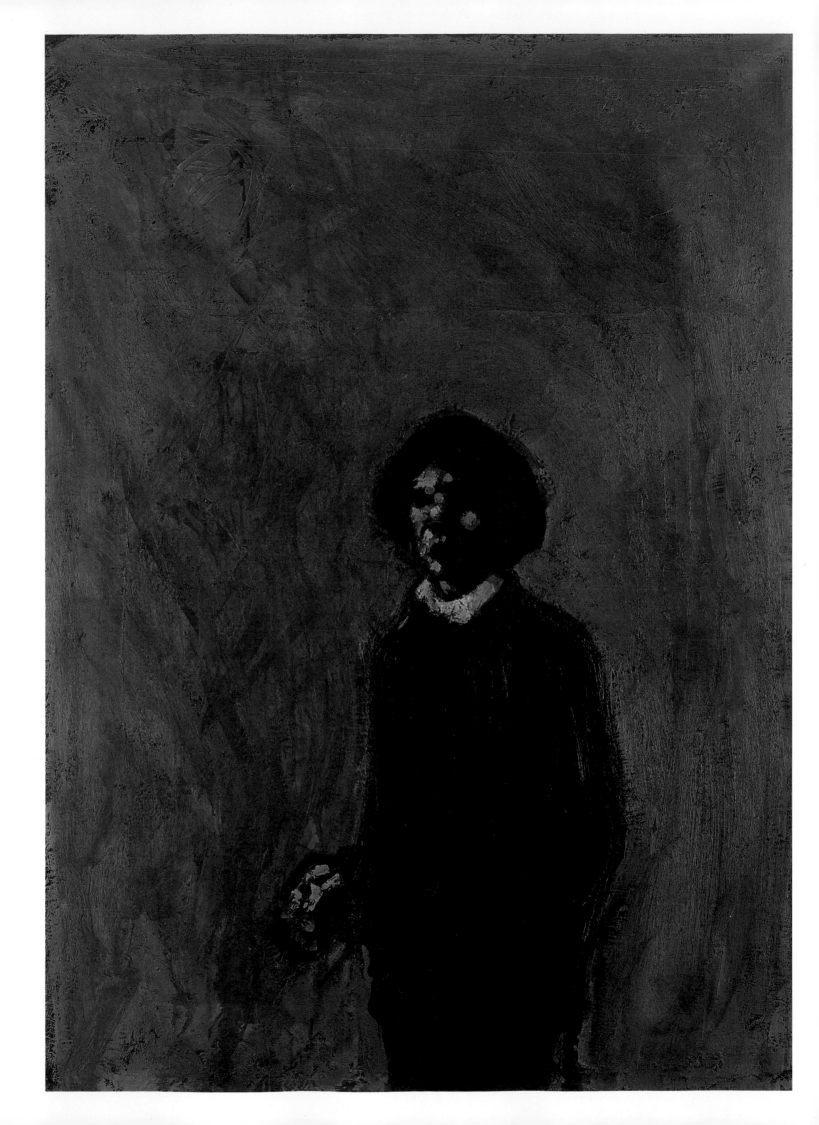

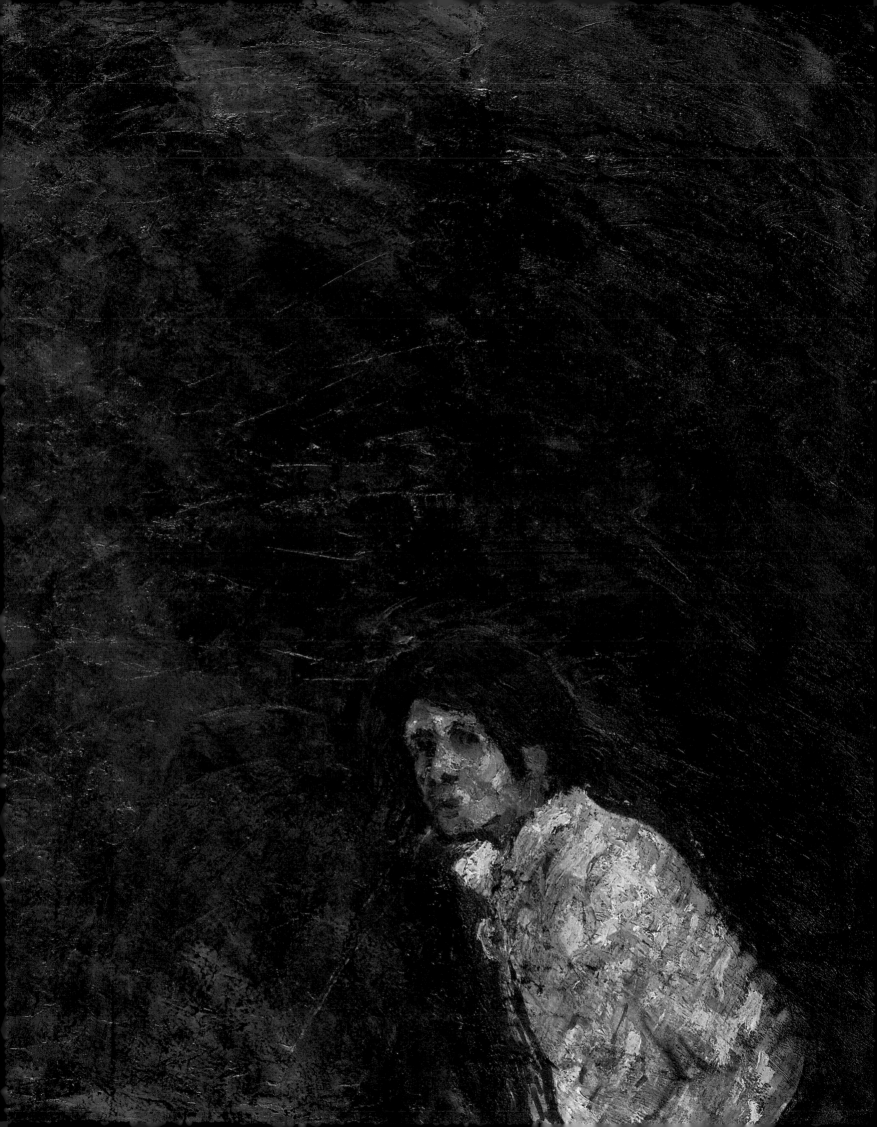

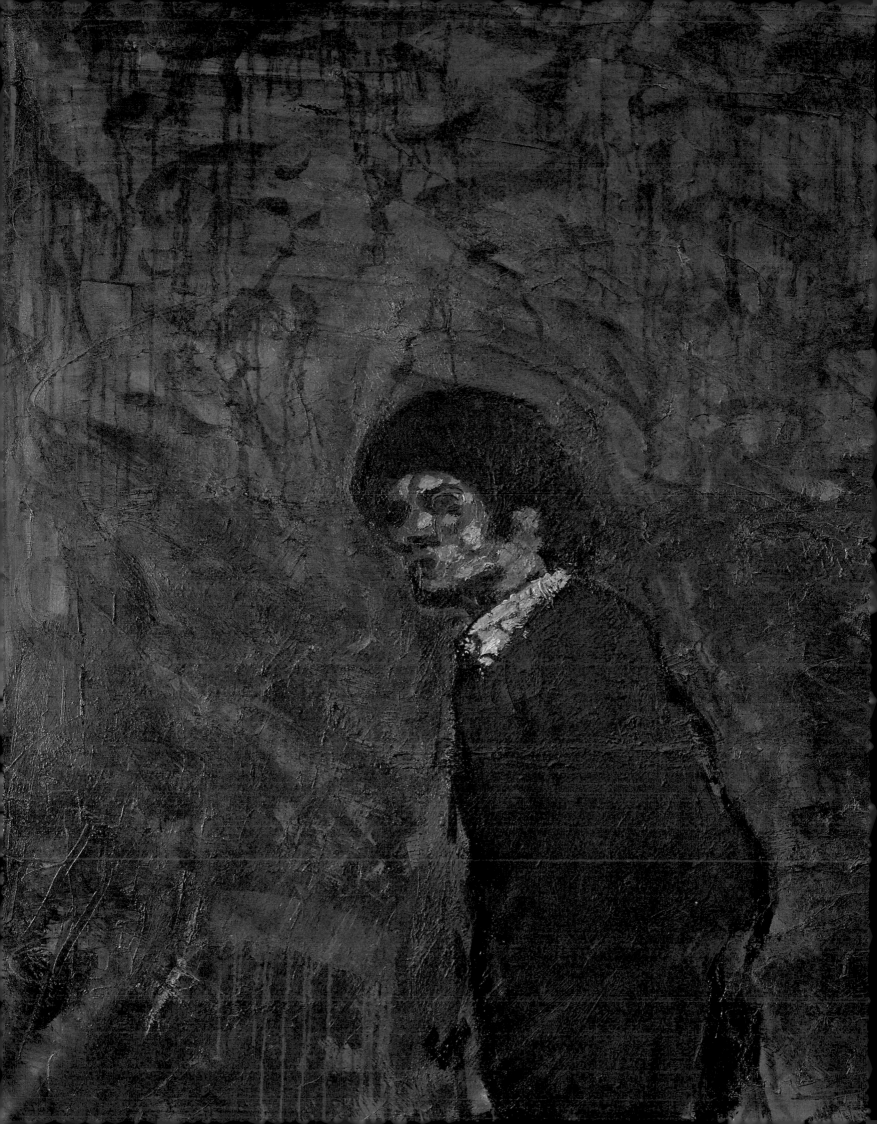

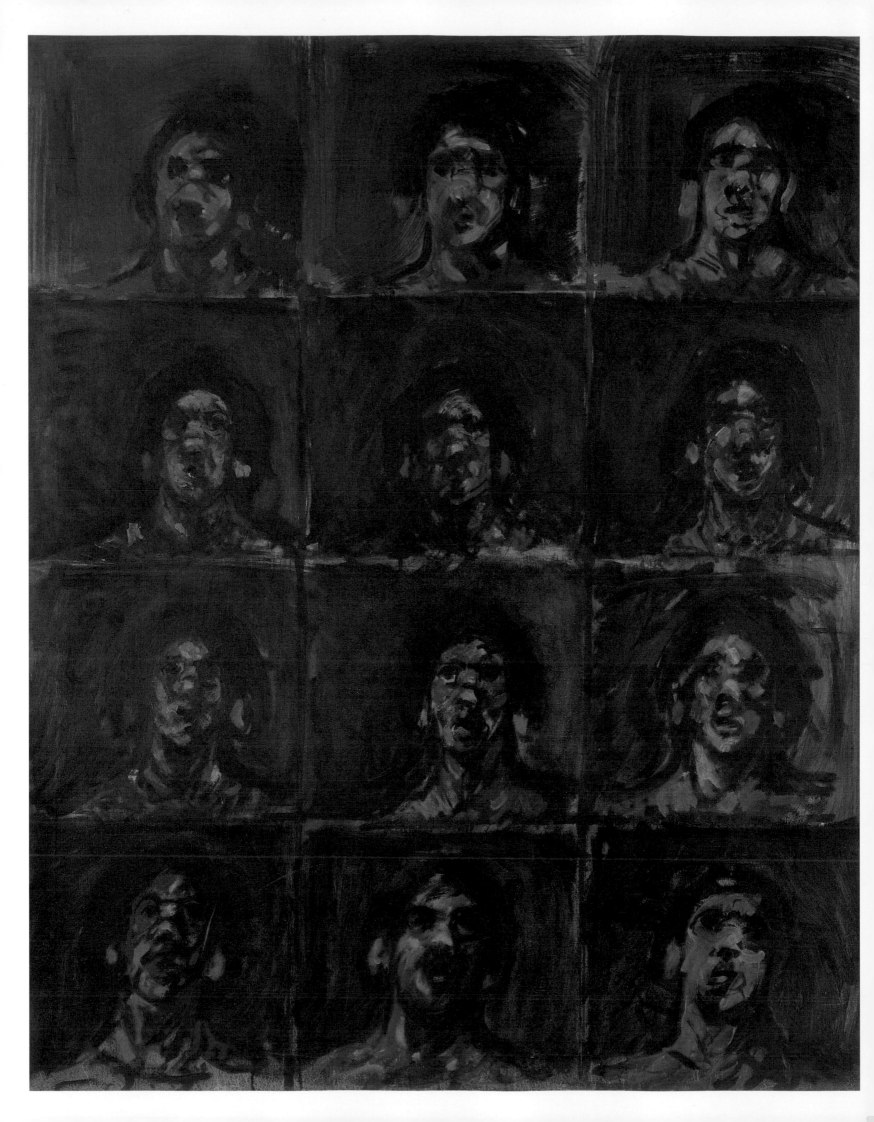

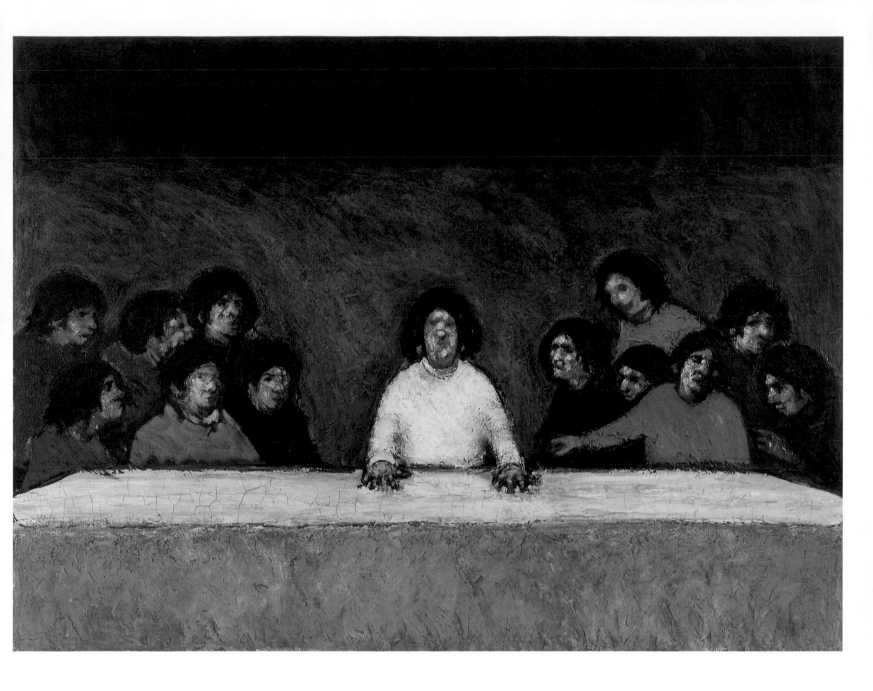

27
12 self-portraits. 1969
Oil on canvas.
162 x 130 cm.

28
The Last Supper. 1969
Oil on canvas.
150 x 201 cm.

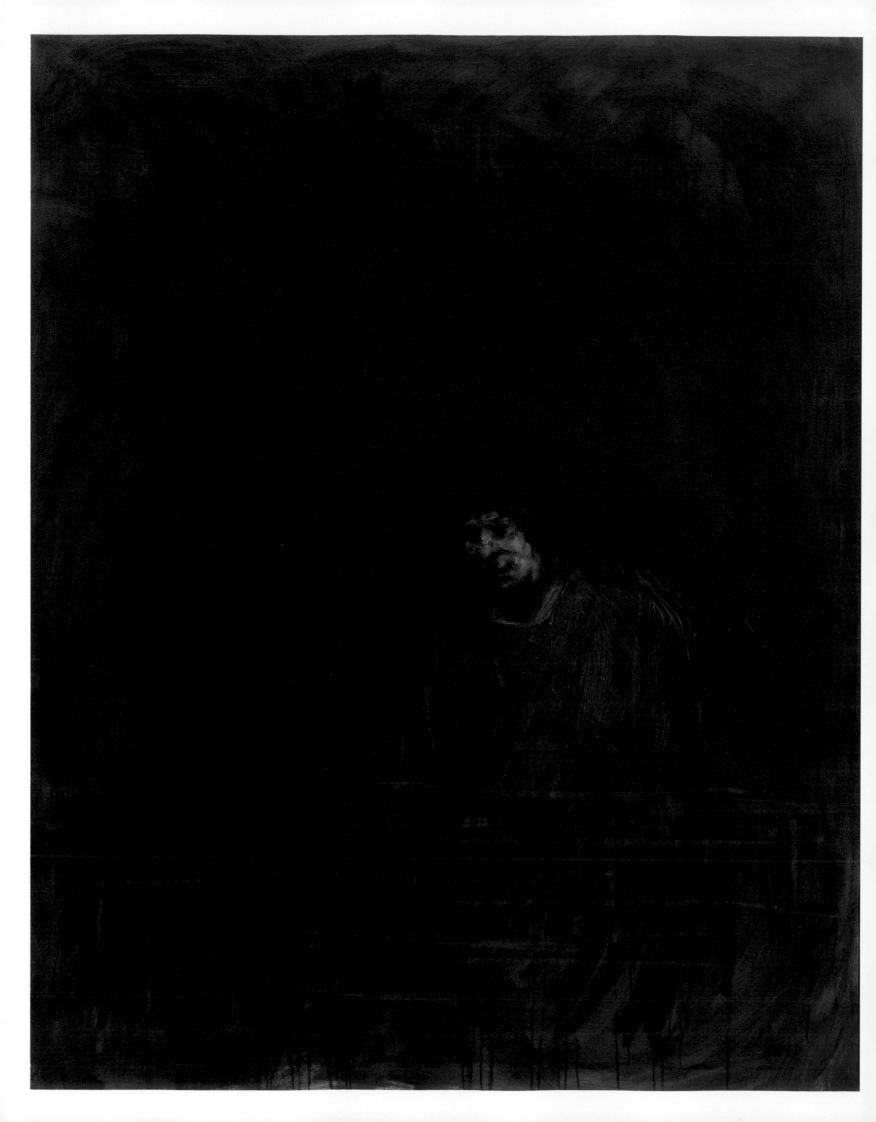

29
Man behind net.
Sketch. 1969
Oil on canvas.
160 x 130 cm.
30
Concert picture.
Rolling Stones.
1969/70
Oil on canvas.
120 x 170 cm.

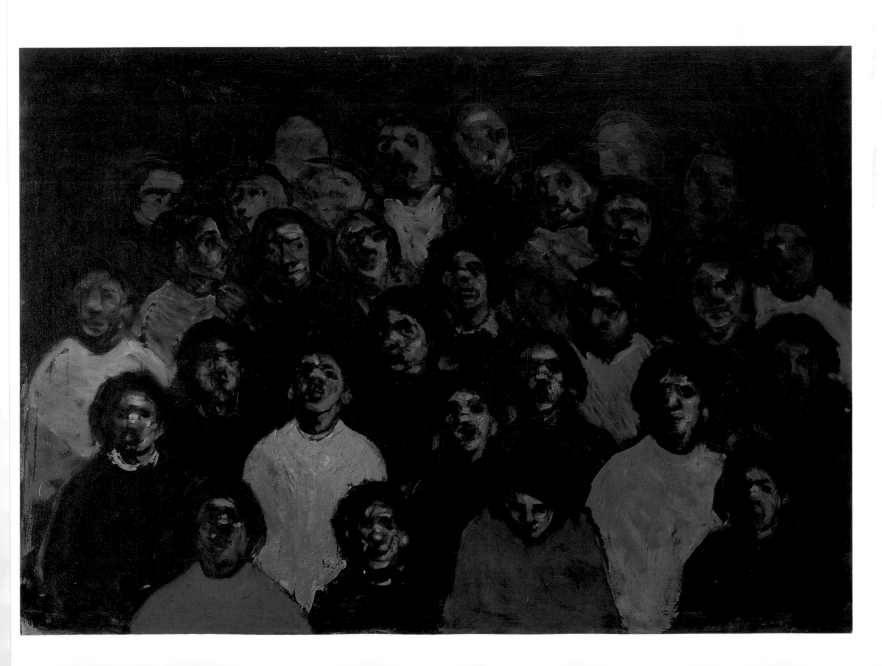

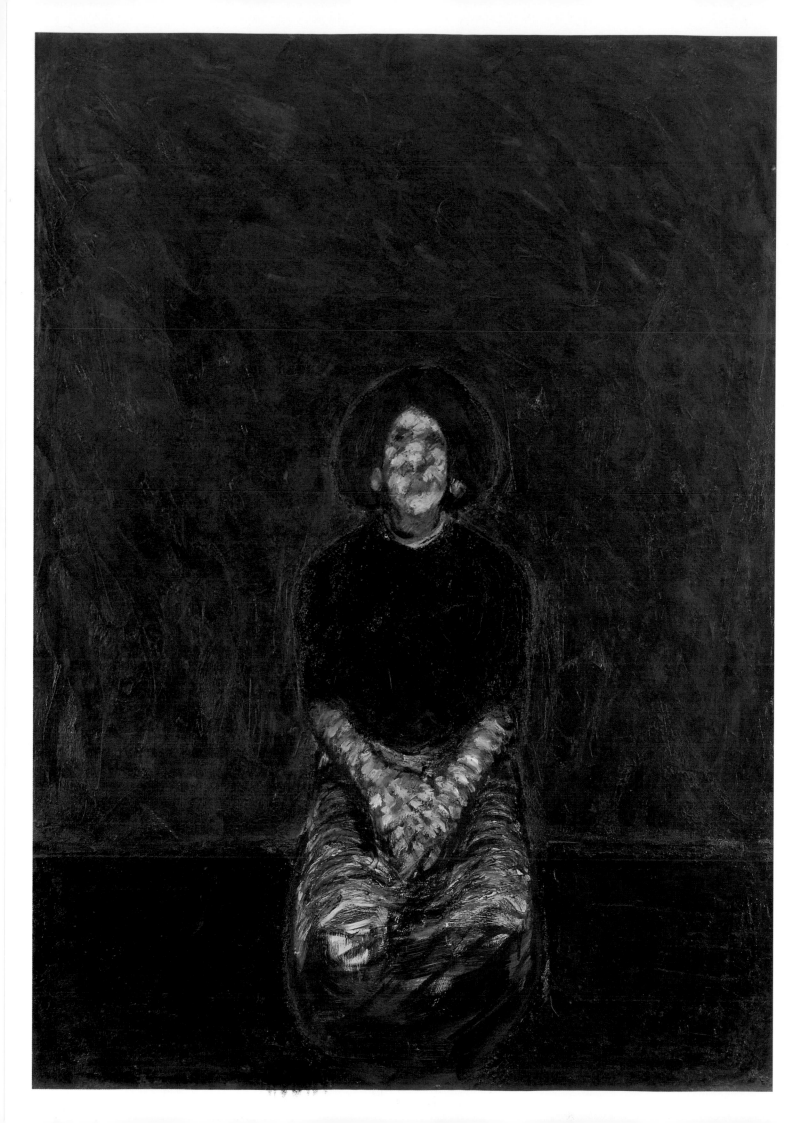

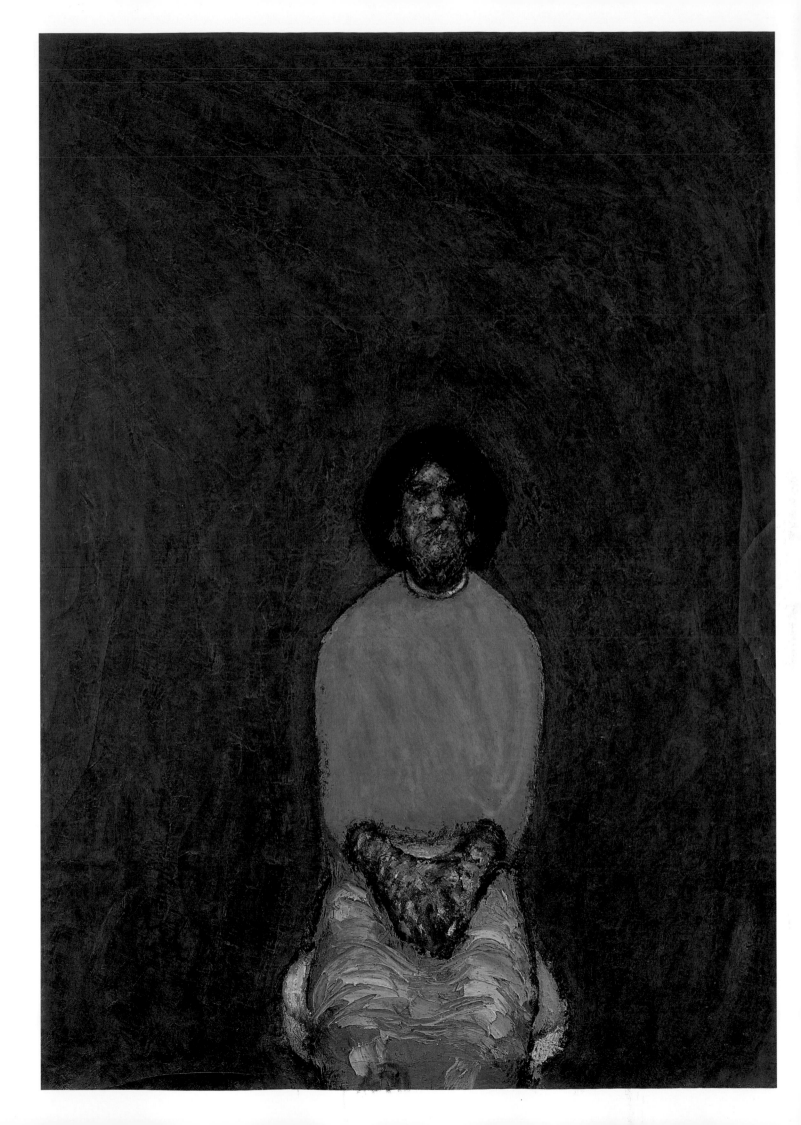

35

Self-portrait. Rome 1969

Oil on board.

23 x 22 cm.

36

Self-portrait. 1968/69

Oil on canvas.

90 x 120 cm.

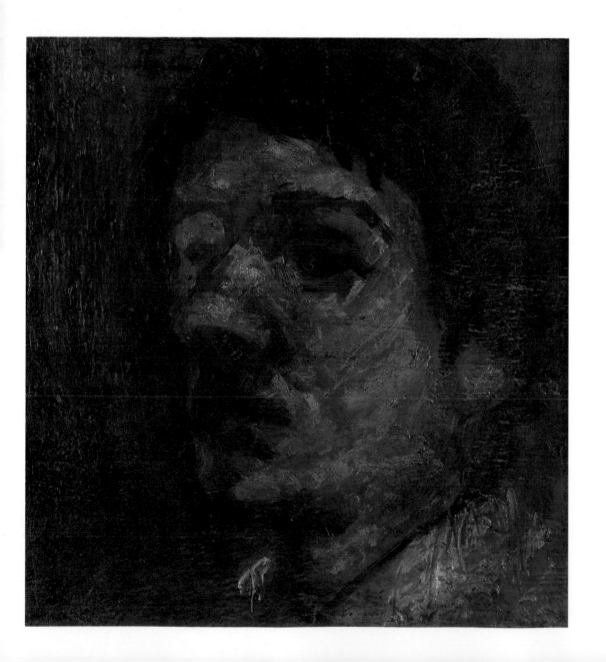

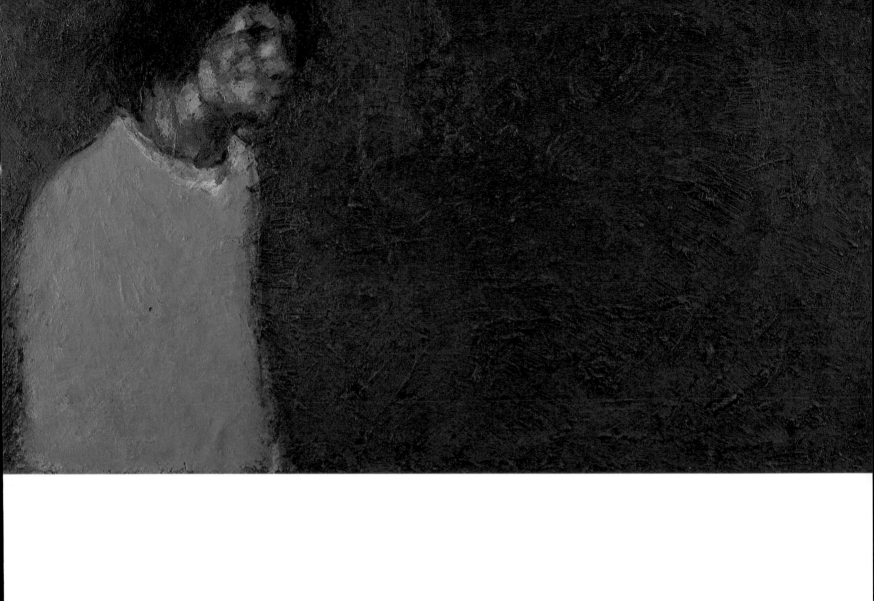

37
Self-portrait. 1970
Oil on board.
75 x 100 cm.

38
Self-portrait. Rome 1969
Oil on board.
69 x 100 cm.

39
Self-portrait. Walking along
wall with posters. Rome 1969
Oil and collage on board.
100 x 122 cm.

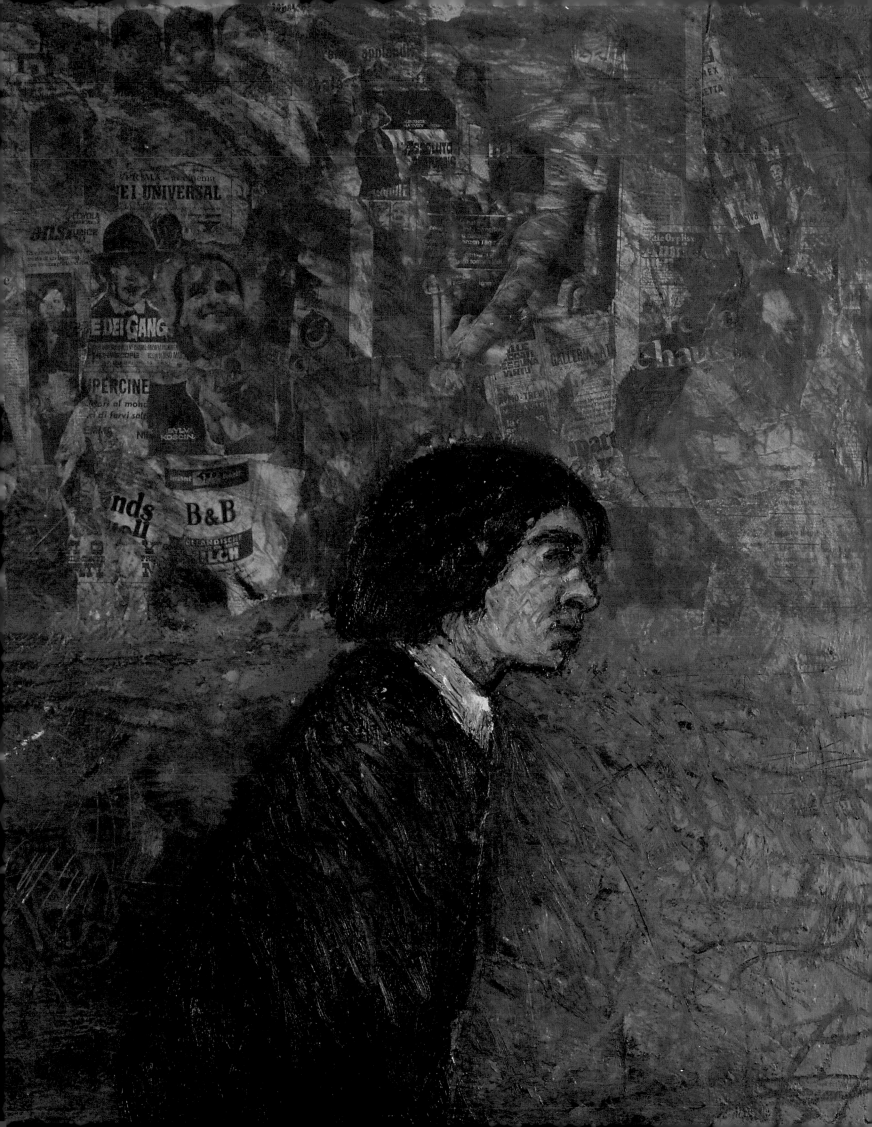

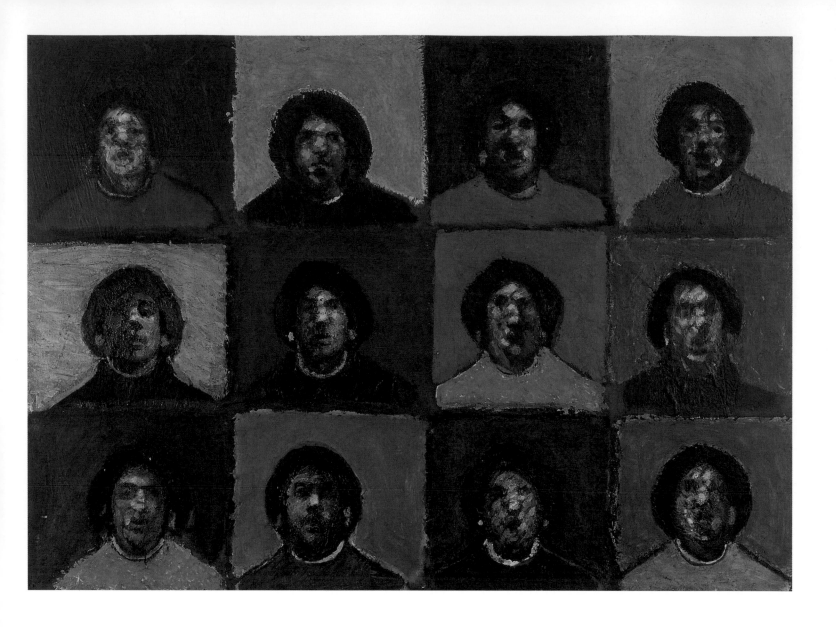

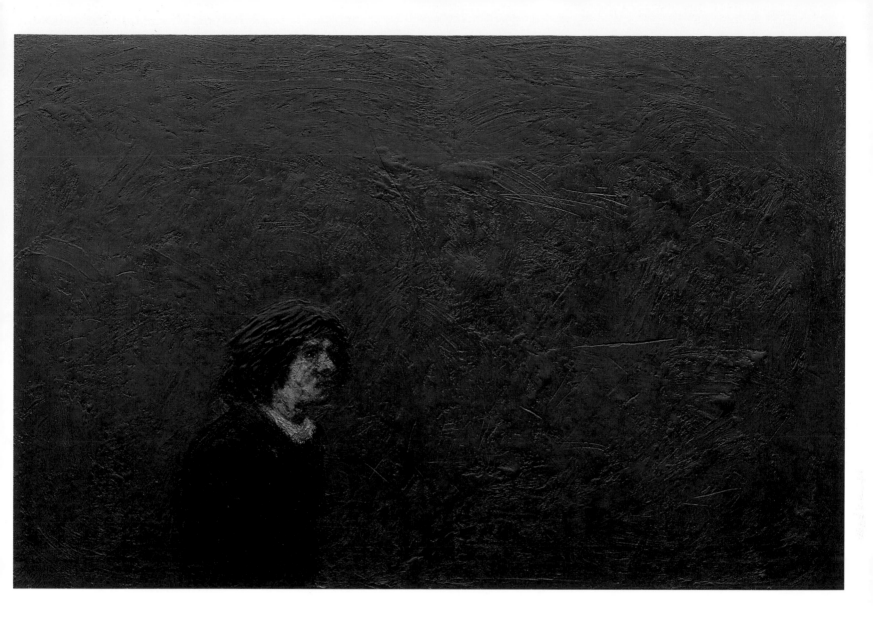

40
12 self-portraits. Rome 1969/70
Oil on canvas, pasted on board.
101 x 140 cm.
41
Self-portrait. Rome. 1969
Oil on board.
124 x 183 cm.

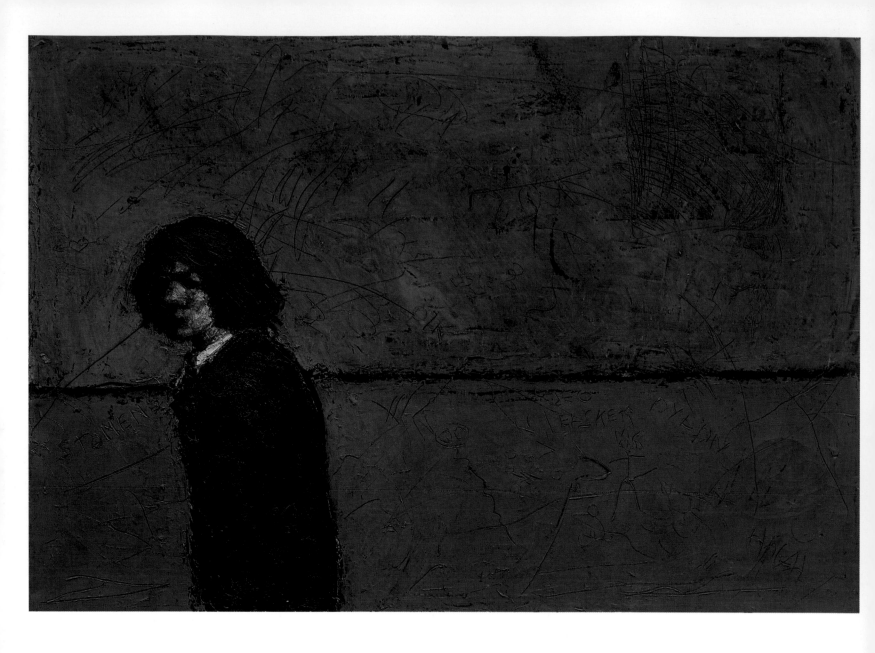

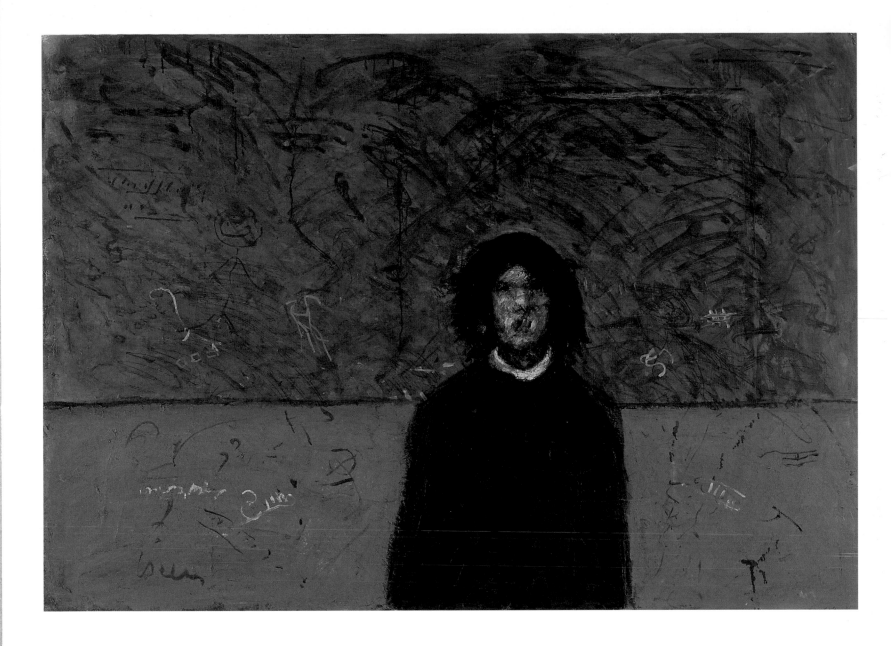

42
Self-portrait.
Walking. 1969/70
Oil on canvas.
100 x 140 cm.

43
Self-portrait.
Standing. 1969/70
Oil on canvas.
100 x 122 cm.

and what they are looking at. Only she is not staring out, but straight in front of her, lengthwise in the picture plane.

The first of these should of course be seen as yet another variation on The Last Supper. But it also plays more privately on Trampedach's own oddly conjuratory attitude to the number 13. Anyone who knows him knows that he sees it as his lucky number, and in the course of time it has indeed had a kind of magical meaning for him. One immediate reason for this is that he was born on May 13 – in other words this was the date when he came out into life or into the light and from then on had to fight his way through the world. But there is also more to it – the figure 13 is not normally considered lucky in the Christian cultural world. On the contrary, precisely because of the betrayal of Christ by Judas on the night of the Last Supper, it has taken on such an ominous aura in the awareness of most people that there are skyscrapers where the thirteenth floor is simply skipped and hotels where rooms with this number are not among those rented out – just as there are those who will not in any circumstances have thirteen people at the table.

If Trampedach chooses to reverse the meaning of this unlucky number in his own life it is undoubtedly because he has felt from the start that he was at odds with the world, a stranger, an unadapted entity among other more adaptable ones. It was only relatively late that he discovered that it was the depressive disposition inherited from his father that gave him this feeling of fundamental isolation from other people. For many years it had surprised him that at night, in the bars, among friends, he stood as if paralysed in the crowd, unable to say anything and unable to explain why to himself.

But gradually he understood that this was much more than just passing melancholy – and along the way toward this at once tragic and comforting realization he tended to see his role as an artist as the reason for his alienation. Since the days of Romanticism there had been a tradition for artists to be isolated, in opposition to the prevailing norms – and he saw himself as perpetuating this tradition. And given this, in a way it stood to reason that he was born on the thirteenth. There was the suggestion of a condition of life in this – or of a destiny. And since he could imagine no other way through the world than the artist's, he assigned the date and the number a propitious meaning.

Thirteen at the Table thus bears witness to this fateful choice of profession. And in his own self-understanding Trampedach is here both Judas and Jesus – both the man who asks the questions and the one who gives the answers. This dual role is inevitable, there is no getting away from it; the bread must be broken and the cup must be drained. And this is what has long since happened: the plate lies there flat and white as a communion wafer on the table and the glass has been emptied of wine. The picture is in that sense theatrical in the extreme – and in fact it would all be too much if the painter had not incorporated a certain distance suggesting the role-playing; partly through the relative cheerfulness that typifies the thirteen heads that float like satellites around the round table – and partly through the illusionistic frame he has painted around the actual scene (Fig. 59).

He has used a similar framing in the picture of the waiting people – in order to emphasize the staged nature of this odd satire. He even has three of the men stick their hands out of the illusionistic space they are in, so that no one can be in any doubt about his intentions (Fig. 57). It is a trick, of course, and Trampedach

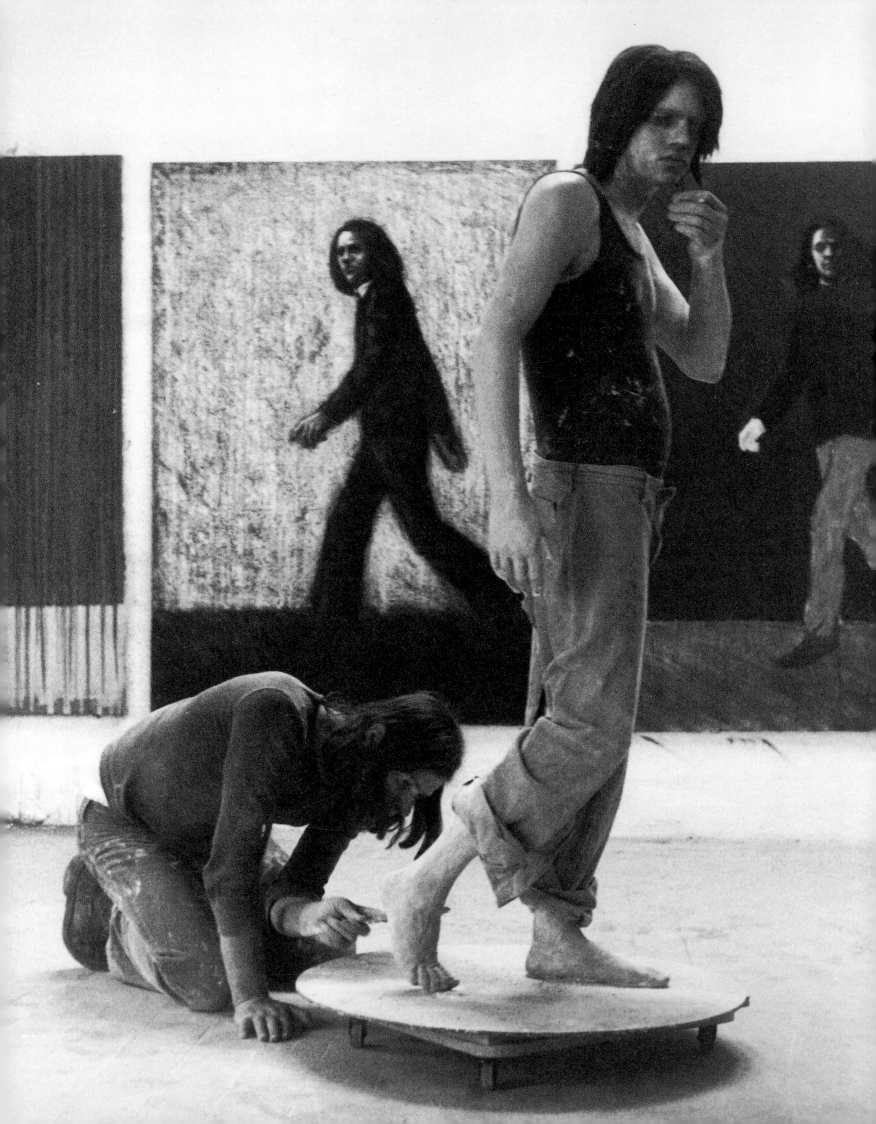

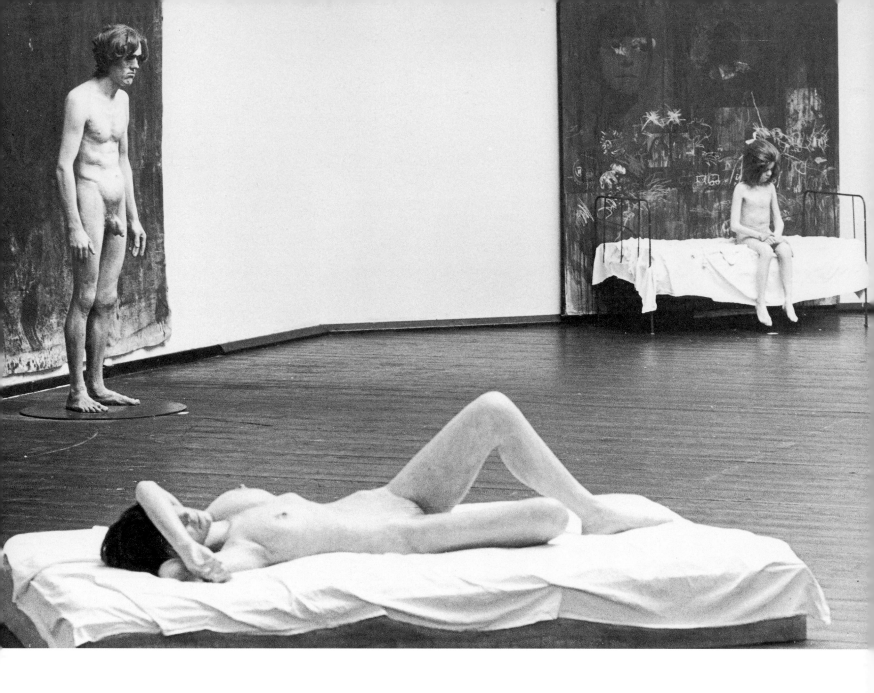

has borrowed it from Rembrandt, who used it in both in his painting and his graphic work to demonstrate his incredible virtuosity; and who did it with equal portions of insolence and subtlety. "Look what I can do", he says to his customers, well aware that he can also do so much more that they are not immediately capable of grasping.

But there is more to it than Rembrandt, the guiding star of Trampedach's youth. For in those very years his eyes had been opened to his own fellow-countryman Vilhelm Hammershøi, and had confronted the latter's masterpieces in the north-facing, light-starved room that Jørn Rubow – with his usual precision – had given him at Statens Museum after the rebuilding at the end of the sixties. The walls were pink in there and imperceptibly enhanced the scale of dusty violet gray tones that are the hallmark of this demonic painter – and this was undoubtedly one of the reasons that Hammershøi regained his status in those years as one of Denmark's most significant painters. But more than that – Hammershøi now also became our contemporary, because like some medium he seems to have anticipated the fundamental angst that dominated the period and had found its strongest visual expression in Giacometti and Francis Bacon. One suddenly felt that he had said the same as they had, in a far more sensitive and differentiated way.

Five sculptural tableaux,
mixed media. Photo from the
installation at an exhibition
in Copenhagen in 1975.
The sculptures still exist,
but in other contexts.

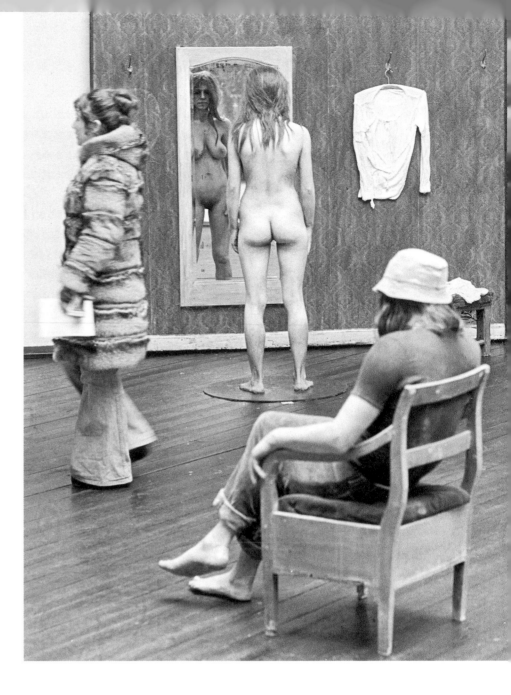

Clearly Trampedach, who had been crucially influenced by Giacometti and who had seen Bacon, through books and periodicals, as a kindred spirit, had to turn to Hammershøi to find confirmation. All the more so as Hammershøi had made use of a similar highly limited color scale. The two pictures that affected him most at Statens Museum were Hammershøi's large composition, still as enigmatic as ever, *Artemis,* and then his late portrait of his wife Ida, who sits apparently lost in thought with a coffee cup in front of her. In the first of these it was not just the static otherness of the figures that fascinated him, but also the remarkably abstract threefold division of the background; and in the second it was not just Hammershøi's intensely empathic scanning of his wife's state of mind but also the frame he had painted in around her – apparently to single her out as an exemplum of existence.

This is the frame Trampedach has appropriated as a theatrical element in his own, less sensitive figurations – and with which he works on in his later compositions, where he creates searching, experimental variations on earlier themes. We still see the seated and reclining women and the walking men and of course the self-portraits – indeed, he paints an updated variant of his breakthrough picture *Bowed Down,* just as he now introduces the first animals in his works: running dogs

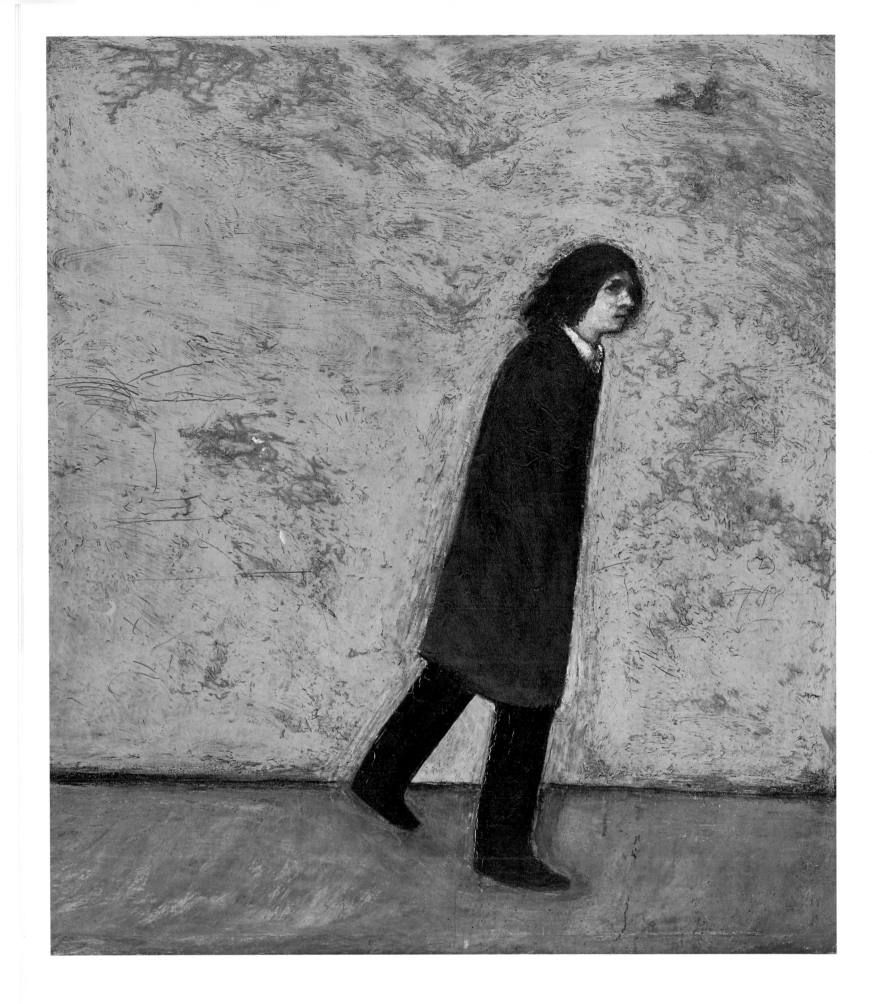

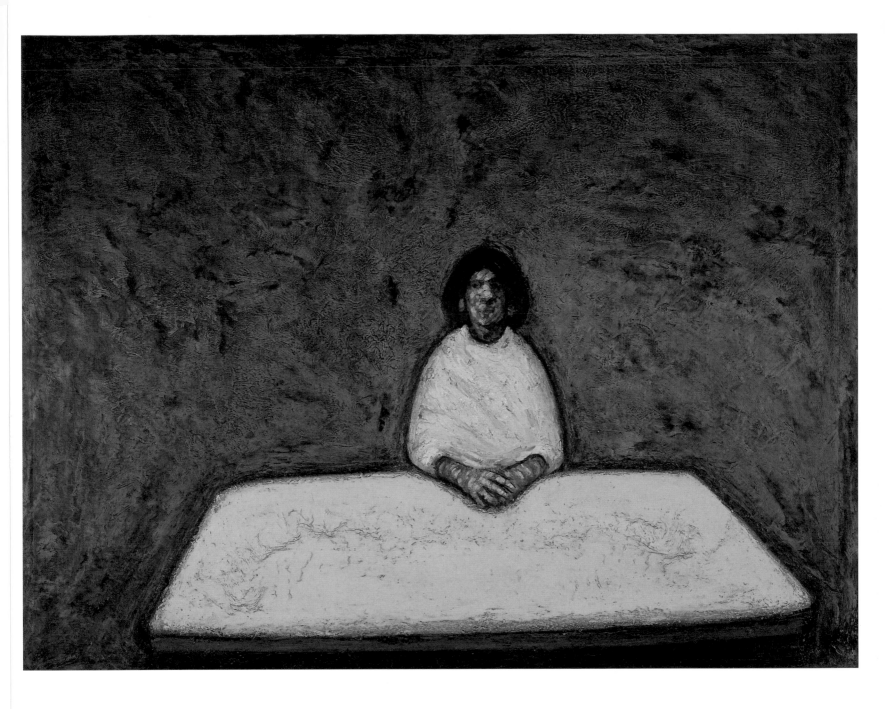

44
Self-portrait.
Full-length, walking. 1970
Oil on canvas.
200 x 180 cm.
45
Self-portrait.
Seated at table. 1970
Oil on canvas.
150 x 200 cm.

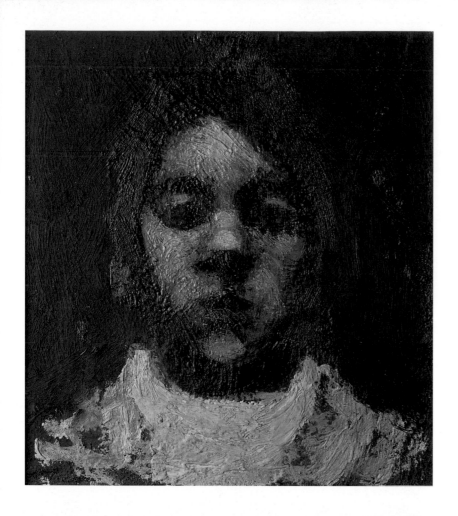

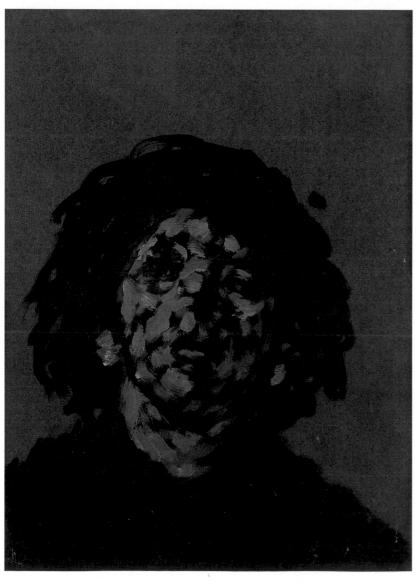

50
Portrait. 1971
Oil on canvas.
24 x 22 cm.
51
Self-portrait. 1971
Oil on cardboard.
25 x 20 cm.
52
Lonely. 1971
Oil on canvas.
180 x 150 cm.

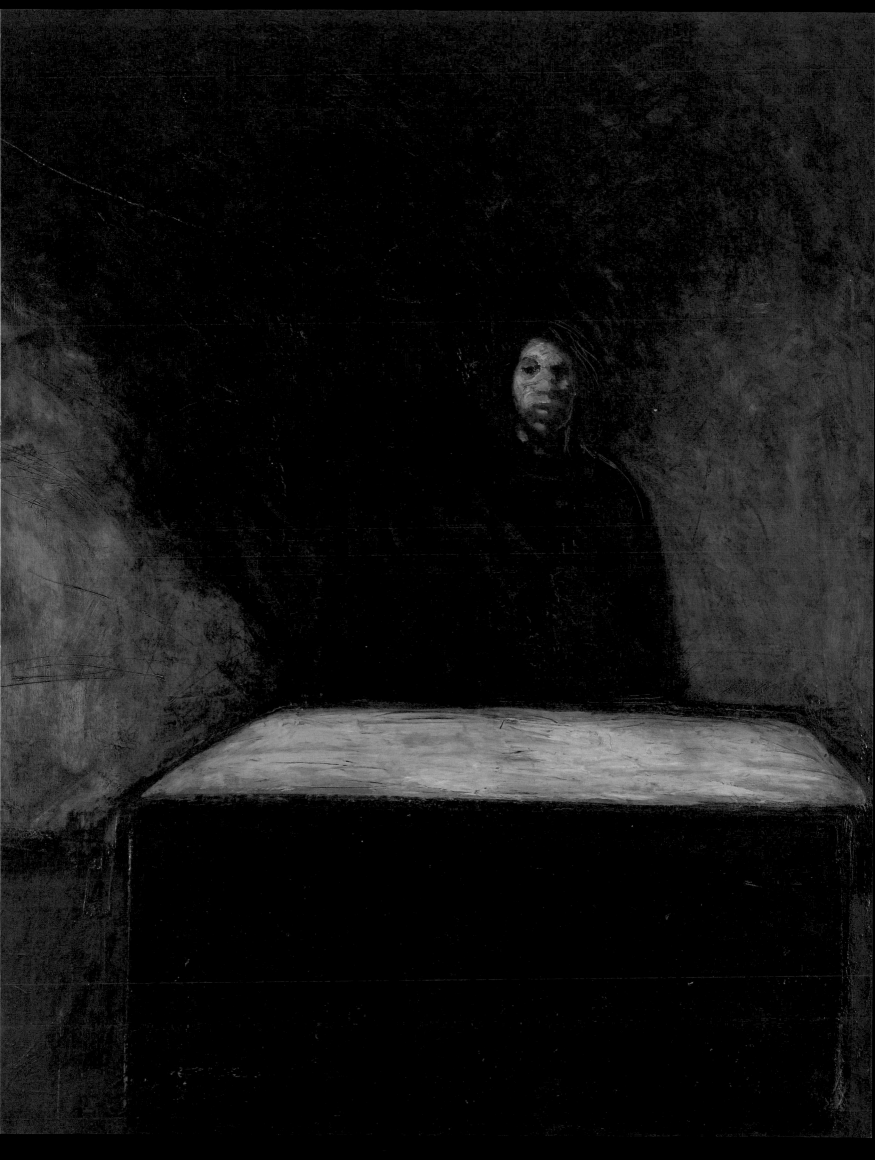

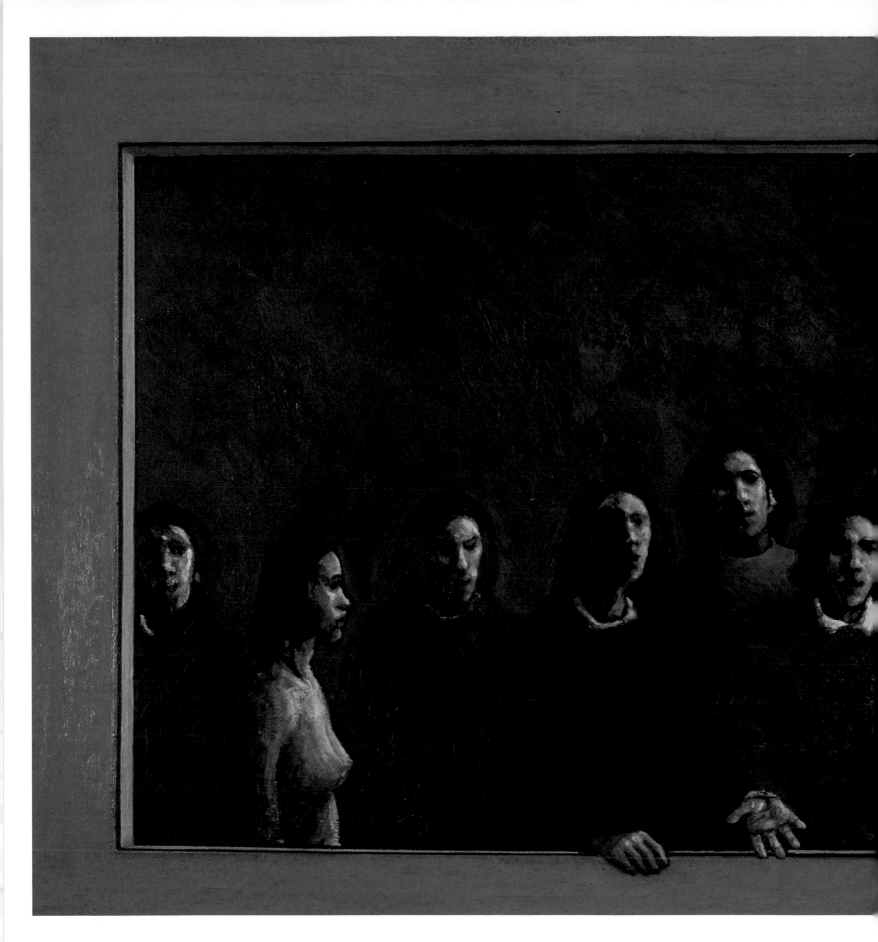

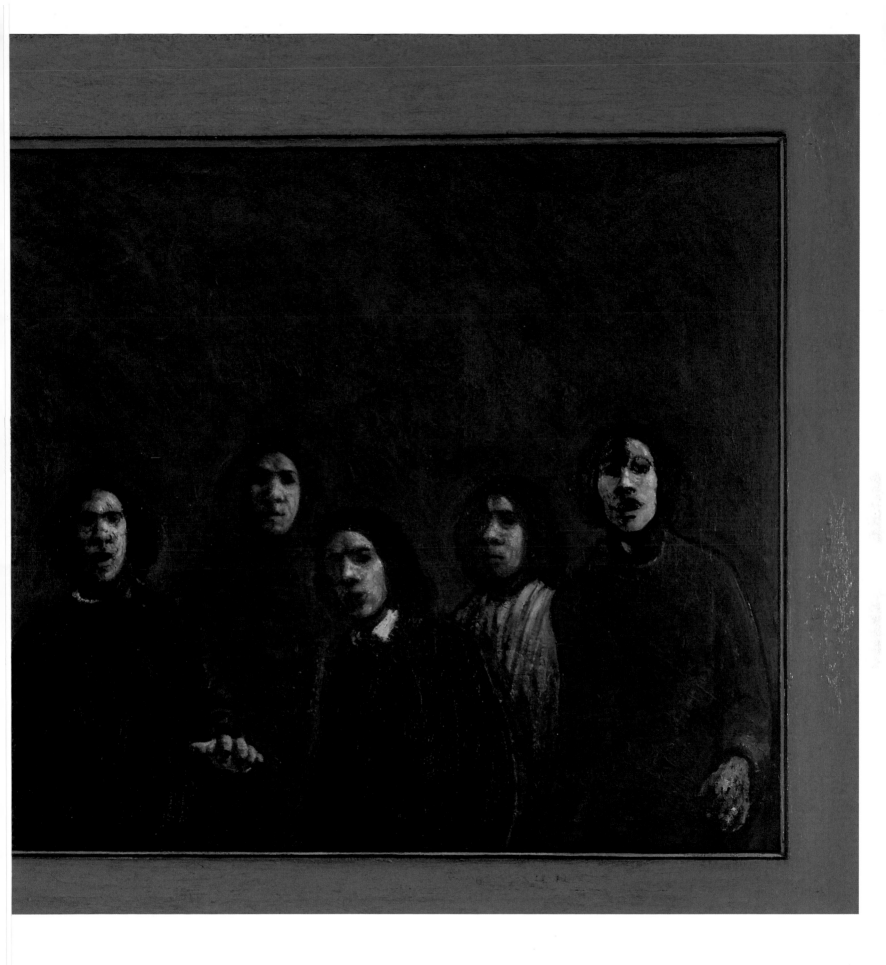

57
People Waiting. 1971/72
Oil on canvas.
150 x 300 cm.

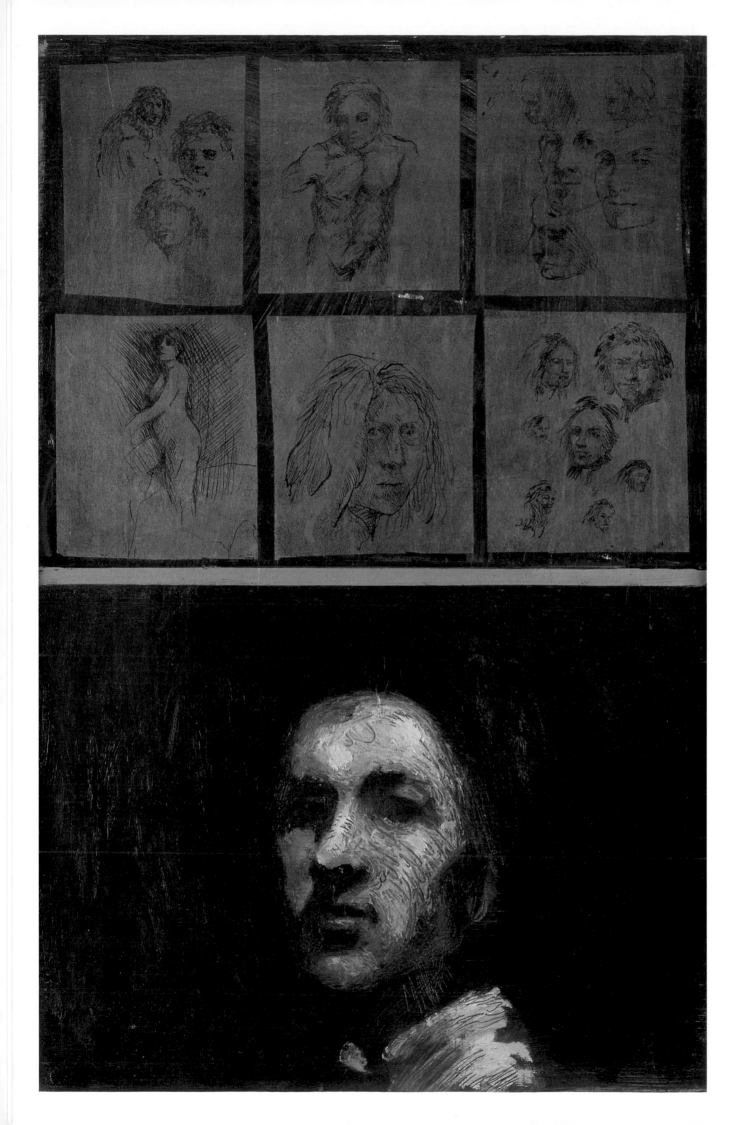

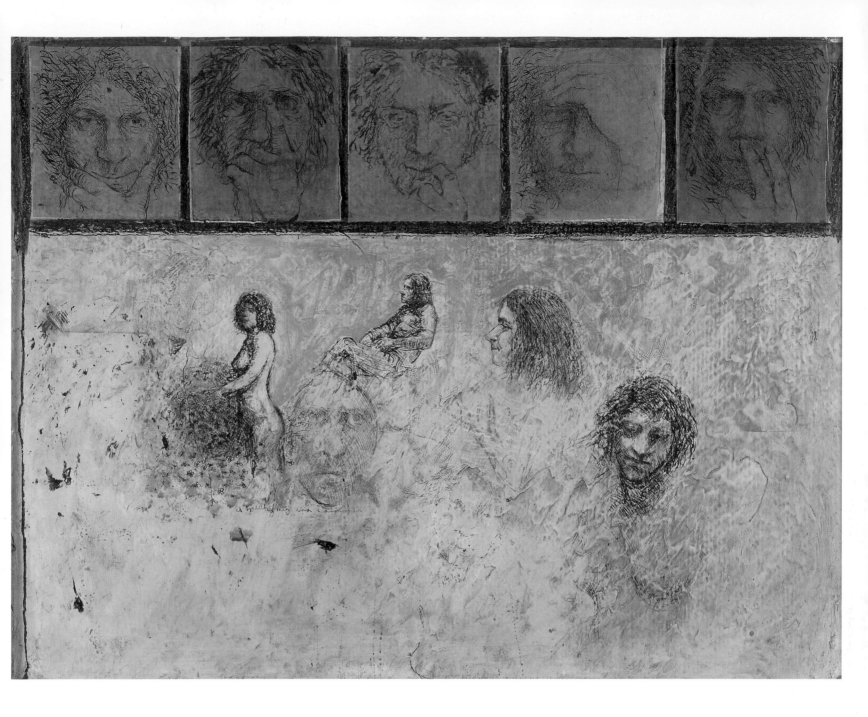

65
Portrait of man below
six drawings. 1971
Oil on board.
55 x 36 cm.

66
A Momentary Glimpse of the Dream. 1971
Pen, ink and oil on paper and board.
78 x 100 cm.

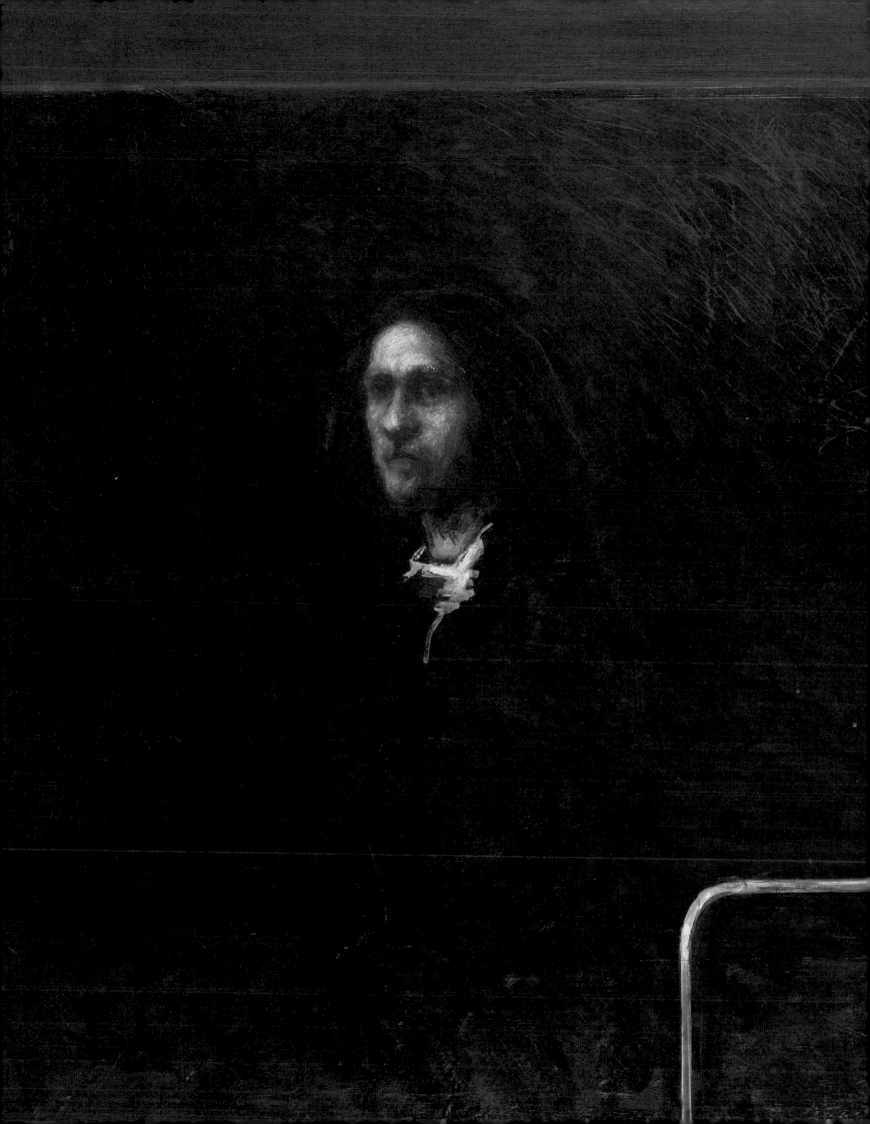

67
Walking man
by banister. 1972
Oil on canvas.
110 x 150 cm.

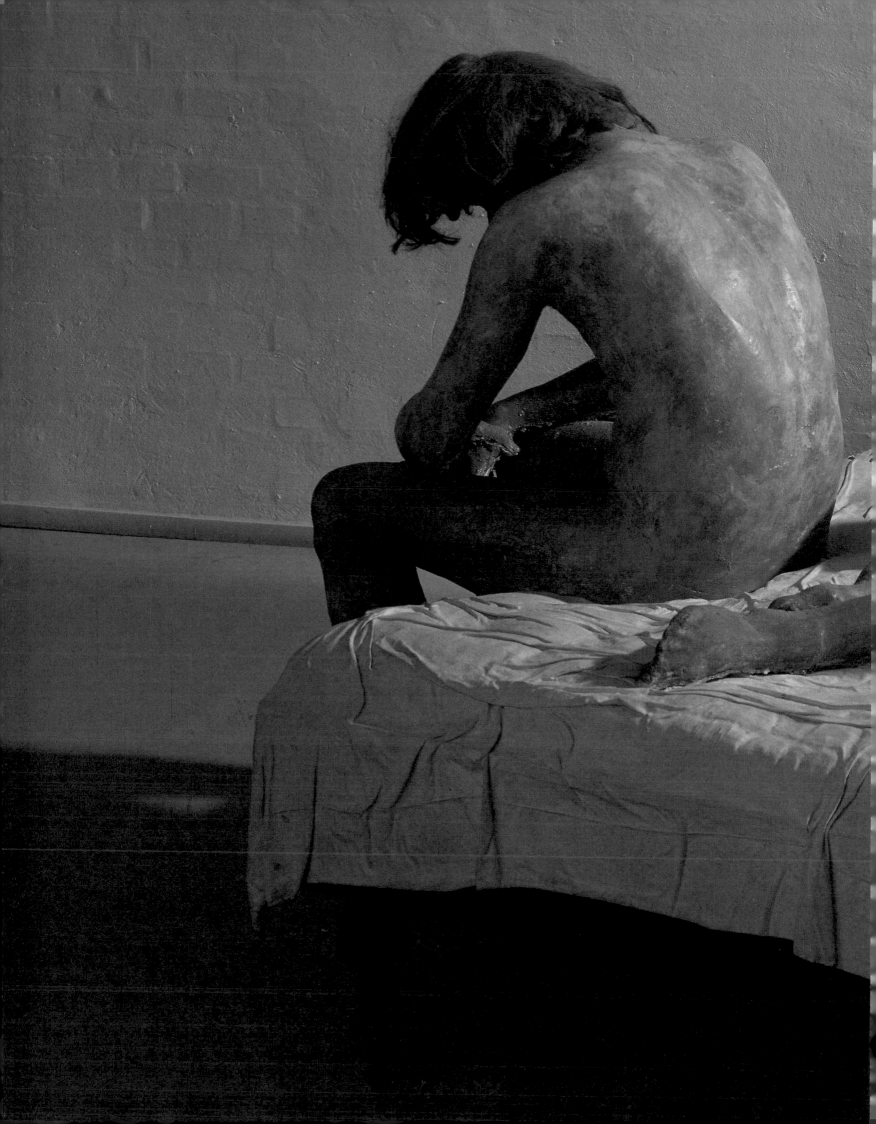

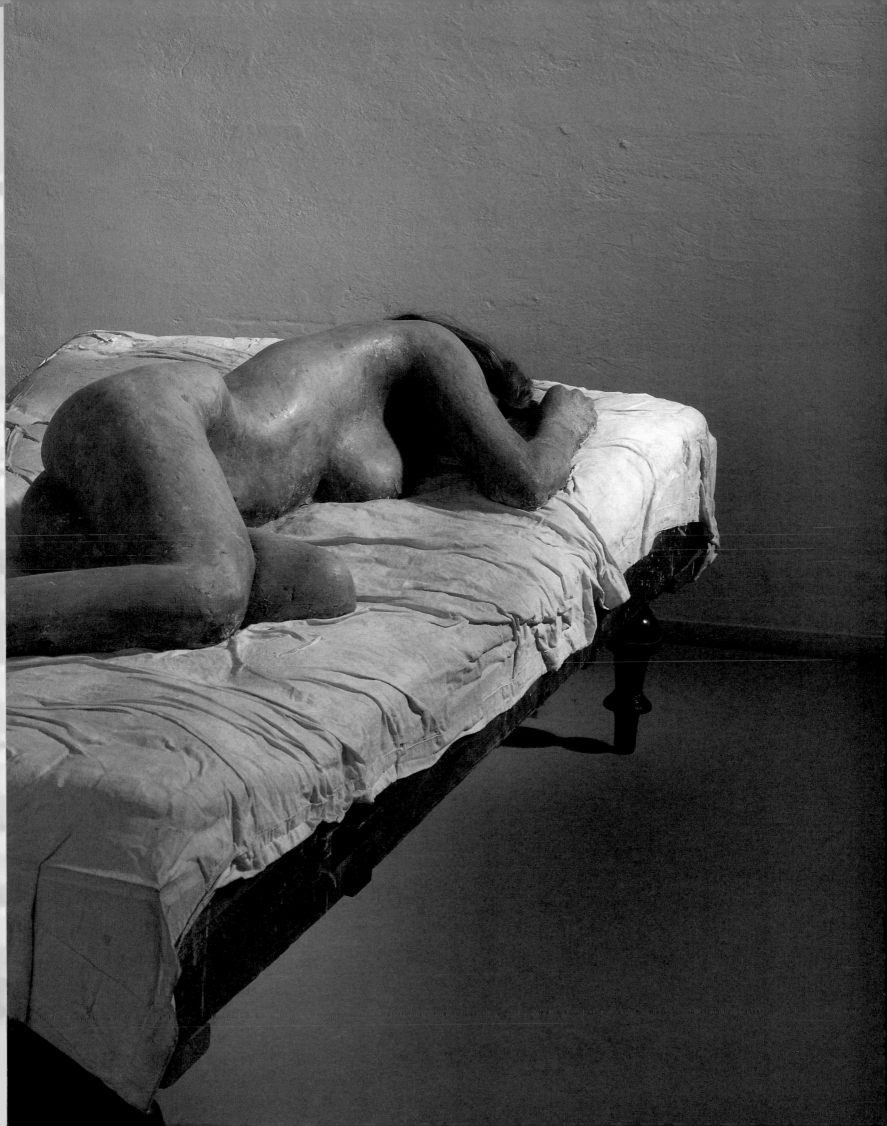

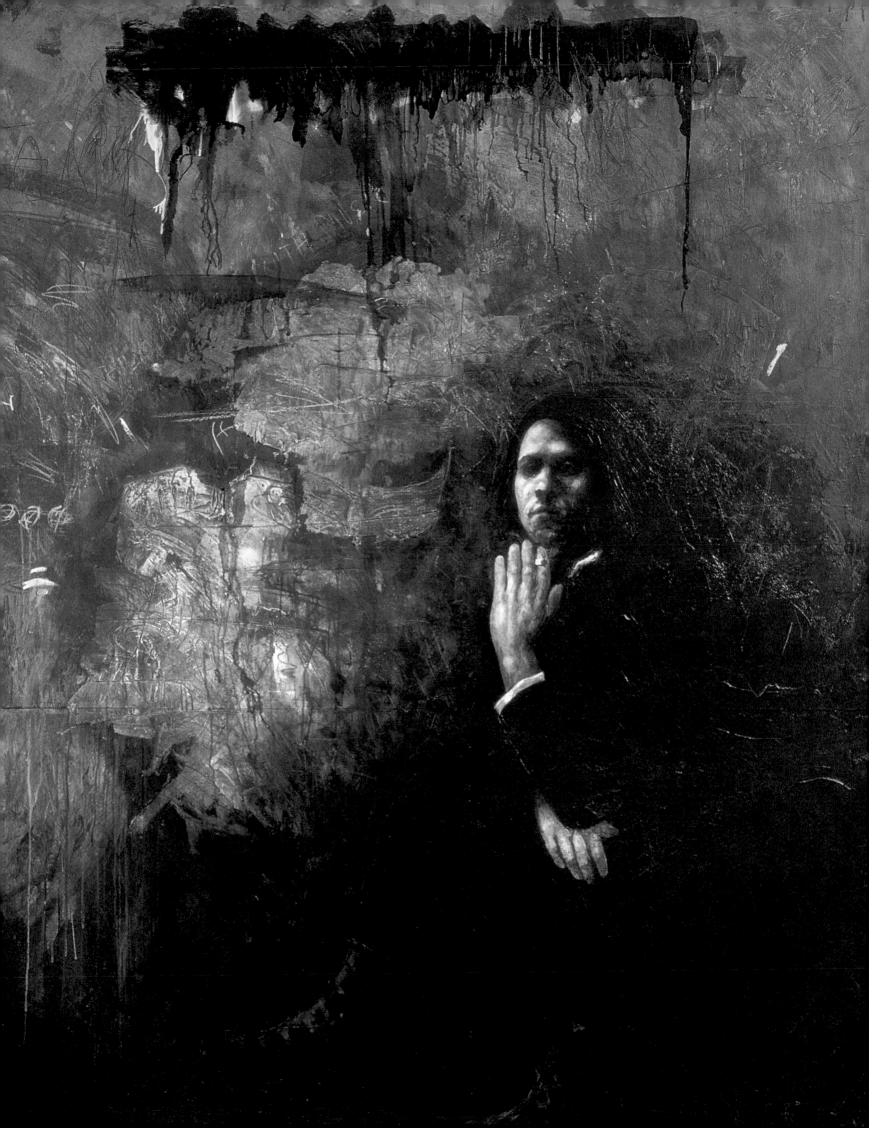

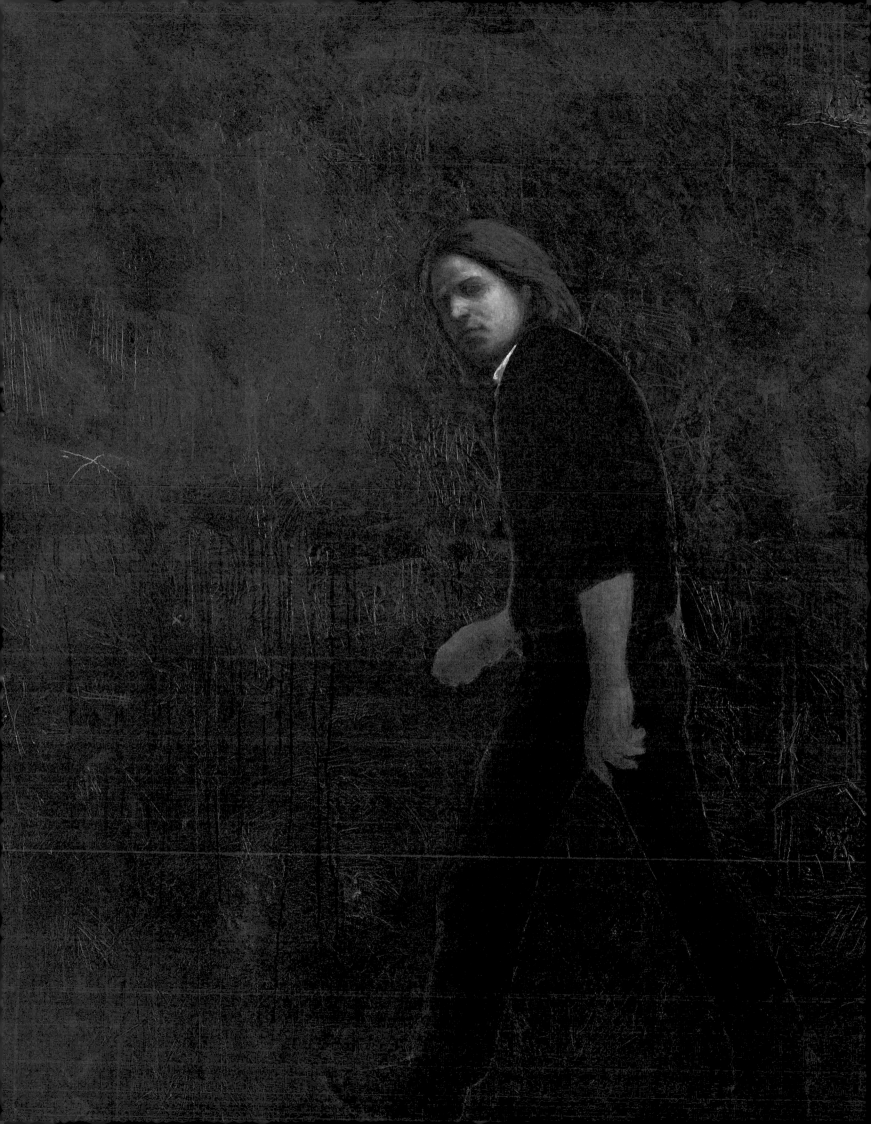

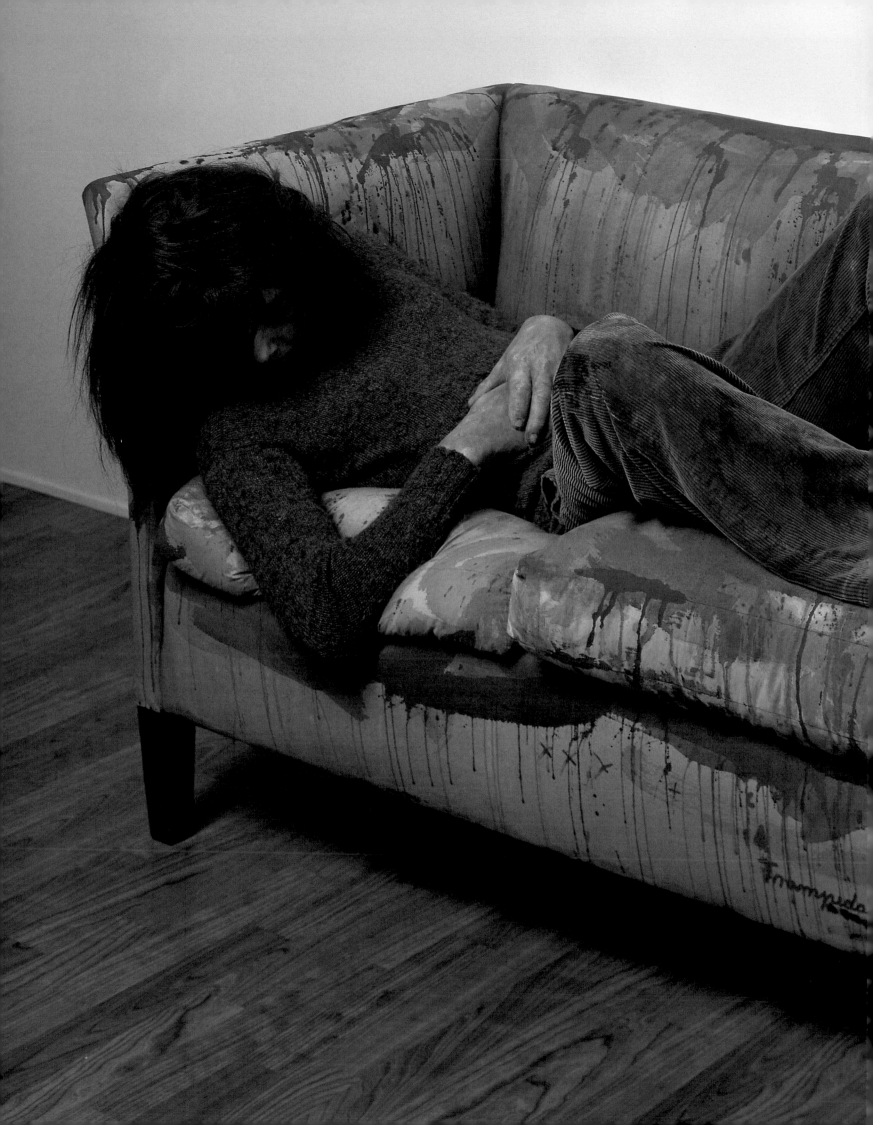

85
Boy sleeping
on a sofa. 1976/77
Sculpture, mixed media.
140 x 75 x 60 cm.

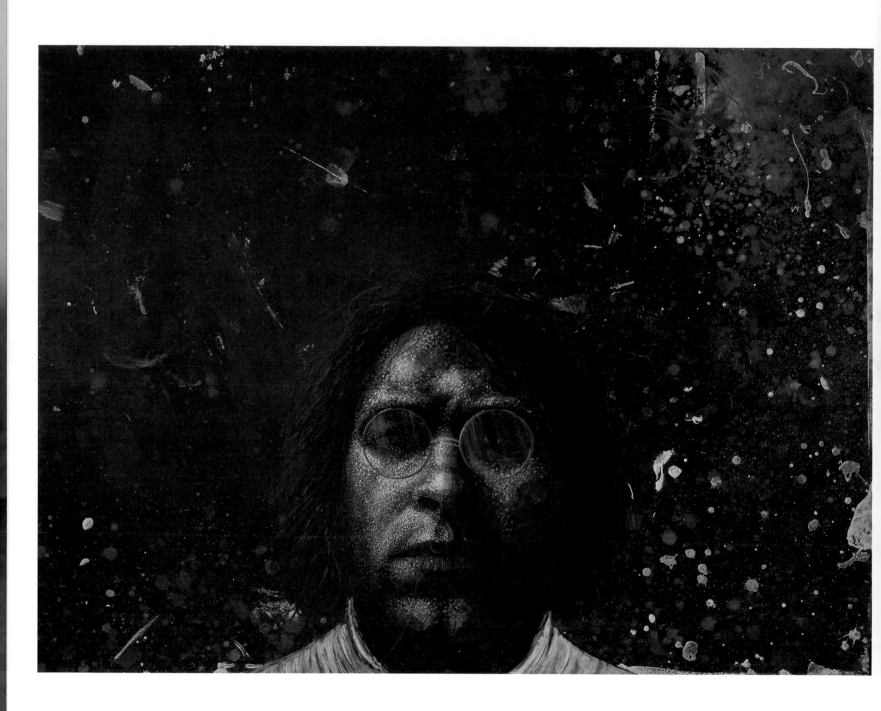

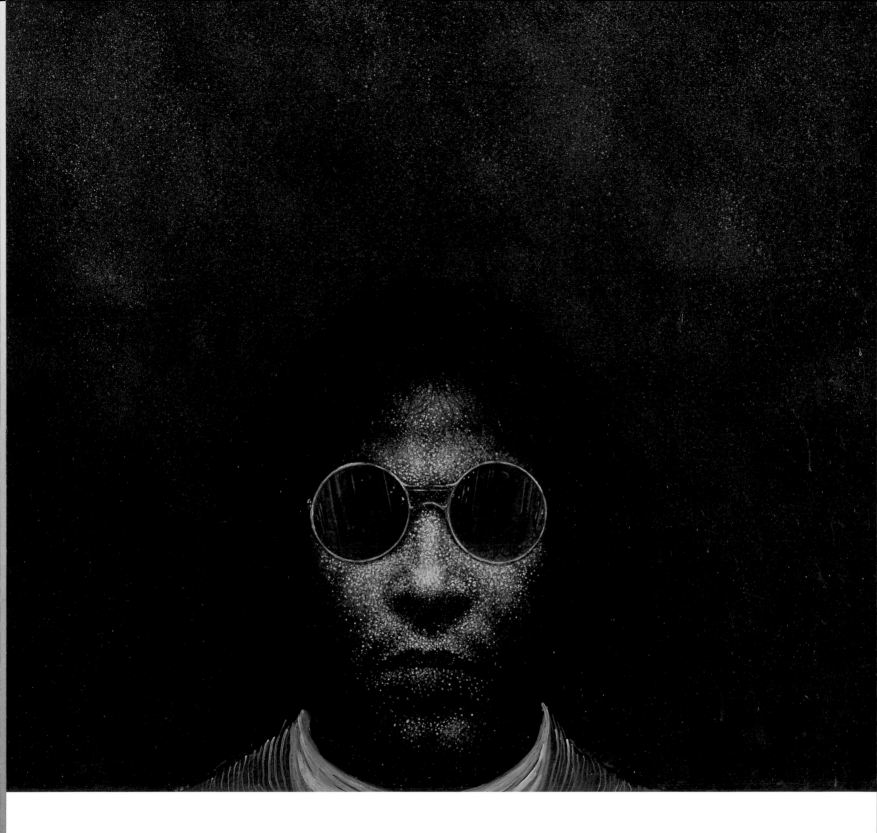

94
Self-portrait with sunglasses. 1978
Acrylic on board.
109 x 145 cm.
95
Self-portrait with sunglasses. 1978
Acrylic on board.
120 x 180 cm.

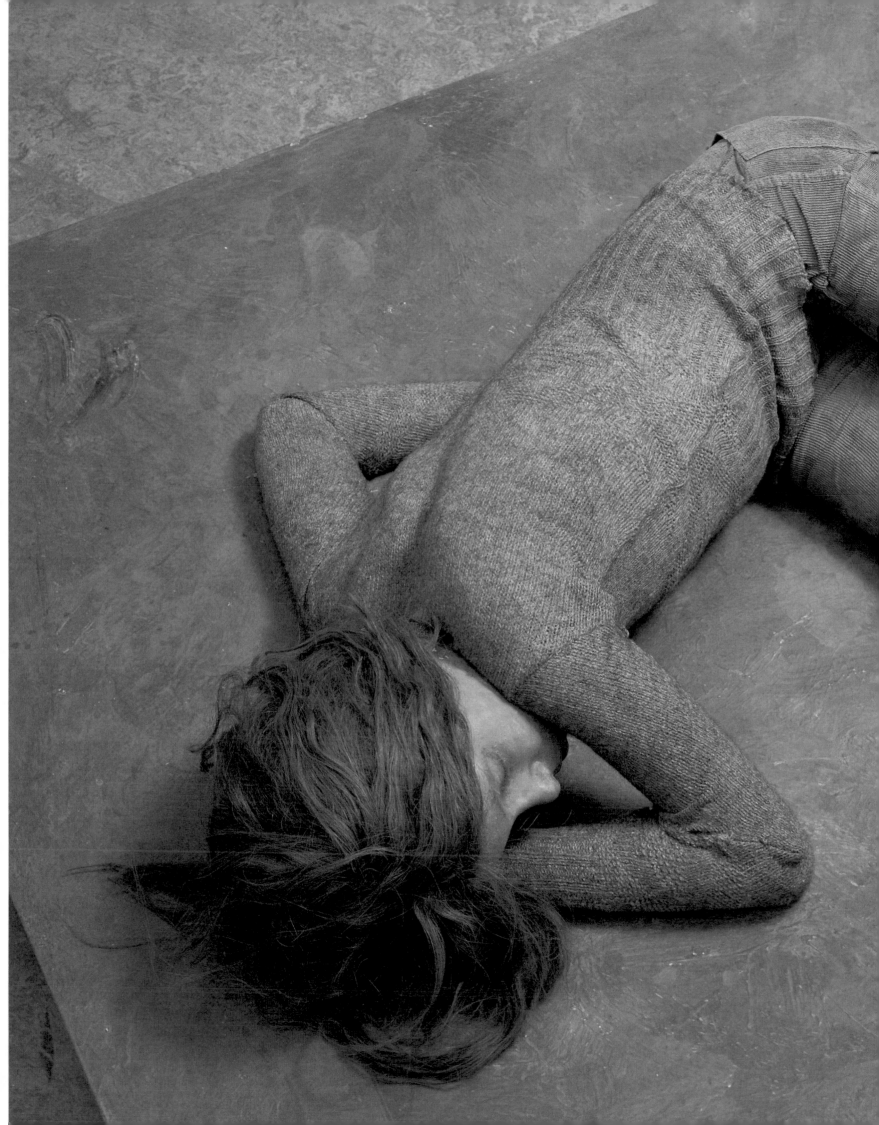

98
Reclining boy.
Henrik. 1979
Sculpture, mixed media.
149 x 121 x 69 cm.

The Fever Cure

Trampedach had been in the Basque Country for the first time in the spring of 1978, when he and his wife had borrowed a house from friends in Saint-Pée-sur-Nivelle – and the region had made such an impression on him that he decided to settle down there permanently – not in Saint-Pée, but in Sare, which was slightly farther south and fascinated him more. And since he has never hesitated for a second when a decision was made, he explored the area and soon found *Chilardicoborda,* then unoccupied and in great disrepair; but it lay where it should, high and isolated and far from Denmark. So with the help of his friends he succeeded the next year in signing the contract note just a nose ahead of several French would-be buyers.

It was a kind of fever cure. He could no longer stand being at home, he had lost his way in his motivic world, his marriage was rocky and he clearly felt that he had got out of synch with the time – or perhaps that the time was no longer worth the effort. For a period he had hit it off precisely with his pictures, but now the distance had grown too great between him and it, so it was better to turn his gaze inward. Just as Bob Dylan did in those very years, when he turned his back on the world and abandoned himself to God. With the purchase of the house Trampedach showed that he wanted to make a radical break with his former practice and with a lifestyle that had become arid and joyless. The move was governed less by panic than by rationality, meant to shift the premises and stop a sequence of events that he could no longer control.

And a new start it was. The first works Trampedach brought home were imbued with a strong, unique will to rise from the ashes. These were the so-called *Basque Drawings,* shown at an exhibition in the winter of 1980 in Asbæk's new gal-

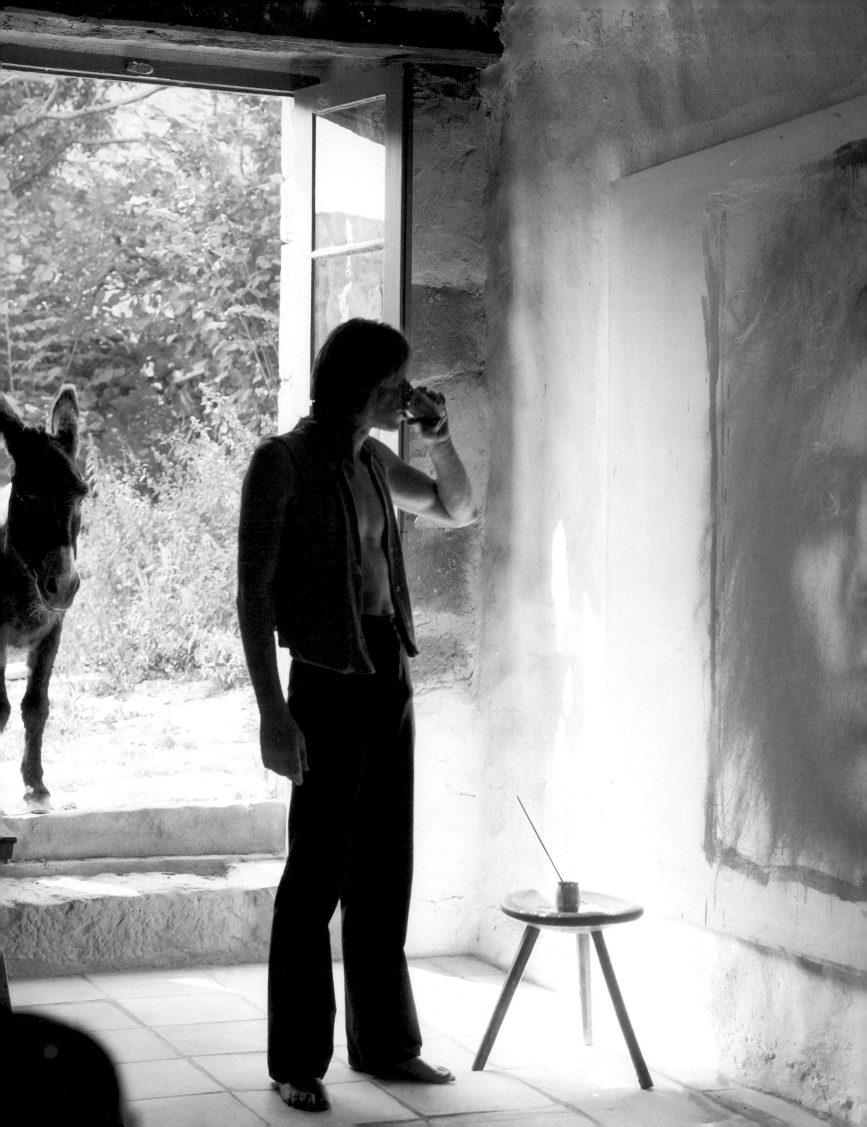

lery building in Copenhagen and representing the first of the sudden breakthroughs that have typified his life ever since – as points of light in an otherwise very turbulent career (Figs. 99-113).

The drawings were done at night, when darkness had enveloped the house and the rest of the little community was only manifested in the form of small lights scattered across the great landscape. Only then was the time ripe and the isolation complete – and precisely that was of course highly romantic. But it was also a necessity. For in the daytime, when the light fell gently over the countryside, everything was simply too harmonious for the kind of confrontation the painter wanted with himself. So in those light hours he chose instead to work on his house – rebuilding it and making it habitable after decades of wear and lack of care. In those hours he just wanted to be constructive in the same sense as his neighbors, the Basque farmers. The unadulterated joy of working he had observed in them had struck him with longing, and just that was perhaps the most important reason he had chosen to settle in the region.

He hoped quite simply that the un-neurotic attitude of the Basques to work would rub off on him, who no longer felt the same joy in working as before. And for that reason too the highly destructive form of self-searching he was in progress with as an artist belonged to the night. It was a part of his Danish past, something unresolved he had dragged down there with him, something that was no concern of his surroundings and that he could only reasonably get to grips with when the farmers had gone to bed. Only then could he turn the mirror on himself, on his own face, and start to stare into it and through it, down through all the years that lay behind him in Denmark. Under the influence of the changed surroundings, of the simplicity of the peasant society out there in the night, and of the huge distance from his native country, it was at last possible for him to have the showdown he had flinched from so long – with his origin, with himself and his gifts, and presumably especially with the way he had recently managed these gifts.

The drawings were done between night and morning, in uninterrupted concentration, with red wine within reach and at a completely exhausting pace – and they bear the traces of this. There is something breathless about them, something intensely impatient testifying to his state of mind. It was quite obviously imperative for the painter to get the truth out before dawn. All the same there is nothing impulsive about the drawings; they are not the product of sudden inspiration. On the contrary they appear well thought out and generated in an awareness of what was at stake. For Trampedach it was simply a job of work that was to be done properly, with the same thoroughness and precision as the restoration of the house he sat in. So the destructive aspect was not at that level but at another more concrete one. For what he had to break down and lay waste was the shadow images that had towered up around him and which he now had great difficulty seeing beyond. It was these ghosts that were to be laid during the nocturnal sessions.

And as usual Trampedach's approach was very literal. He sat down in front of the mirror and stared at himself, and gradually built up a hatred of what he saw there and everything it stood for; a hatred that was deep enough, but as yet only vaguely acknowledged, which only the isolation in the landscape of the Basque Country had been able to bring to life. But once acknowledged it burst out like spurts of flame, with a violence that Trampedach tried with all his might to carry intact on to

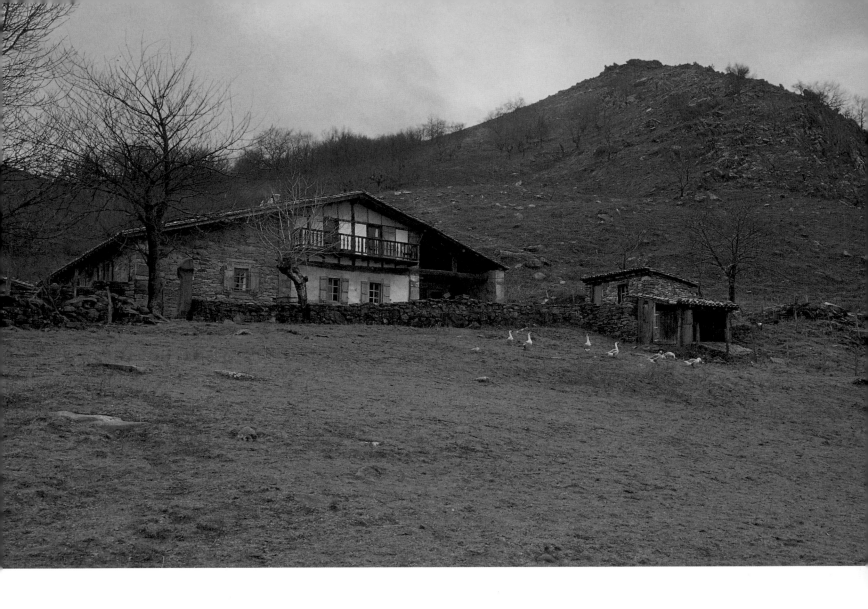

the paper. For that way he would be rid of the experience and put it behind him as something belonging to the past.

It is especially in the earliest of the drawings – those from 1979 – that the aggression feels intensely present now. This is when it seems to have been most direct, so it is still communicated to us with troubling brutality. The faces emerge from the darkness and are stripped off one by one like distortions with glazed eyes, bared teeth and the hair hanging in a tangled mess around the head. Trampedach worked with them night after night and with as violent a rage as if they were his deadly enemies every one. He poured Rioja out over them and soiled them with paint, and he belabored them with the pencil so hard and so long that the paper has crinkled and developed folds and cracks as signs of the injury done to it. One can almost hear it groaning in pain below the painter's hand.

The message is clear and direct. This is how it was seen, this is how it was felt – and there was no other way to go about it. The drawings are heavy and dark in tone, the surface lies as solid as a barrage, and the heads only laboriously fight their way through it and out into the open air. Deafened and crushed by booze and brooding, and with obvious despair over the whole situation, they stare out at us. And here and there dead animals and plants are stuck to the surface – as mementos. The only things living in there in the gloom are the staring eyes, the gaping mouth and the hands that grab at empty air.

Although these are mental states, the drawings are in many ways highly realistic in expression. The heads really emerge from the darkness one by one, as if on a strip of film. They are in motion and alive and one can't help listening for their breathing and the hoarse inarticulate growls that stick in their throats. They are impossible to dismiss because they have long since crossed the threshold there usually is between people. They have stuck their ugly faces right up against your own like a wino on the street who won't leave you alone.

The effect is related to the one Trampedach achieved in his sculptural work. Like those disturbing figurations, the drawings are in a way "dressed" and have taken on a kind of three-dimensional character. Bits and pieces from everyday life have been stuck to surface in the heat of the struggle – for example there are real hairs among the drawn ones, both human hairs and hairs from the wild horses' manes; and there are wristwatches, strings of bead, bills and wine labels. And then there are dead animals and plants – flowers and ferns, fish and flies, lizards and worms, moles and mice, all of which have been through the mangle before they were glued on. That does not mean they are collages in the banal sense – the things have been attached not for the sake of textural effect or because they have a useful color, but first and foremost to intensify the realistic element, and to tell us where Trampedach was. They were all found in and around the house and can thus be regarded as a kind of souvenirs bearing witness to his new habitat.

Yet that is not the whole truth. Trampedach also works at a more metaphysical level. The things were not chosen at random and when he attaches them to the surface it is not only in the name of realism. It is also a kind of exorcism and a

quite private mythology. When he puts a ripped-up hundred-krone bill in the middle of the forehead of one of the earliest heads, this is of course no accident; it quite clearly indicates that his aggressions are directed toward Denmark and perhaps also toward the dangerous dependence on Mammon he had developed at home. The targets, both inward and outward, are clear (Fig. 102).

And if he so often adds worms and lizards, it is to emphasize, in Freudian fashion, the erotic element, another recurrent theme in the drawings, a theme that he explores further in the later ones – those from 1980 – via small, faded photographs of a pornographic character which, recalling Robert Rauschenberg's method, he rubs on to the surface as atmospheric accents (Figs. 111-113).

The reason for these erotic cross-sections down through the psyche are in reality quite straightforward. Trampedach had already for some time been aware that his wife was having an affair with another man, someone he had no time for, but whose existence was now forced upon him as something physically as well as mentally distasteful. The drawings take this distaste up for harsh treatment – and in this respect it is an easy step to crosscut from them to Munch's famous picture *Jealousy* from 1895. For Trampedach's distorted self-portraits have exactly the same insistent frontality as the Pole Stanislaw Przybyszewski's martyred head in Munch's icon. And indeed at bottom it is the same thing the self-portraits deal with – the jealousy that strikes inward at the mind as darkness and outward into the world as fire. They are clearly fueled by the fear of losing what is really already lost – and thus by a desperate recognition that the subject is alone yet again.

In the broader view, the art historian Rolf Læssøe, in his little monograph on Trampedach from 1990, has finely and shrewdly analysed both the self-reflecting and the erotic aspect of the drawings, and seen both as an extension of western myth – and further to this an extension of Freud. He notes the obvious similarity between the self-portraits and the suffering face of Christ. He actually speaks of them as "a kind of personal crucifixions" and as "nailed-down reflections of the ego" and refers in this connection to the Byzantine icons and to their later derivations, the versions of the *Veronaculum* motif (p. 241).

But he goes further than this – back to the classical Greek myth of Medusa, who was originally a beautiful young woman, but as a punishment for erotic excesses in the very temple of Athene the goddess changed her into a horrible monster with hair that was a tangle of venomous serpents and with a gaze that turned anyone unfortunate enough to look her in the eye into stone. Of course one could not have such an entity at large, and in the end the hero Perseus, through a ruse, was able to chop her head off, snakes and all. For the same reason Medusa was traditionally shown only as a head floating freely in the air, just as Christ is shown on the Veronaculum – and as Trampedach represents himself in the drawings. It is part of the story that Pegasus, the white, winged horse of inspiration, was born from the blood that flowed from the lifeless body of Medusa – and that Pegasus too was later to play an important role in Trampedach's own private mythology (Figs. 135, 143, 153, 161 and 162).

Læssøe suggests that the myth of Medusa had come to Trampedach via Munch, who used it both directly and indirectly in his succession of disturbing images of the conditions of sexuality. Beyond the personal feeling of jealousy and powerlessness that was the real motive force behind Trampedach's drawings, there was thus, it was claimed, a corresponding, frightening clash of conflicting emotions in his interpretation of the erotic: partly the attraction of the female and partly the fear of the consequences – pleasure versus unpleasure, the inexorable but also fatal element of sexual attraction. Læssøe also mentions that, in Freudian psychology, the severed head of Medusa is viewed as a symbolic expression of the male fear of castration, well aware that the theme should not be interpreted quite so literally in Trampedach's work.

For Munch as for Trampedach, what they were afraid of losing in this part of their lives, by abandoning themselves to the erotic, was the artistic power that was the precondition of their creative work. And in this respect Munch was the more consistent – his monumental nervousness prevented him ever allowing a women to gain power over his working life. Trampedach, on the other hand, had married and thus ceded power, willingly enough, because at first he was happy in doing so. He was no longer happy. But if he now chose to create distance by settling down on a southern French mountainside, this was still not a final break on his part but rather a momentary emancipation where he tried to find out whether he still had his power intact – and whether it could carry him through.

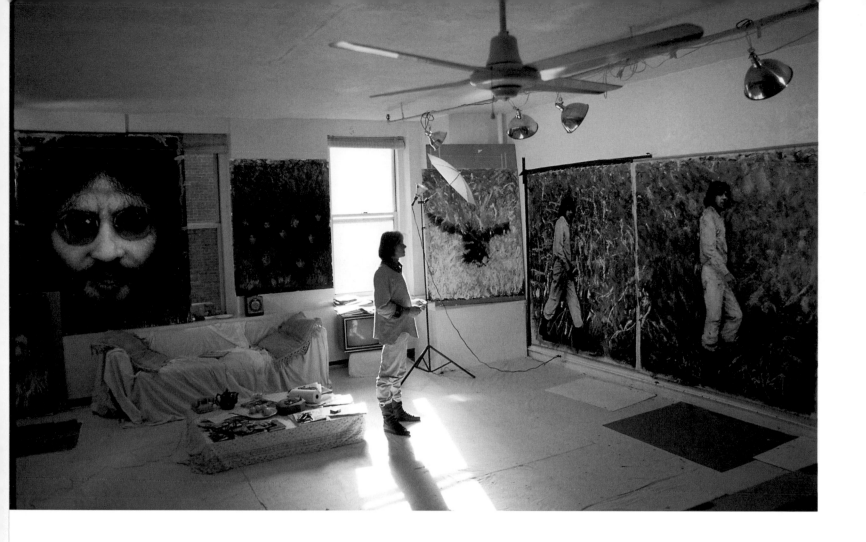

Kurt Trampedach
in his studio on Wooster
Street, New York 1983.

weakens – and one gets a disheartening sense, not only of repetition, but also of mannerism.

And here we come to the actual Achilles' Heel in Trampedach's art, as it has developed since; the repetitious or mannered element, the compulsion to repeat and the style-seeking dilution of the original message. All painters repeat themselves. It cannot be otherwise, it is in the nature of things: respected masters from the CoBrA generation, for example Egill Jacobsen and Carl-Henning Pedersen, are striking examples of this. But when painters like Trampedach, who are preoccupied with existence itself, do it, it is somehow more depressing than when it is done by painters who have nothing vital on their minds. There is a mechanism that comes into force here – one does not think that such a serious message needs repetition once it has been said and said precisely – as in the case of Trampedach and his drawings from the Basque Country.

But Trampedach could not stop, and it is characteristic – of his oeuvre as a whole too – that the drawings that followed in the wake of the excellent ones from the nightly sessions in 1979 and 1980 became more outward in their self-hatred. Not that they were poor drawings; quite the contrary, but the anger imperceptibly shifted from experience to attitude. There are many Danes who have difficulty forgiving him for this – and it should in fact be seen as one of the most important reasons for his fall from grace in the hierarchy of art politics. Ill-feeling toward his works grew, and in a way this is as paradoxical as it is unreasonable – other significant painters such as Egill Jacobsen and Carl-Henning have for example never been similarly downvalued, although they have repeated themselves far more and for a far longer period with increasingly watered-down pictures as a result. And several still highly-

esteemed Danish artists from Trampedach's own generation have similarly been spared reprisals although they have boiled their artistic soup thinner and thinner.

It has not been understood that Trampedach's repetition compulsion was not only a matter of continuing to turn out salable goods, it was part of his actual process of creation. For the persistent, unceasing output has constantly led to the unexpected – and it is of course on that basis that his work should be judged. Suddenly, and quite without warning, pictures of a strangely unprecedented character have appeared, perhaps even to his own amazement – and then he has firmly caught hold of them and churned them out in serial sequences with sheer incredible intensity – only, when the inspiration has lost height, to resort to solutions that resembled the previous ones to the point of indistinguishability, but which were not really quite the same.

There is a rhythm here that has borne the work up over the past twenty years: the sudden breakthrough into unknown territory inexorably followed by a kind of consolidation phase where gains are capitalized and gradually lose impetus. The method is far from unknown in the history of art – giants like Titian and El Greco used it, as did Edvard Munch. Titian for example had a couple of best-sellers of an almost pornographic character conspicuously on display, and they are still rather awful to look at. And El Greco was at all times quite ready to deliver perfectly shameless repetitions of especially popular motifs which he could vary in size depending on the customer's means. And Edvard Munch painted his own pioneering visions over and over again, throughout his life, until they lost all meaning – *The Sick Girl, Madonna, The Scream* and *Vampire;* the whole existential repertoire was run through the mill with increasingly desperate monomania.

Not that I will claim that Trampedach is necessarily an artist of the carat of those three; but since he has always turned out work of a certain standard, the comparison is not completely without relevance. Not many of his contemporaries have held the banner so high, so there are not many either whose soaring ascent, fall and perdition have had the same dramatic character. Although the repetitive element is striking, and the actual repetitions are many, Trampedach has fundamentally never been satisfied with a result he has achieved; on the contrary he has always used it as a platform from which to search further, on and into the material to see what it might reveal. And that is in the long run the trademark of the good painters.

But the period at the beginning of the eighties did constitute the most serious crisis in Trampedach's turbulent career. This was when everything ground to a halt. The personal crisis he lived through in his marriage, the increasing alienation he felt, not only from his wife but also from the milieu that was hers, rubbed off on his pictures and assumed increasingly visible forms. He felt betrayed by her, and felt very strongly that he was betraying his talent and his origins by staying in the relationship. But he did stay in it, if half-heartedly, right up until 1987, when at last he broke out and got divorced, because it was all becoming too destructive.

Before this, in 1982, he had experienced his first serious depression, which left him drained of the power to act for almost nine months – as a result of this he had sought help from a psychiatrist and stopped drinking, almost from one day to the next. The drinking had taken on exorbitant proportions and had been close to costing him his life when, on a particularly hard-drinking day on the Sound, the strait

between Denmark and Sweden, he had fallen overboard and had seen his whole life flash past while he sank to the bottom. But it was a visit to his father at the nursing home that was the triggering factor. The stroke had left the father helpless in a wheelchair beyond any rational communication, and on that particular day the visit made a particularly depressing impression. "I won't end up like you," said Trampedach so loud that he himself could hear it – and from then on he drank no more.

The pictures became ever more panic-filled during this course of events. Trampedach now shuttled restlessly between his homes in Vedbæk and Sare and even got himself another studio in Copenhagen, in a backyard house in the center of the city. His output was extensive but the quality fluctuated. The pictures were bigger and texturally coarser than before, because he no longer painted them with a brush, but with sticks, which gave the surfaces an almost hairy look. The motifs were the familiar walking and sitting figures in natural size as well as some oversized heads or portraits of both women and men – partly himself, of course, but also more international figures like John Lennon and Yoko Ono (p. 223).

John Lennon had been shot in 1981 and the murder instantly took on symbolic importance. It was not a human being who was shot in New York that day, but a myth, so what this myth stood for was also killed in the minds of those who heard about it. An epoch had ended, definitively and abruptly – like a dream broken off in the middle. On Trampedach, who was after all himself in a state of crisis, the murder made a great impression and he immediately converted it into an atmospheric installation at the Decembrist exhibition, where a number of light canvases with ghostly pictures of Lennon & Co. rose above a sculpture of a couple of boys who sat on the floor, bowed down in despair (Figs. 115 and 116).

But he also took the theme a stage further two years later in the big portraits, and it was in this phase that he began to combine silk-screen with oil paint – for example he had a greatly enlarged photo of Yoko Ono printed off on a number of canvases which he then later worked on with oils. This was serial production of salable items that certainly did his reputation no good. But he was on the move, and completely indifferent to criticism, so the technique came to influence his work in a banal direction all the way up to 1987, when he at last scrapped it. He did this in New York, at the same time as he was going through his divorce.

He had been living over there since 1983. An American businessman traveling through had bought two of his sculptures at an art fair in Copenhagen. But when they were unpacked in New York, they turned out to have been damaged during transport, so Trampedach had to go off to repair them. He had been over there once before, in connection with his one-man show at Stefanotty in 1974, and at that time he had certainly not cared much for the city. But this time everything was different – now he suddenly saw a chance to put a considerable distance between himself and all that had tormented him back home, and without further ado he threw his return ticket in the waste basket.

At first he lived for a while with the businessman in his apartment in a mid-town skyscraper, but he quickly found his own in Wooster Street in SoHo where he created his first group of American pictures (pp. 174 and 177). Naturally enough they resembled those he had painted at home; there was no great difference, so he soon began to look around for more authentic surroundings that could help him to wrench himself free of the past. He found them just round the corner, in Broome

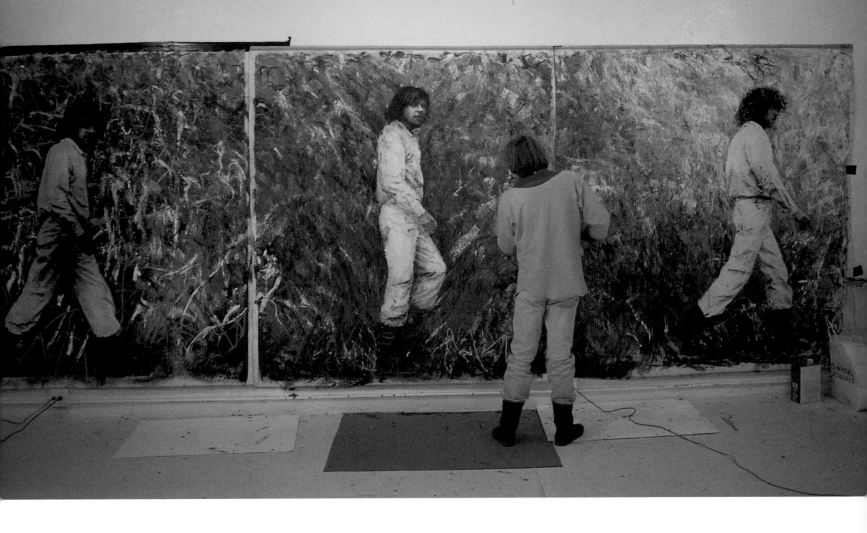

Street, where he rented a loft that was as big as a hangar and stretched in through the whole depth of the building, with rows of slender wrought iron columns as the bearing elements (pp. 178-79).

There he settled down with a kitchen, bathroom and bedroom at the far end, while he painted his pictures in the remaining space. And since there was lots of this the result was absolutely colossal canvases – real American formats, nailed to the walls one by one by one. They were dark in tone and wildly splashed with paint, a little like those of the local Abstract Expressionists. But of course they were figurative as always. Some portrayed Trampedach himself striding along through the ferns back home in the gloaming; others, perhaps more characteristic, showed gloomy heads with unkempt hair or the bodies of naked women embedded in an inferno of color (Figs. 129 and 130). The gestures bordered on the violent – the color was thrown on, twisted on, splashed on, with equal portions of arrogance and aggression, liter after liter, kilo after kilo.

In many ways this was an act of will where the painter tried his utmost to indicate his new standpoint. But at the same time it was a kind of monumental farewell to a motivic world that had tormented him for a long time and of which he wanted to be rid once and for all by enlarging it up *ad absurdum,* as if blasting at the limits of what was considered permissible back in Denmark. Although Galerie Asbæk was the biggest gallery in Copenhagen, it was not big enough for these desperate figurations. This was quite deliberate, and made its point. The relationship worsened little by little until the break became inevitable – with the art dealer, with his wife, with Copenhagen. He was now ready for a new start.

Kurt Trampedach
in his studio on Wooster
Street, New York 1983.

Following pages:
Kurt Trampedach's studio
on Broome Street,
New York 1984.

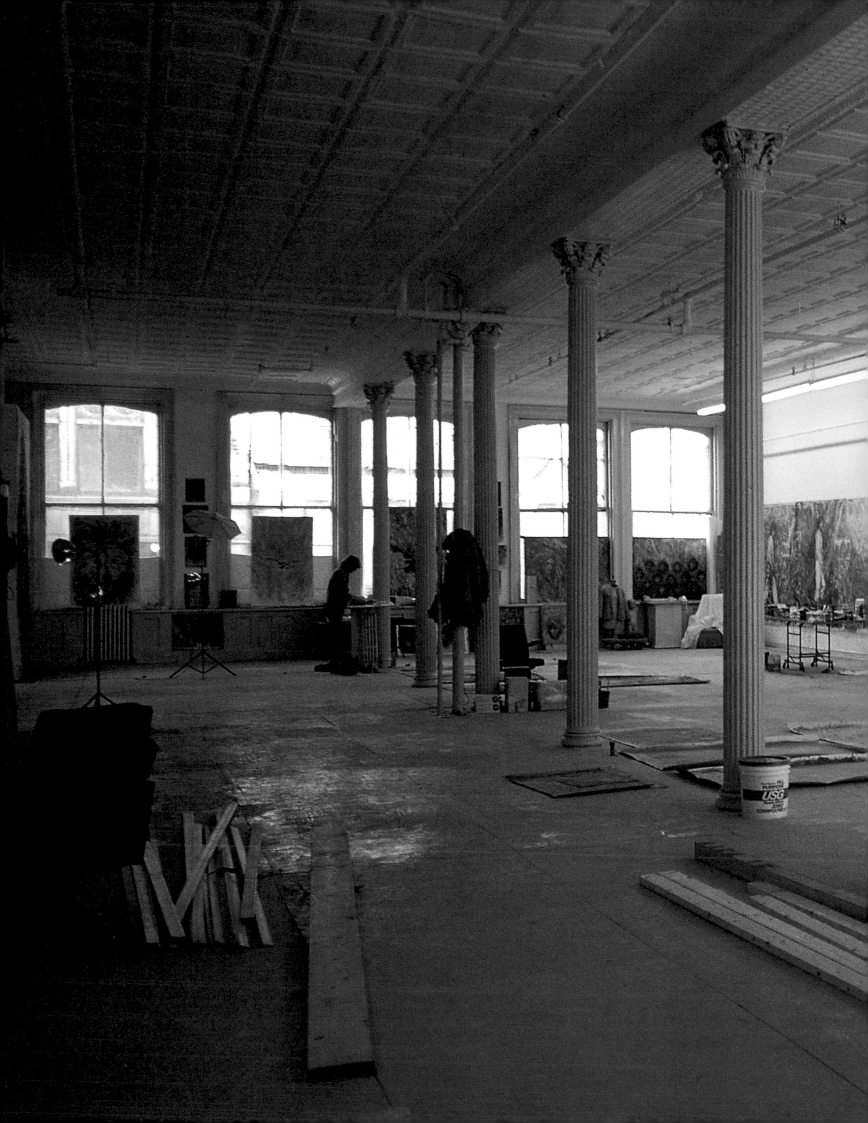

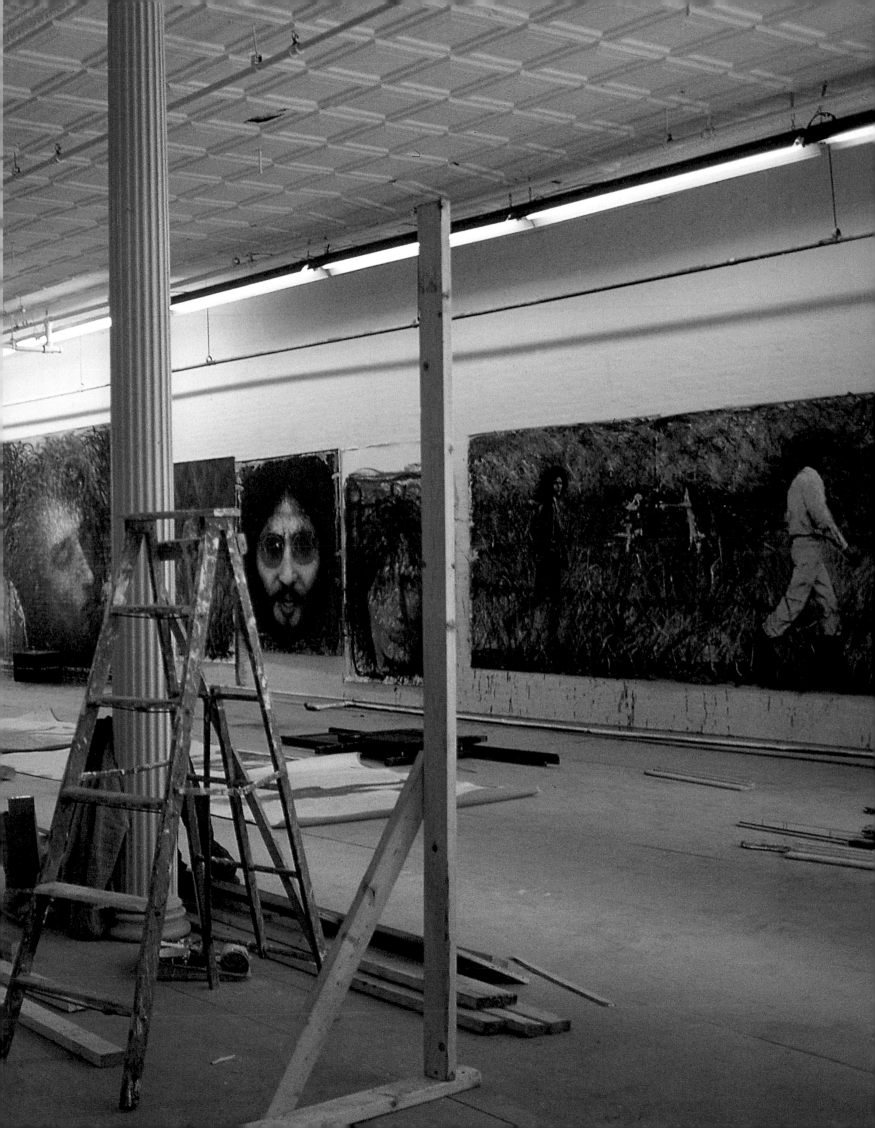

104
Self-portrait. With feather
and moths. Sare 1979
Pencil, water-color
and collage on paper.
310 x 225 mm.

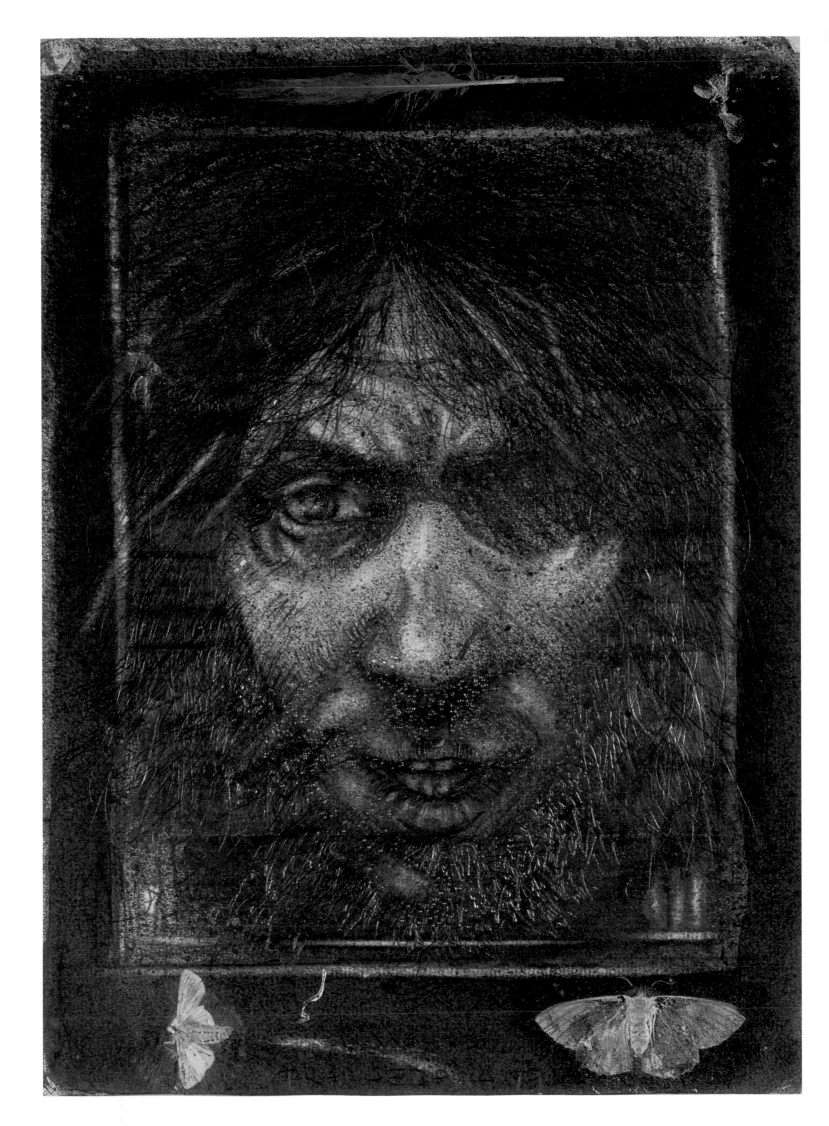

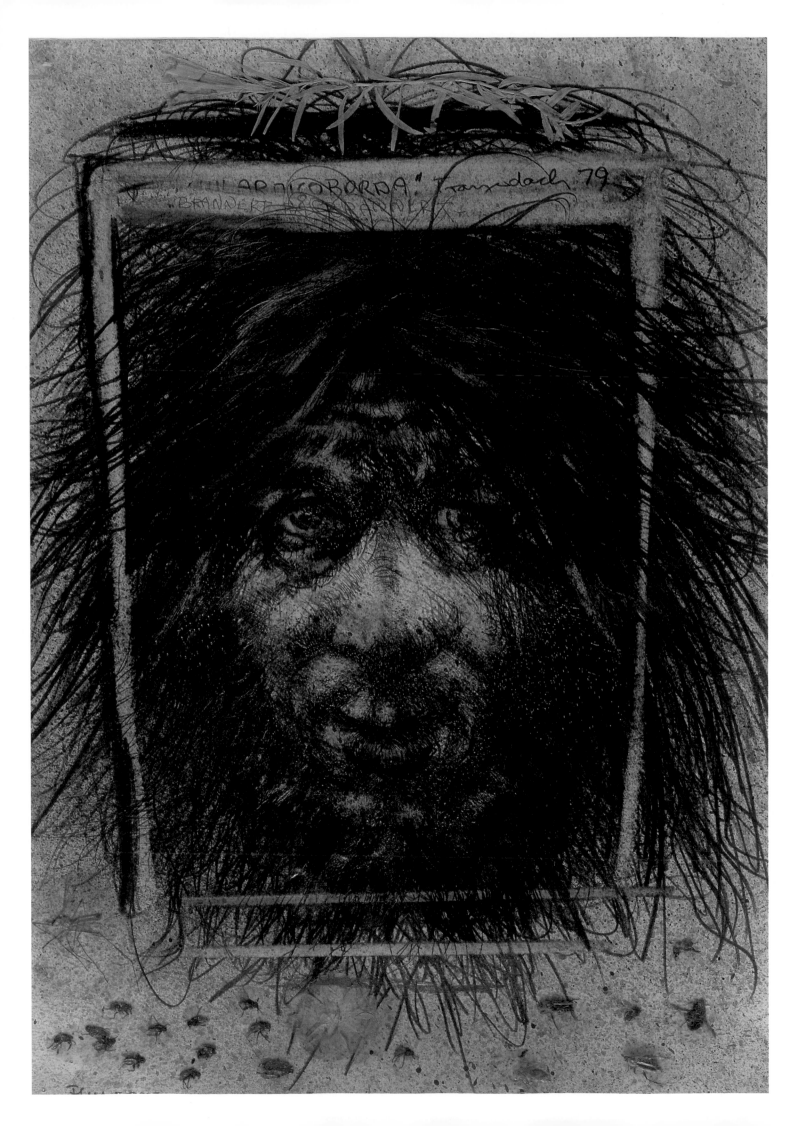

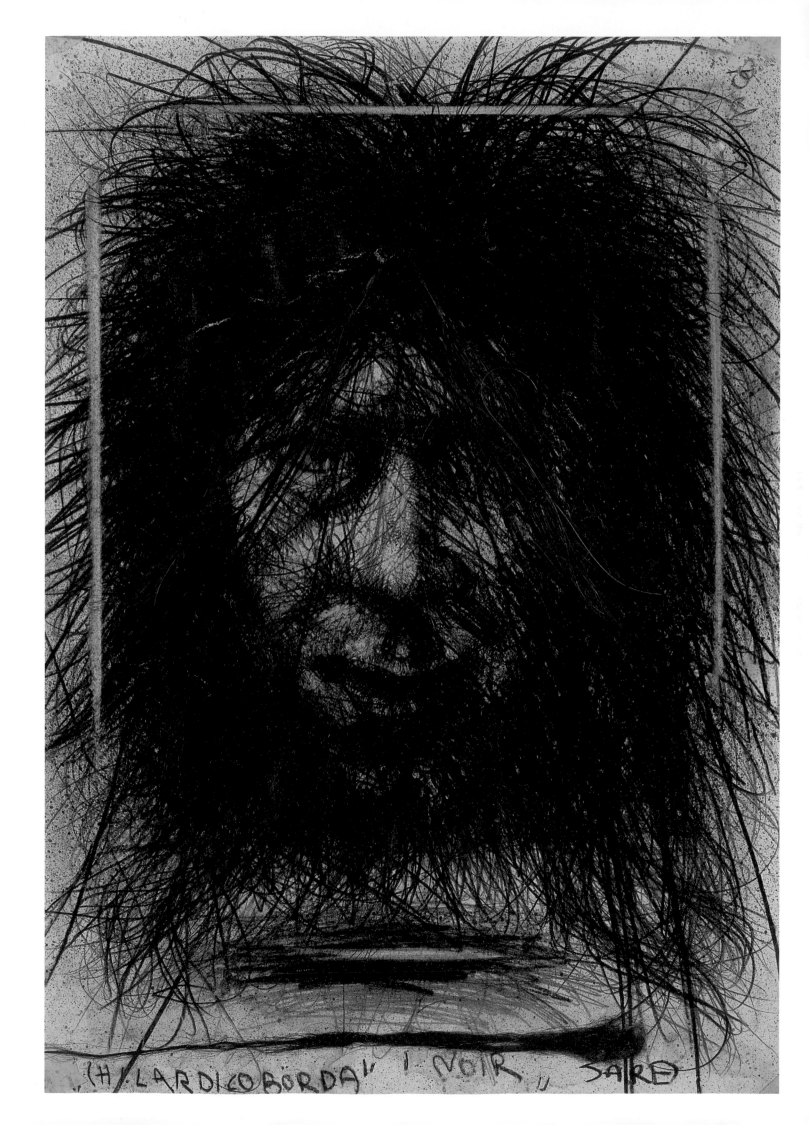

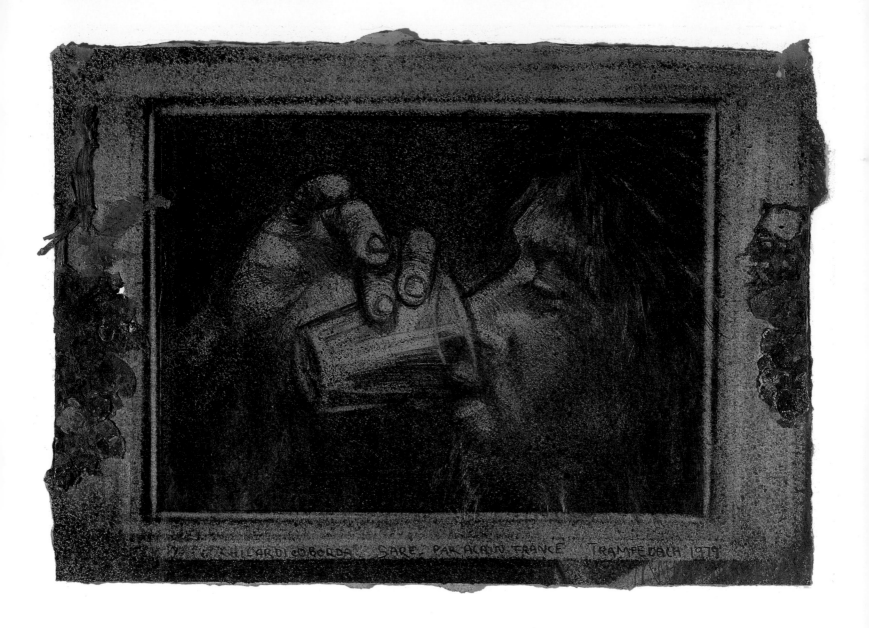

109
Self-portrait, drinking. With squashed grapes. Sare 1979
Pencil, water-color and collage on paper.
300 x 420 mm.

110
Self-portrait. With the family's hair. 1980
Pencil, water-color and collage on paper.
410 x 300 mm.

following pages:

111
Paranoia I. Self-portrait above lizard. Sare 1980
Pencil, water-color, transfer technique and collage on paper.
420 x 295 mm.

112
Self-portrait. With leaf and lovemaking couple. Sare 1980
Pencil, transfer technique and collage on paper.
420 x 295 mm.

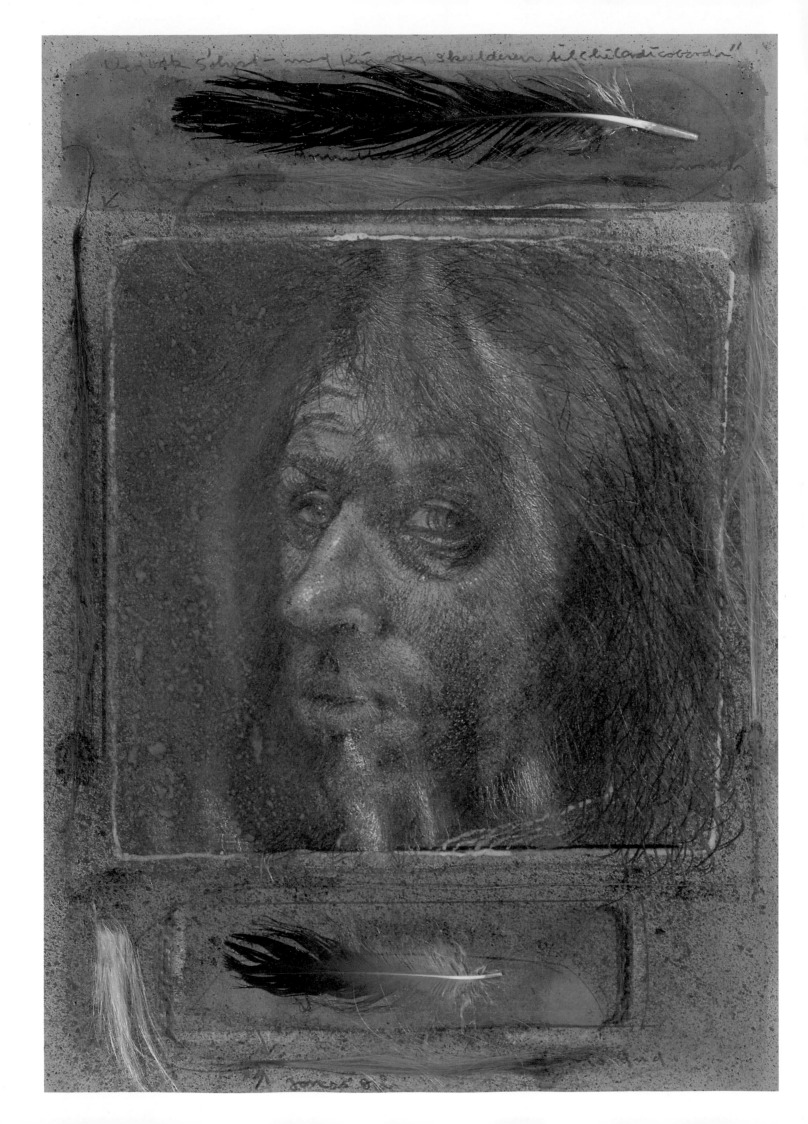

PAY BASQUE

"CHILARDICOBORDA" SARE . FRANCE.

TRAMPEDACH PARANOIA I

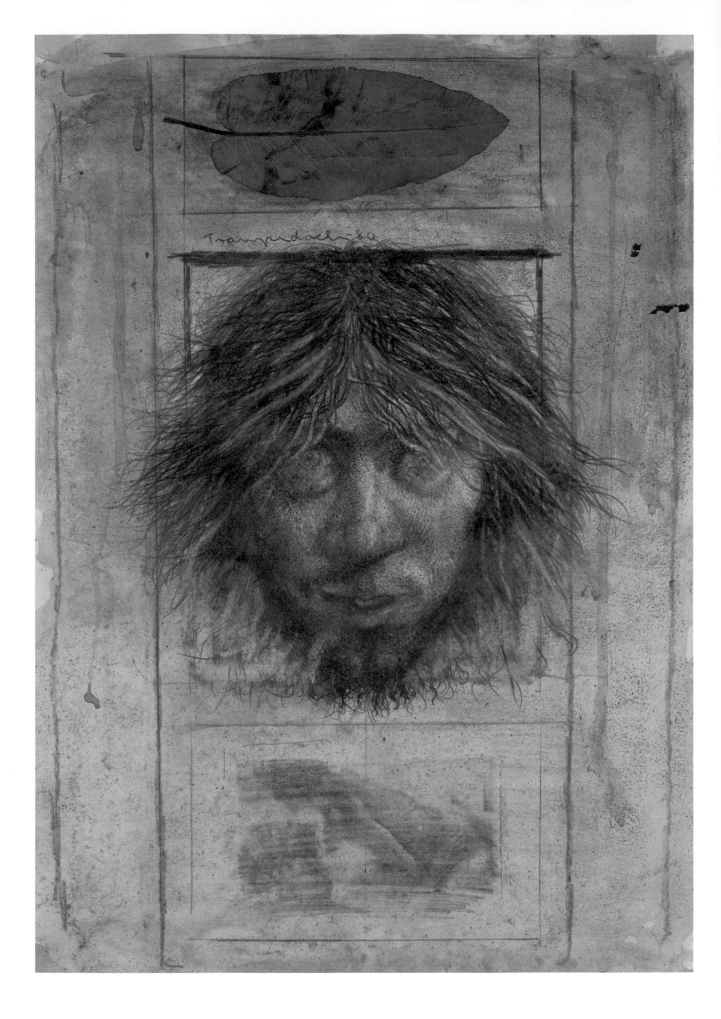

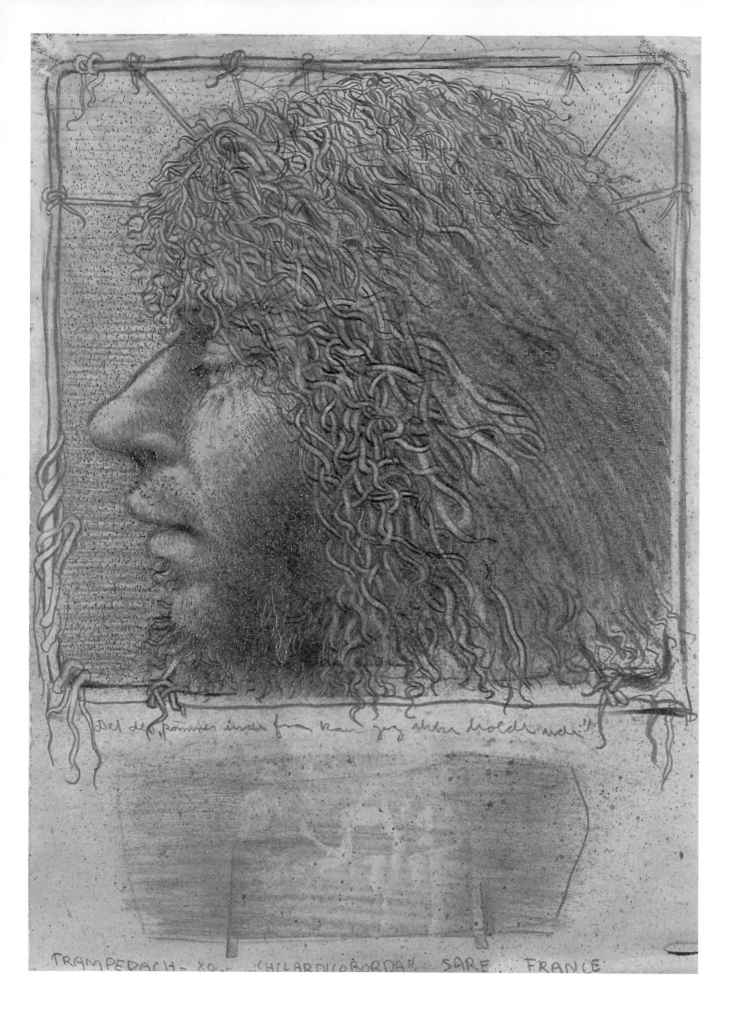

Det de kommer inde fra kan jeg ikke holde ud!!

TRAMPEDACH · 80 · CHILARDICOBORDAX · SARE · FRANCE

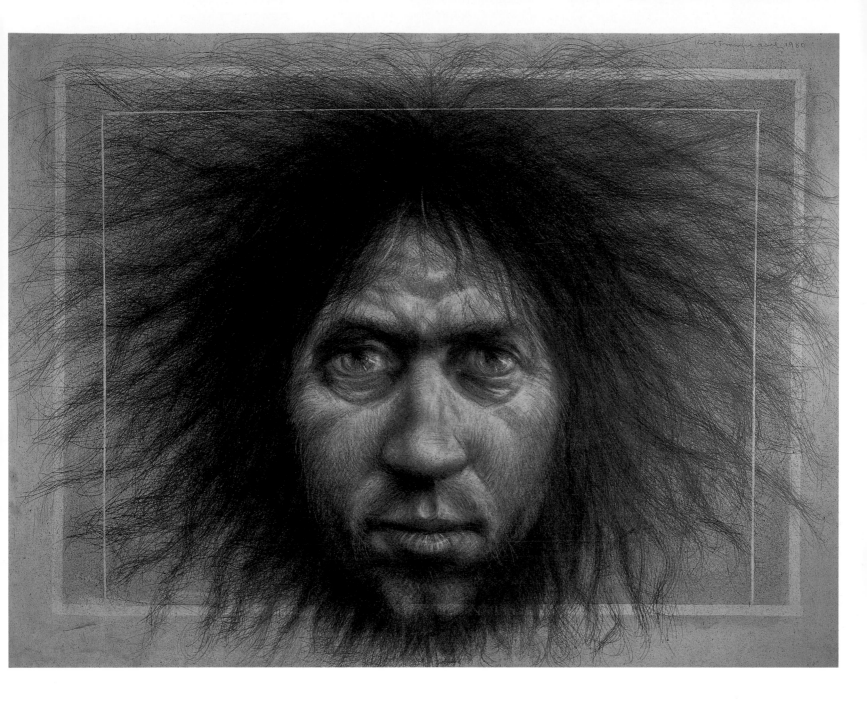

113

What comes from within
I can't keep out.
Self-portrait. Sare 1980
Pencil, water-color and transfer
technique on paper.
410 x 290 mm.

114

Self-portrait. 1980
Pencil and oil paint on board.
120 x 160 cm.

115

Two boys. 1981
Sculptural group, mixed media.
65 x 115 x 100 cm.

116

John Lennon and Yoko Ono. 1980-1981
Charcoal, oil and transfer technique
on damask cloth.
170 x 254 cm.

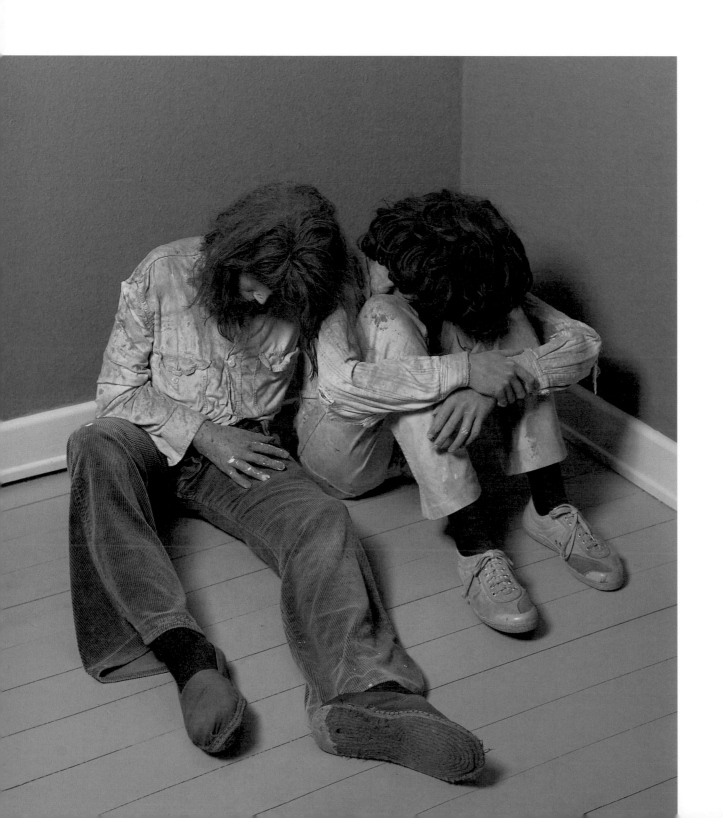

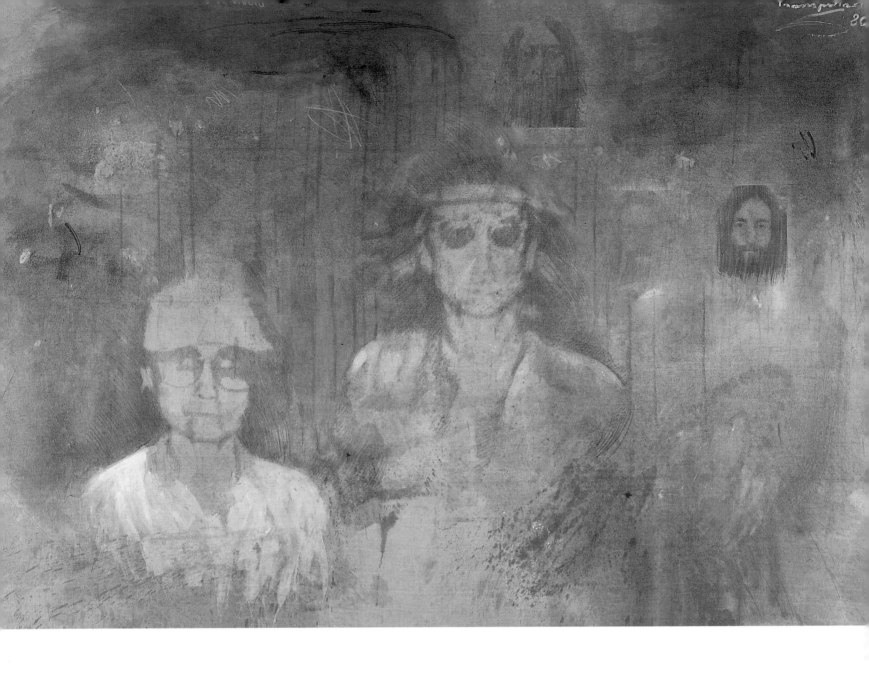

following pages:

117
Jonas. Asleep. 1983
Sculpture, mixed media.
16 x 58 x 128 cm.
118
Jonas. 1982
Sculpture, mixed media.
54 x 46 x 46 cm.

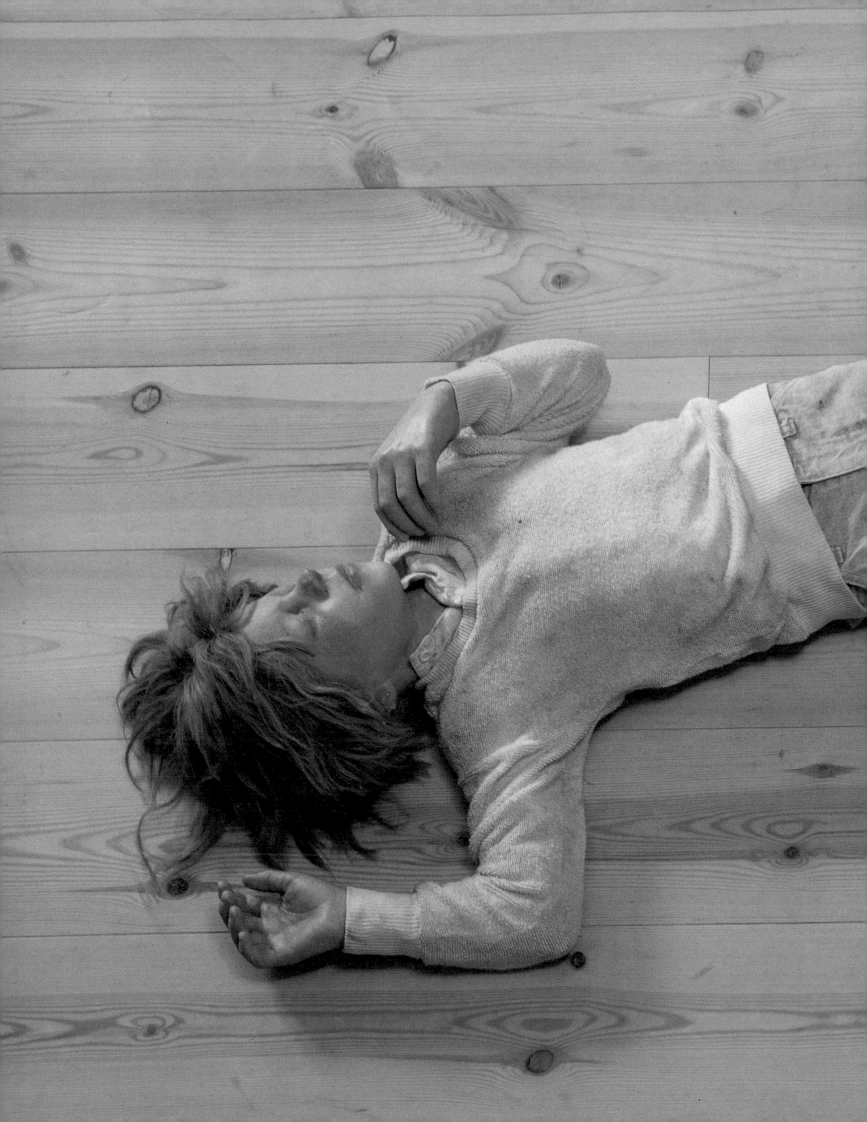

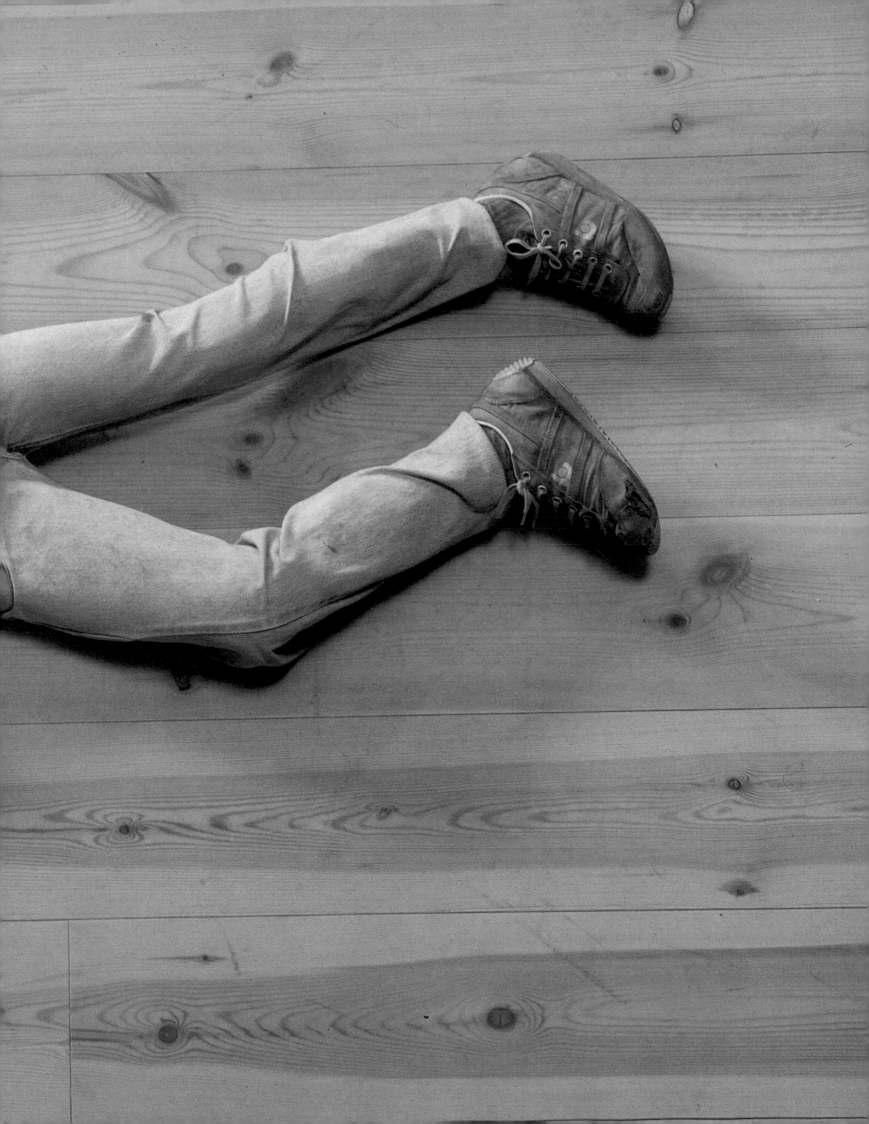

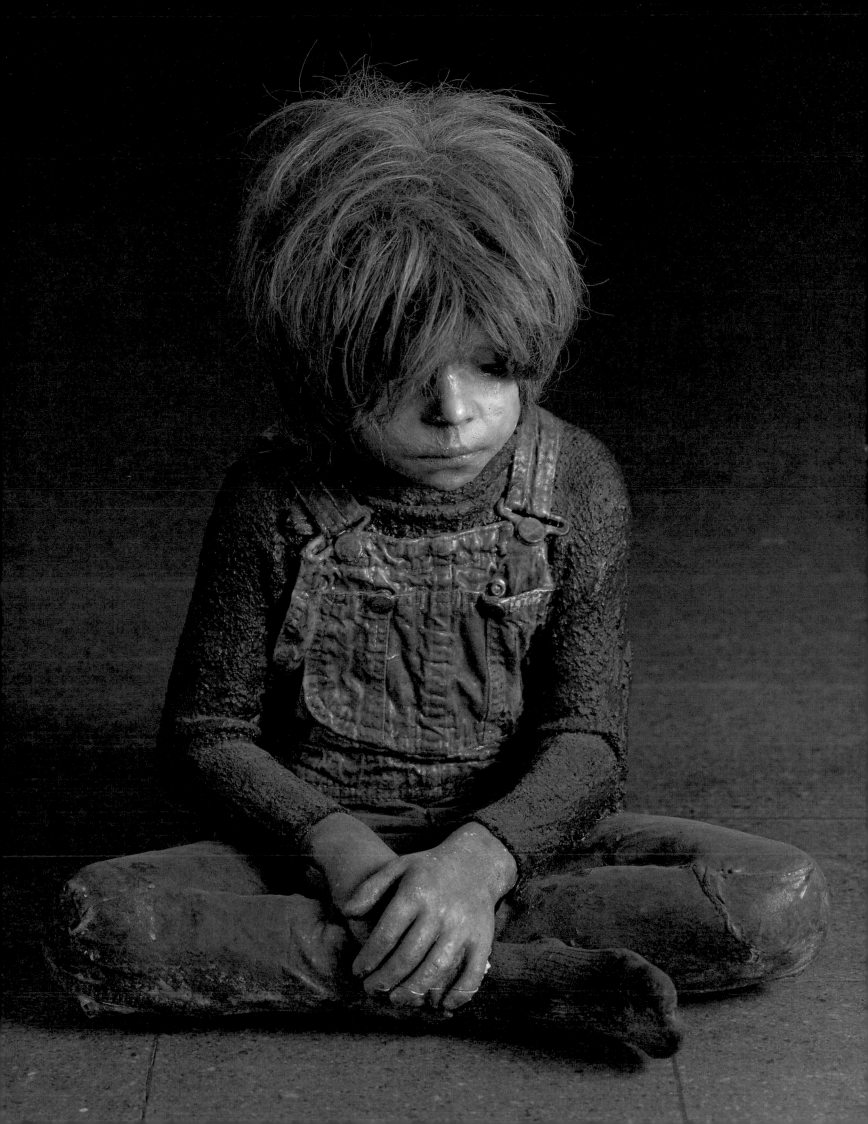

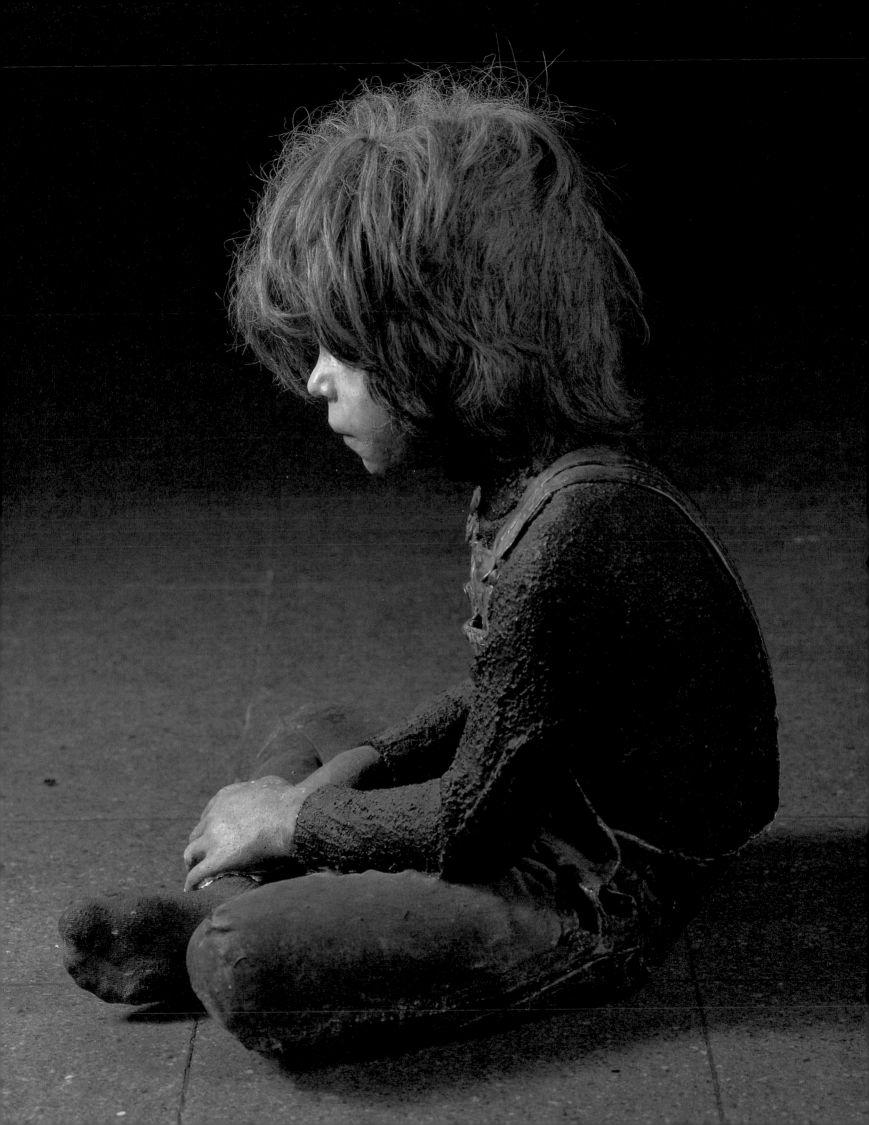

119

The Rioja Drinker. 1983

Oil on canvas.

171 x 212 cm.

120

Eagle and Carrion. 1983

Oil on paper, pasted on canvas.

100 x 71 cm.

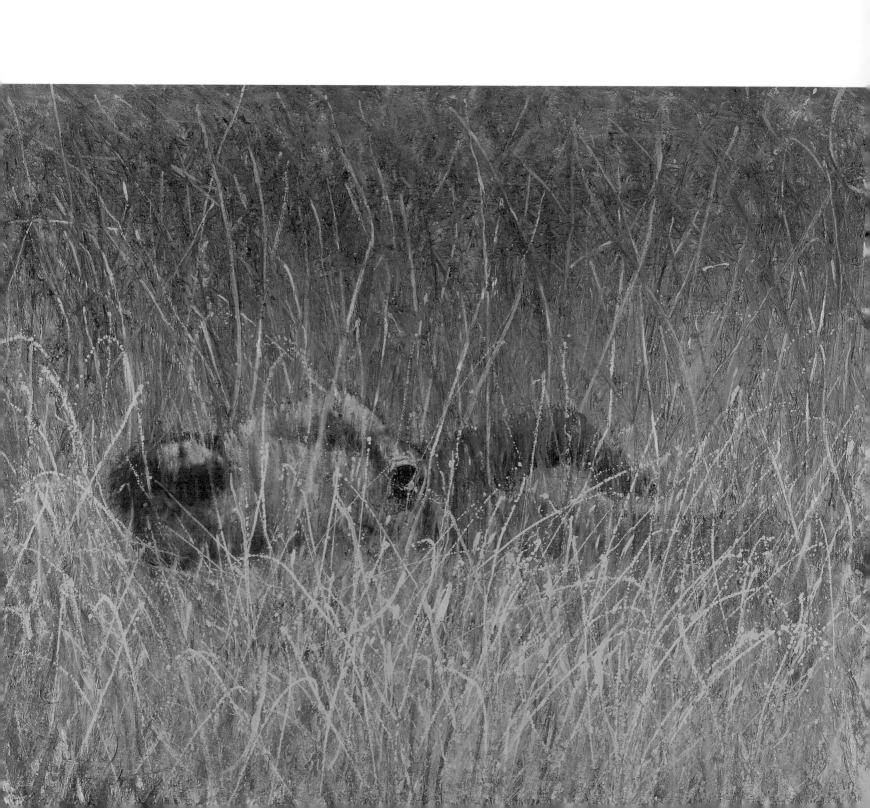

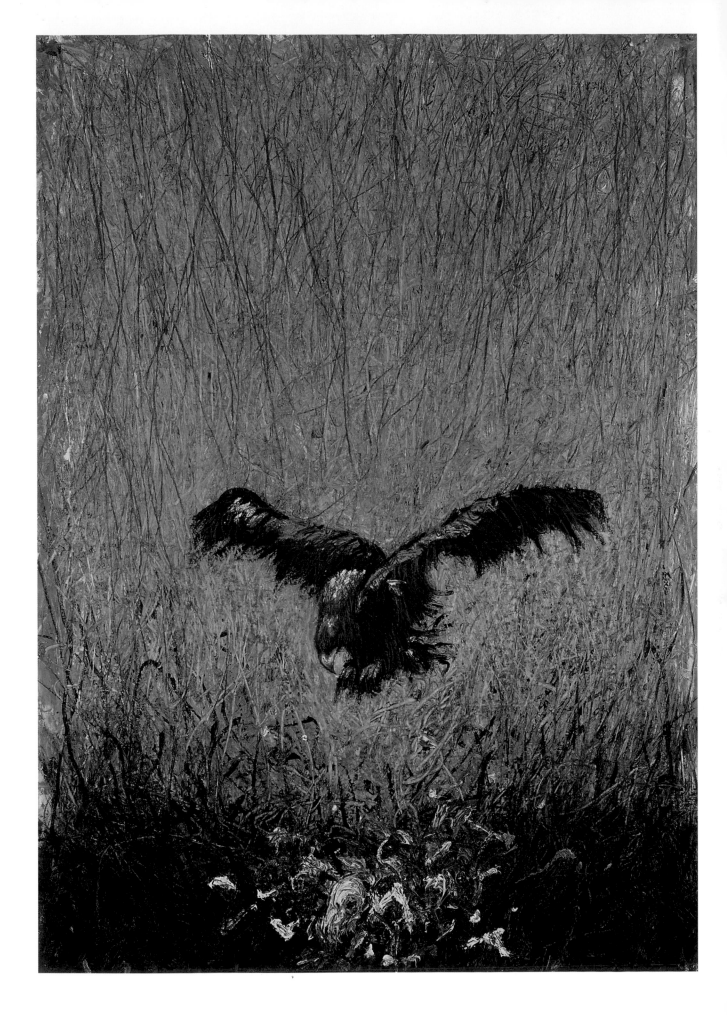

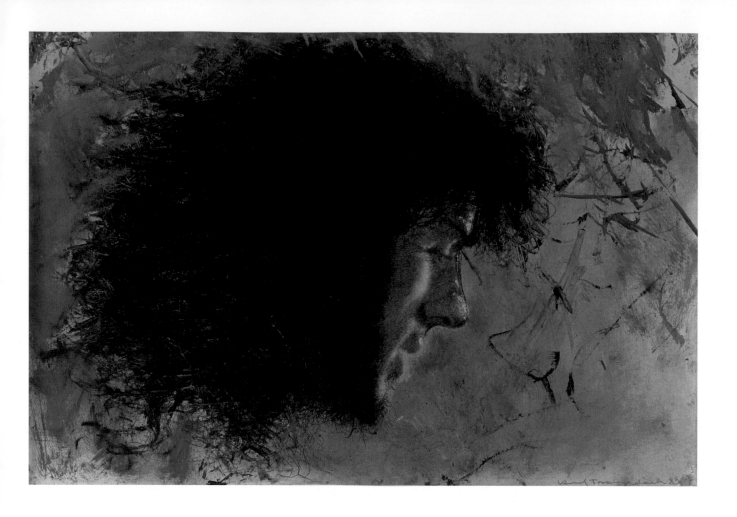

121

Self-portrait. 1983

Oil on paper, pasted on canvas.

38 x 56 cm.

122

Seated Figure. 1983

Oil on canvas.

210 x 170 cm.

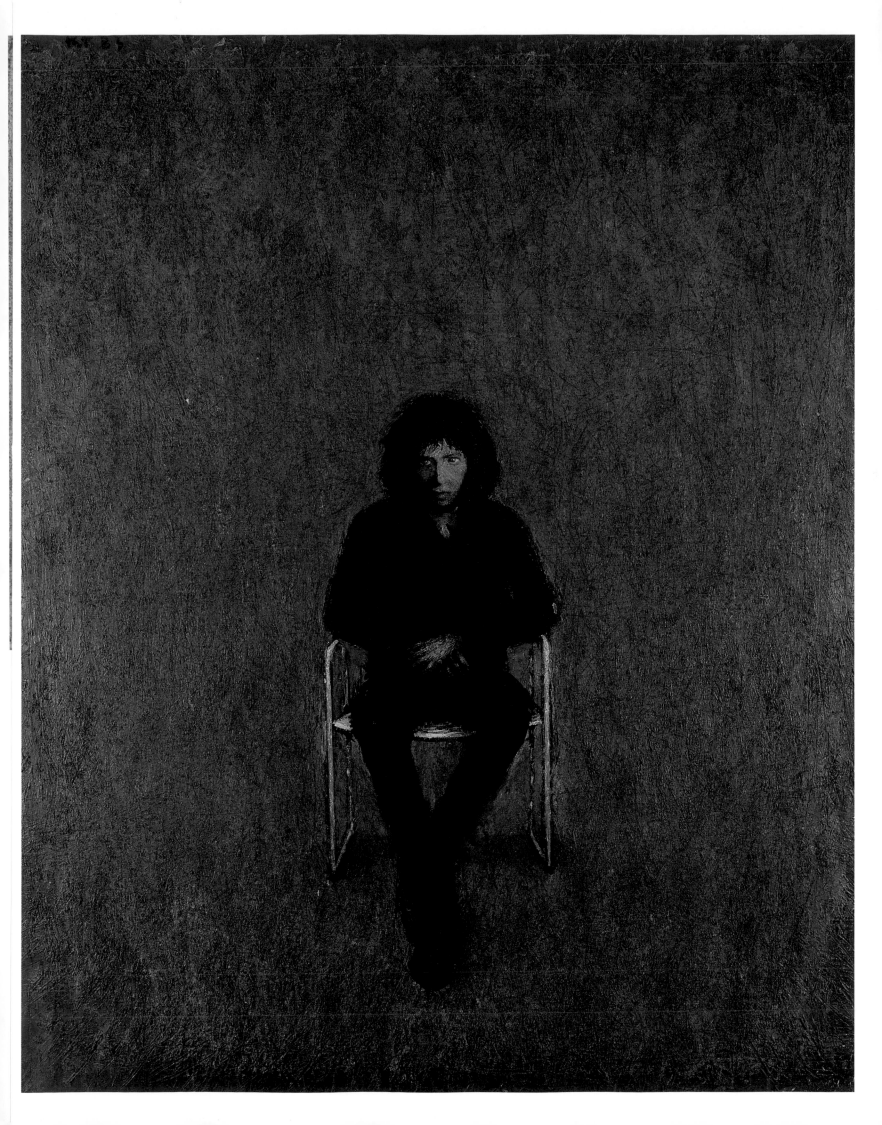

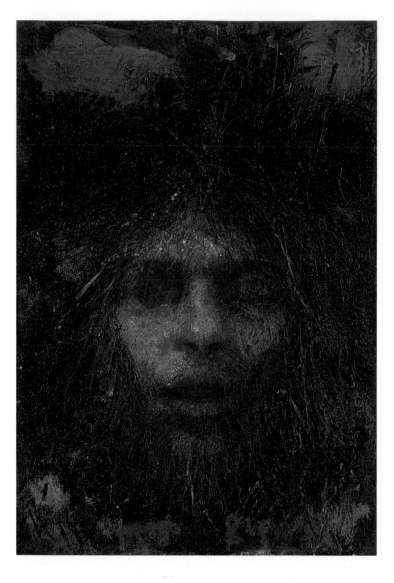

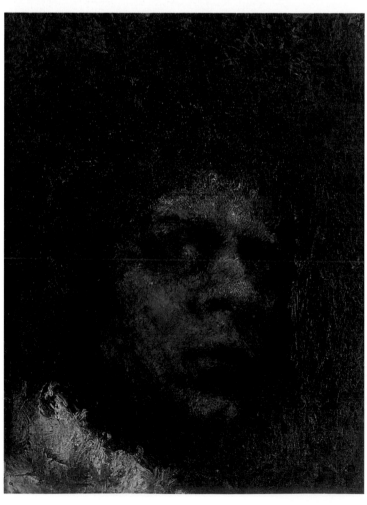

125
Self-portrait. 1984
Oil on paper, pasted
on canvas.
35 x 24 cm.
126
Self-portrait. 1984
Oil on canvas.
26 x 20 cm.
127
Self-portrait. 1984
Pencil and oil on
paper, pasted on
canvas. 36 x 24 cm.

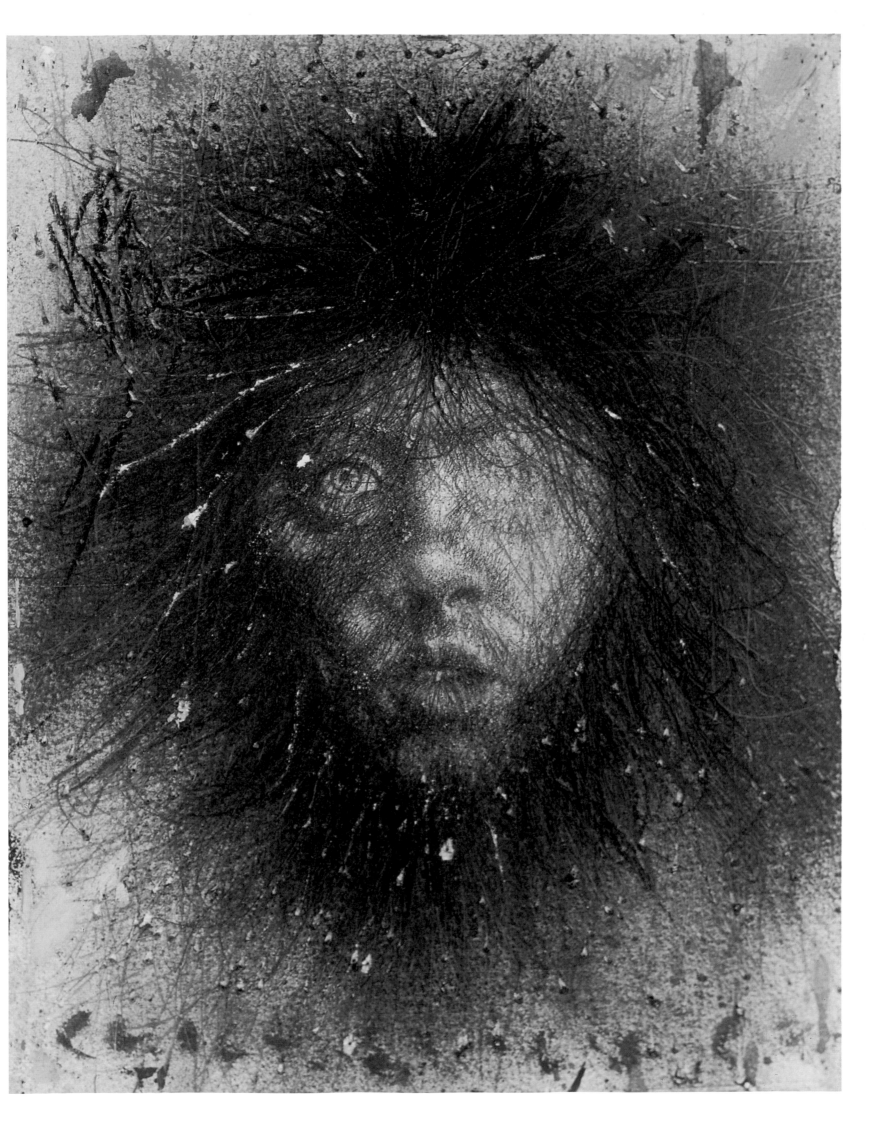

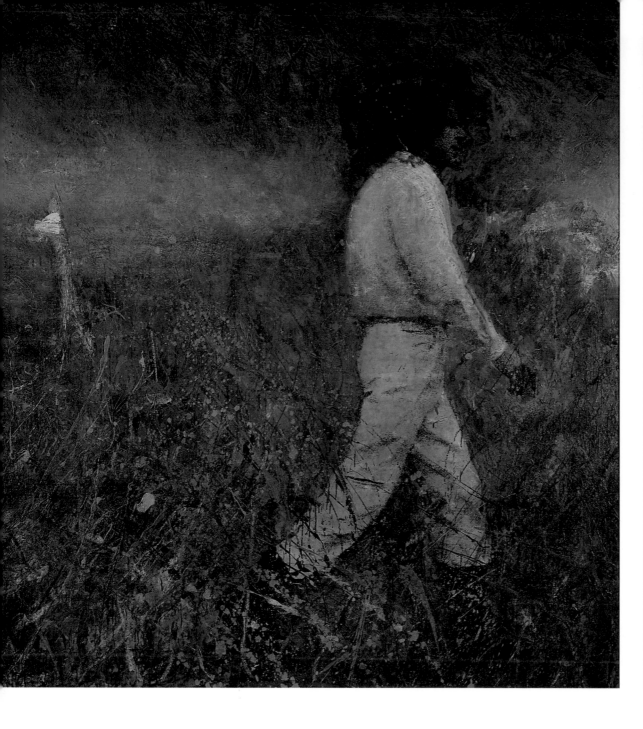

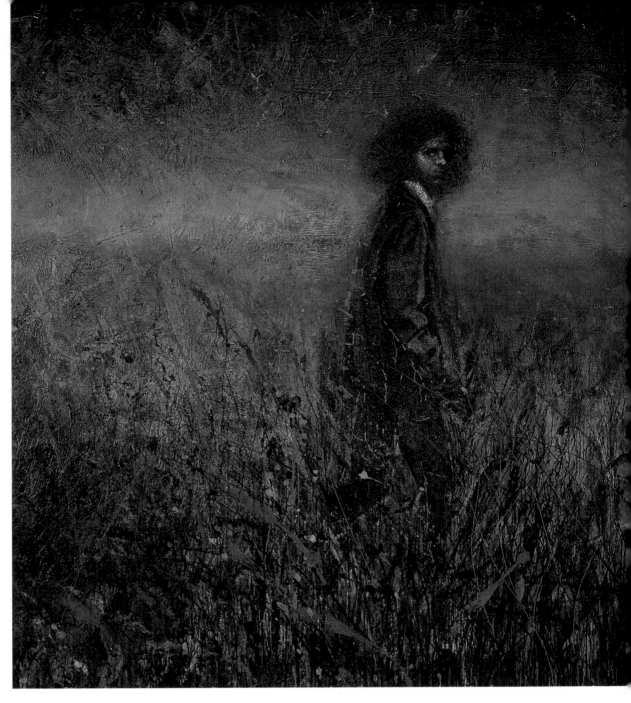

130
Two walking figures
in a landscape. 1984
Oil on canvas.
210 x 560 cm.

135
Self-portrait with Pegasus and
mummy. 1985/86
Oil on canvas, pasted on canvas.
117 x 158 cm.

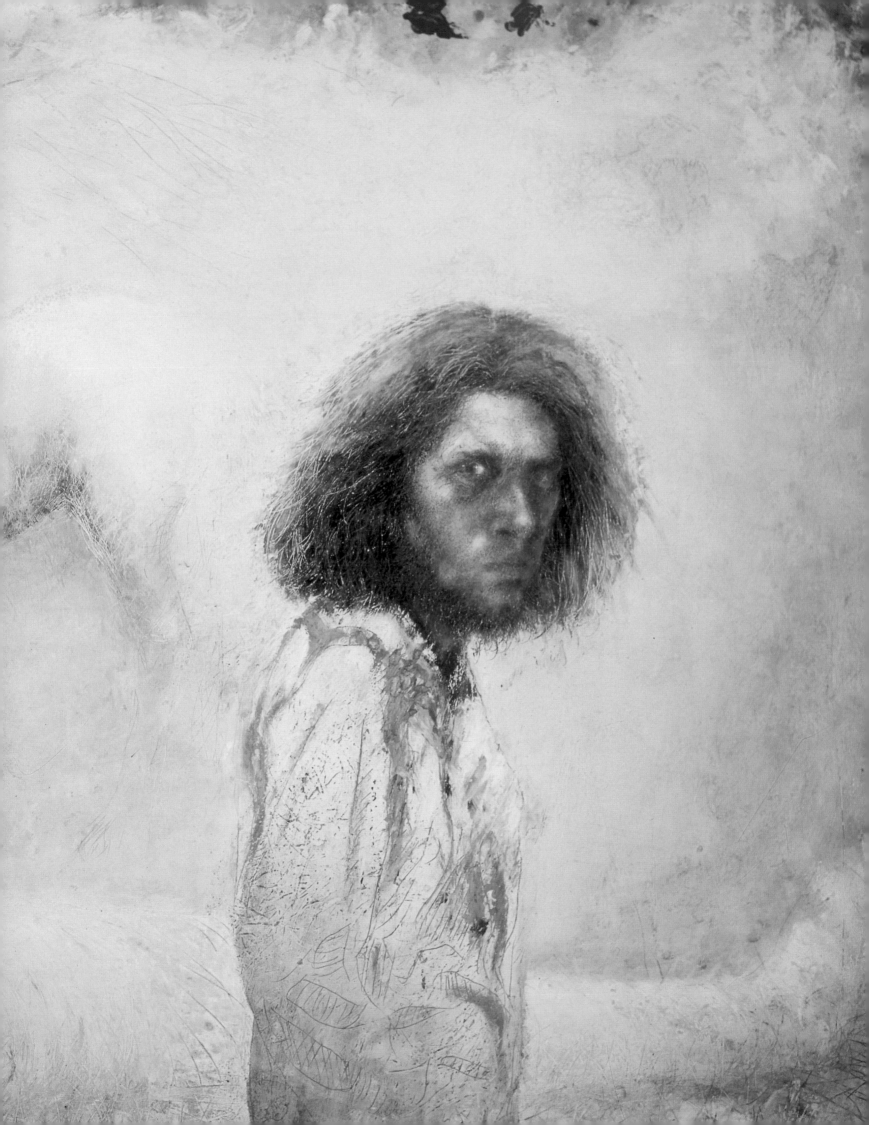

A New Start

It came in 1986. The approaching divorce and the break with the Copenhagen art scene intensified the need, but the renewal must also be seen as a natural result of the changed surroundings and the great distance Trampedach had put between himself and his European origins. When he settled down in New York, he was at one blow reduced to an unknown artist among thousands of others – he says himself that he felt he was in exactly the same situation as when he came to Copenhagen from Hillerød in 1963. And this feeling oddly enough had the effect of a liberation on him. When he walked through the streets there was no one who knew him; when he bought supplies from the paint shop he was just one among many other hopeful artists on their way to possible fame. This was an emancipation – not only of his personality but also of his talent. He would once more have to struggle over the mountains and make his mark – and that is exactly what has always been especially inspiring for him.

The divorce and the break with the art dealer had not only embittered him but also brought new financial conditions. "If it had been up to them, I'd have been poorer today than the day I was born," he said of the situation. But things did not quite go that badly – as always there were people ready and waiting, and interested in his pictures; now they were simply other people than before. But he was still forced to limit himself in purely spatial terms, so he soon abandoned using the whole of the big loft. Instead he rented the lower third, which in his usual fashion he rebuilt so it suited his needs of the moment – and there he began to paint again in earnest. And now things really happened!

When Trampedach stopped drinking in 1983, his pictures almost immediately became lighter in color. It seemed he no longer felt himself in the grip of the

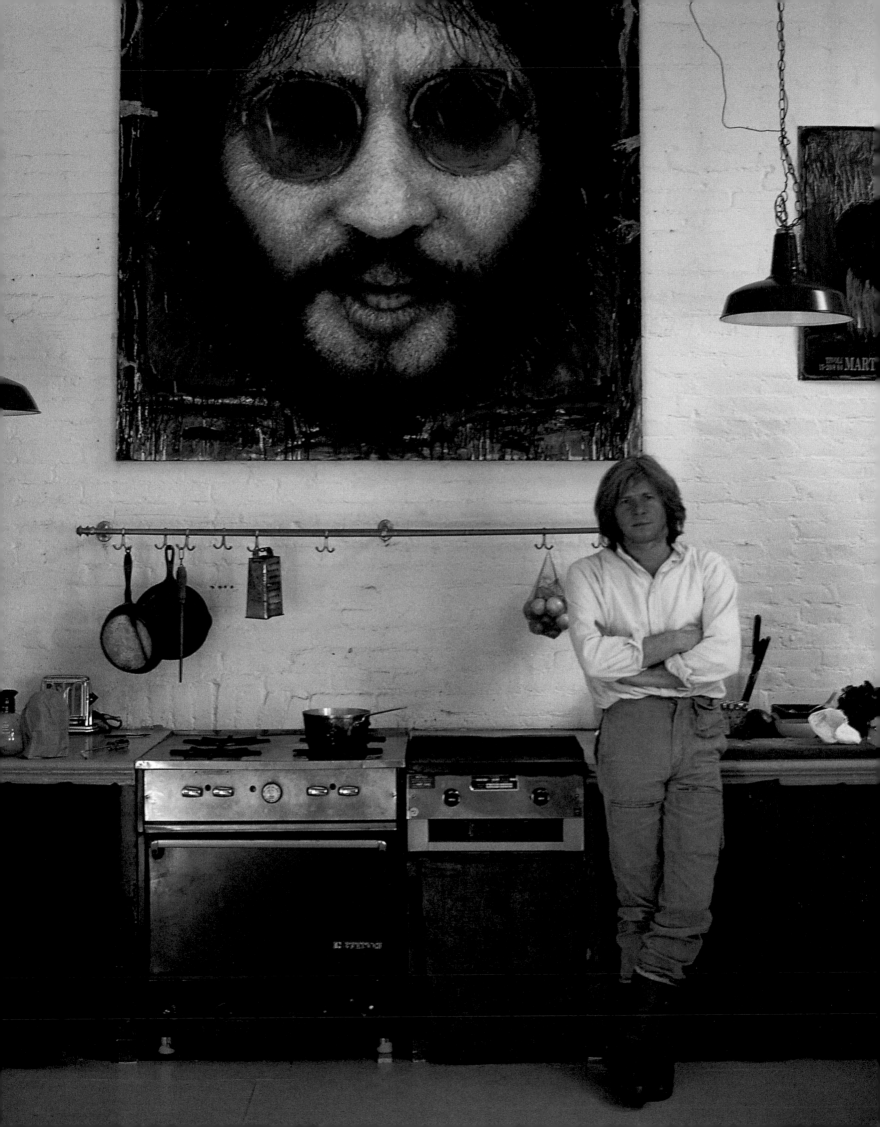

Back to the Mountains

This acceptance from one of the best in the business of course gave Trampedach a boost into another world. Allan Stone was clearly impressed by the primal power of his pictures and said among other things that it was the best painting that had come out of Europe since Balthus had made his breakthrough in the USA. And the comparison was not inappropriate – Balthus too was a figurative loner who defiantly and with supreme implacability painted his figurations as if nothing had happened in the milieu around him, without so much as a sidelong glance at the more fashionable demands of the age for consensus. Balthus was not one of the artists Stone himself represented, but in the formative years he had been a dealer for people like Willem de Kooning and Franz Kline – so Trampedach was in good company when Stone took him in.

The first exhibition was, as mentioned above, held in the winter of 1987, and since then Trampedach has had several one-man shows with Stone, while his pictures have been shown in the regular art fairs at The Armory in New York, side by side with figures like Picasso, Giacometti, Bacon and Rauschenberg. And these confrontations with the international big league have been life-giving for the oeuvre – which has taken an ever more radical turn. The material has become heavier and the figurations more and more personal. It is if the brakes are off and from now on Trampedach is on his way at increasingly breakneck speed into unknown territory. The pictures look like no one else's; they are all his own and as such strangely daunting to look at. They still show children – or symbols which take possession of the surface with accelerating authority (Figs. 158ff).

These peculiar figurations were not only created in the studio in Broome Street. Now that Trampedach had established a bridgehead, he was just as happy to

Affinities

It was undoubtedly the meeting with Sofie and her direct, empathic understanding of the situation that stimulated the clarifying work with the seven interpretations of the stages of life. For an outsider these pictures may not seem exactly happy – certainly not if one measures them with a banal yardstick. In that case there is something almost threatening about them, just as there is about the many smaller self-portraits he painted at the same time, where he has seen himself as if from slightly below, in a mirror that is hung high (Figs. 163-165). But the pictures are anything but banal, rather strong-willed and with no real precursors in contemporary art. As Trampedach himself sees them, they are on the contrary beautiful, because they have a history – his history, but also the longer one that runs off down to the secure darkness of the caves.

It is the *Veronaculum* that is rearing its head again (p. 241). The self-representations hover in dark spaces, surrounded by tracings that suggest associations going far back and in many different directions – to the rock paintings of the Australian aboriginals, to the animals in Lascaux, Chauvet and Altamira, to the pictures of Egyptian gods, to Precolumbian sculpture and to our own Danish Sun Chariot. The heads are bald and the primary colors are painted in around the scalp as testimony that it is a painter who has looked into his own eyes. The basic and the timeless. But there is also much more to it than that – a spark that jumps from these prehistoric sources of inspiration to the present, to life in the twenty-first century.

Trampedach has always had an absolutely insatiable appetite for movies, especially in New York, where he was a regular customer of the local video store when night fell and he wanted to relax in front of the screen. And with his visual gifts he is not squeamish – even in the Hollywood mainstream he can see something

good or something relevant. For example he has no trouble identifying with Mickey Rourke in *Year of the Dragon* or with Sylvester Stallone in *Copland* and making the mental connection between their battles with the corrupt authorities and his own in the art establishment. Deepest down there is no difference, in his eyes – and of course there is some truth in that.

But where there are really up-to-date parallels, and where the films feed creatively into the process, is in the more futuristic parables where replicants, androids and other more mechanical entities play a major role. Cult films in the science-fiction genre like *Blade Runner, Alien, Twelve Monkeys* and *The Matrix*. This whole array of fantasy material is absorbed, digested and transformed during the nightly sessions in front of the screen – and then later in the daytime unfolds or rather is folded into his figurations. Like the genetic engineer J.C. Sebastian in *Blade Runner* he creates life from dead things, so he always has friends to welcome him when he walks into his studio. "I make friends ... My friends are toys", Sebastian says to the replicant Priss in the film – and Trampedach feels something similar when, morning after morning, he confronts yesterday's work, with or without cackling geese as his loyal followers.

Virgin and Child. Detail. Spanish-Philippine. 18th century. Ivory and various materials. Height 120 cm.

P. 241:

Virgin and Child. France. Ca. 1150-1200. Height ca. 30 cm. Wood, polychrome painting. The Metropolitan Museum of Art, New York.

Francisco de Zurbarán: The Veronaculum. Oil on canvas. 76 x 56 cm. Nationalmuseum, Stockholm.

In his pictures Trampedach combines an ultramodern perspective with a classic or ancient one, so he can build a bridge between the past and the future. It may well be that there are some allusions to Velazquez' dwarves and to Goya's pictures of children, but they are secondary to the references that reach into the universe of the films and on into the ongoing discussion of the dubious blessings of genetic manipulation. The actual technique, oil on canvas, ties him to the expressive idioms of the past, but the motifs he takes up are very much of this world. And although the pictures as such are quite unique in their expression, he is not totally alone in his aspirations. We can draw certain parallels with other marginalized figures in the art of the day.

Balthus has been mentioned, but the closest parallel is with English art and the people who like Trampedach himself have been inspired by Francis Bacon's example. Painters like Frank Auerbach, Lucien Freud and Leon Kossoff and sculptors like Anthony Gormley and Marc Quinn. In English art throughout the twentieth century there has been a living, forward-looking figurative tradition. There has been no loss of innocence, as there has been in other parts of the western world, in relation to the genre – on the contrary it has been maintained as something essential without resorting to ironic distance or pure meta-art, as has been the case in the USA, Germany or Italy during the same period.

The affinities are also interesting from a local Nordic perspective. Frank Auerbach, for example, paints like Erik Hoppe and Leon Kossoff paints like Svend Guttorm. And Gormley and Quinn, like Trampedach himself, has been inspired by Segal and by the Pompeiian castings – and both, like him, in an existential direc-

toward unknown territory. In the process the figures have been given a gravitational weight as if they were made of a different material from the paint itself. There is no longer any point speaking only of paintings: the effect is that of the relief – the figures have been built up through months of uninterrupted concentration and are now well on their way, wrenching themselves free of the surface to come out to us. Their heads are fleshy and gnarled and their gazes are penetrating and accusing. There is no way back (p. 239 and Fig. 177).

At the beginning of the eighties, when Trampedach, with a decided urge toward the self-destructive like some kamikaze pilot, plummeted toward the depths at breakneck speed and sent strings of banal pieces flooding on to an apparently insatiable market – when he painted beautiful women with their hair shaken out, alluring gazes and attractive bodies – at that time he said in his defense that a painter was surely allowed to paint women just as beautifully as Botticelli. But of course it wouldn't do. Botticelli painted his women in fourteenth-century Italy, in another mental climate and on quite different philosophical premises. Although his pictures are also marked by great literalness, the line is flawless and unfolds searchingly in the space in increasingly beautiful arabesques. Botticelli defined a new space, and one cannot simply step into that space again five centuries later.

But if one must insist on the connection – and one must – it is not with Botticelli's *Venus* or *Primavera*, but with the illustrations he drew between 1480 and 1495 for Dante's *Divine Comedy*. With meticulous care they depict the poet's path through Hell and Purgatory to Paradise – or through the *Inferno* and the *Purgatorio*

Sandro Botticelli:
Illustration for Dante's
Inferno, Canto 15. 1480/95.
Pen, brush and water-
color on parchment.
Ca. 325 x 475 mm.
Biblioteca Apostolica
Vaticana, Vatican.

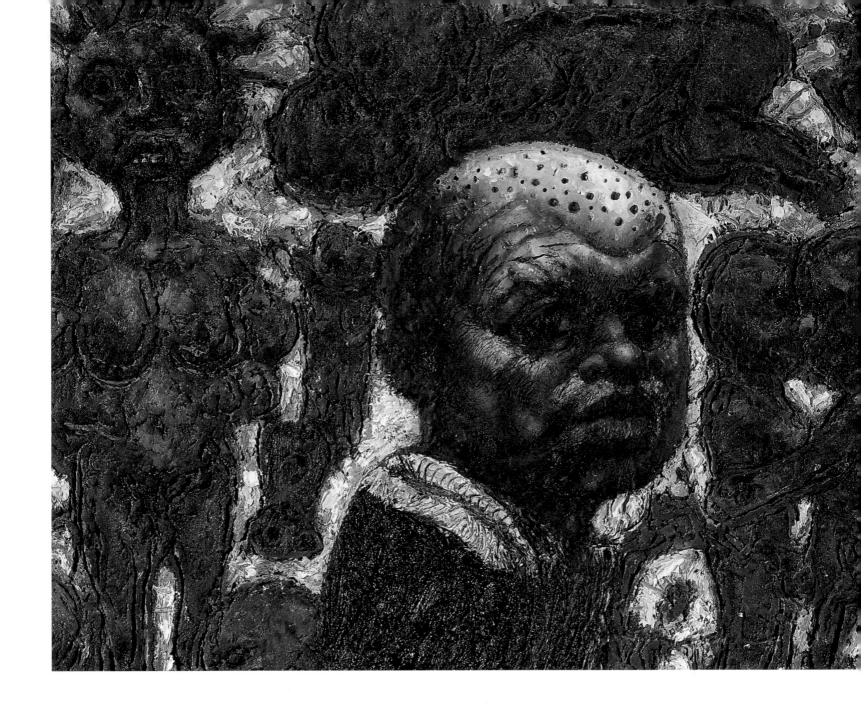

to the *Paradiso,* to give the places their proper names. The great majority of these are pure line drawings where the narrative takes form with a certain gravity-defying lightness, despite the great seriousness of the text. They seem suffused by a belief in the continued relevance of the Divine Comedy. With self-effacing empathy Botticelli has drawn his way through the material – nothing has escaped his attention along the way, nor is there anything too horrific to be visualized (p. 246).

It is clear that the subject here is not primarily Botticelli himself, but Dante and his visions. The drawings thus follow the text with great literalness from first to last, canto by canto, stage by stage, downward and outward and upward. And as they are executed they balance at some indefinable point between the naive and the sophisticated, between the registrative and the expressive. Certain of them bear an odd resemblance to those van Gogh drew out in the landscape around Arles and Saint-Remy four hundred years later. One sees the same touching attention to detail, the same strong will to transform the seen into adequate, evocative form. And the similarity extends all the way to the line – the infernal flames of Botticelli are thus almost identical to the martyred cypresses of van Gogh. There is no difference

Inferno.
Detail of Fig. 177.

– and the intention was presumably also the same. Van Gogh too was on his way from Hell to Heaven, from Inferno to Paradiso. Although he perhaps never, like Dante, reached his redeeming destination.

And here we are back with Trampedach, whose works of the last fifteen years trace a pilgrimage like that of Botticelli's flawless drawings. But now, in contrast to the self-destructive years, the visions emerge from an inner necessity. There is no learned material in them, they are all conjured up from constant confrontations with the Self and are based on his own hard-won experience. Like Dante and Virgil Trampedach has moved downward into the abysses of the psyche, through circle after circle – and on the way to Purgatory he has met his Ego in ever more frightening shapes; which he has then, without a tremor, given enduring form – in order to engage in a dialog with it and arrive at an understanding of its nature. He has gone through the gates of Hell with his eyes wide open and has ferried himself across the Styx, because he knows that only this way – on his own initiative and under his own power – can he be rid of his demons.

The figures Trampedach has left behind on this stony path to awareness remain as witnesses to the inevitability of the journey. The constantly down-spiraling movement has sloughed them off by the wayside, exhausted and confused – like a race unto themselves, like autonomous entities who have their own wondrous life. And if we are to compare them with anything else in western art, it must be with the poet William Blake's claustrophobic figurations, which like Trampedach's exist in a world of their own, as pure experienced matter from the innermost regions of the spirit. In this case too one can refer to nothing else but Blake himself and his own quite private imaginative world from around 1800.

Blake lived and worked in the middle of London, but in self-chosen isolation, and the visions he had were without any real connection with the more academic milieu of the city. They were without precedent and without contemporaries, and as such only had the future in their favor. But this was no tragedy – for Blake too there was no way round them. Of course he knew Dante too, and worked in the last years of his life on illustrations of the Comedy. But he never managed to finish them, and his visions are far more dreamlike in execution than Botticelli's. They are without substance in the material, either fleshly or concrete. They were the result of a kind of spiritual inbreeding.

If there are parallels to be drawn all the same, it is because Trampedach's figurations too are in a way self-generating. One figure begets the next in a constant development inward, downward and outward in the material. Trampedach is still on his way through Purgatory toward the painful redemption, out of the darkness and into the light. The most recent pictures bear witness to his state. They vary between visions where his childlike *alter ego* wanders along through landscapes populated by figures he can only have met in Hell, and others where he sits as if cocooned within shining circles, ready to be born anew from one state into another but still wound around by a figure-forming past (Figs. 177 and 174).

These new pictures are borne up by a certainty of the way forward and are among the most impressive Trampedach has ever painted. They are violent, not only in gesture, but also in content – one of the walking surrogates for example passes the human race as a whole; men, women and children who simply stand watching as he walks by, naked and martyred as if a firestorm has swept over them (Fig.

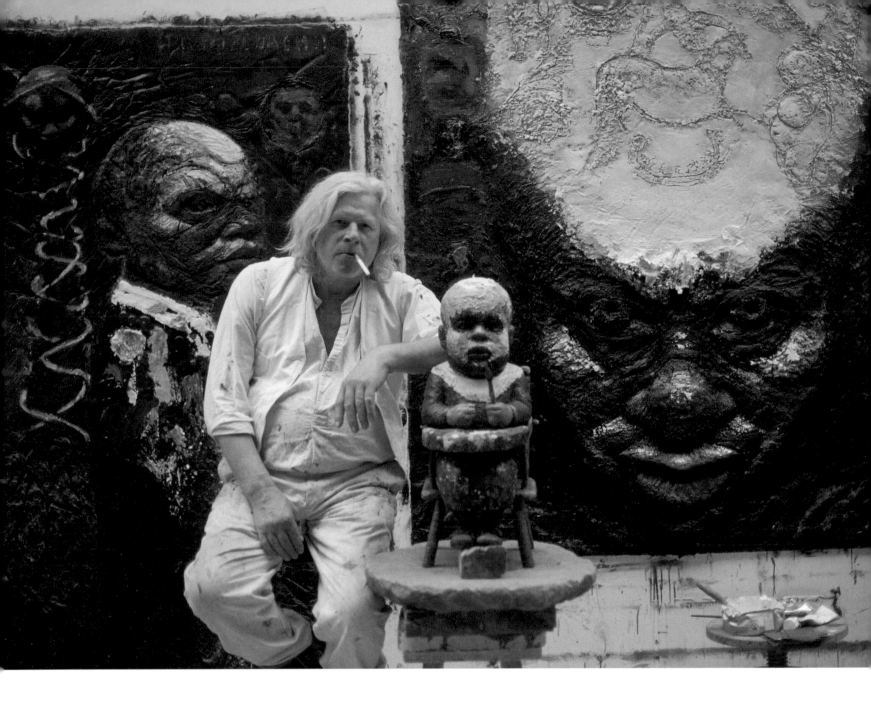

177). This martyred race has the same color as slag from a blast furnace, and bears a striking resemblance to the damned in Dante's *Inferno,* who must live out their afterlife in boiling blood and pitch or must flounder around groaning in their own excrement.

Botticelli's drawings show this – and precisely in these cases he has exceptionally felt called to use color to get his message across (p. 246). And it is on the whole also characteristic of him that as an artist he is most 'comfortable' in Hell. Here he is in some strange way on home ground. When it comes to Purgatory and Paradise it is all more difficult to imagine. And it is the same with Trampedach – he too has a natural affinity with the Inferno, while he constantly draws back from a description of the more redeeming regions. He stands right on the border – and he looks in. He crouches in his aura, with wide open eyes and fetuses whirling round him – or he lies like some Moses on a palm leaf with his finger in his mouth and with a penis so huge and potent that one is not for a moment in any doubt that new wondrous figurations are soon to be begotten.

136
Self-portrait on yellow
background. 1985/86
Oil on paper,
pasted on canvas.
75 x 60 cm.

following pages:

137
Untitled. Little Painter
on a disk. 1984
Oil on paper,
pasted on canvas.
70 x 56 cm.

138
Untitled. Little Painter
in a landscape. 1984
Oil on paper,
pasted on canvas.
80 x 56 cm.

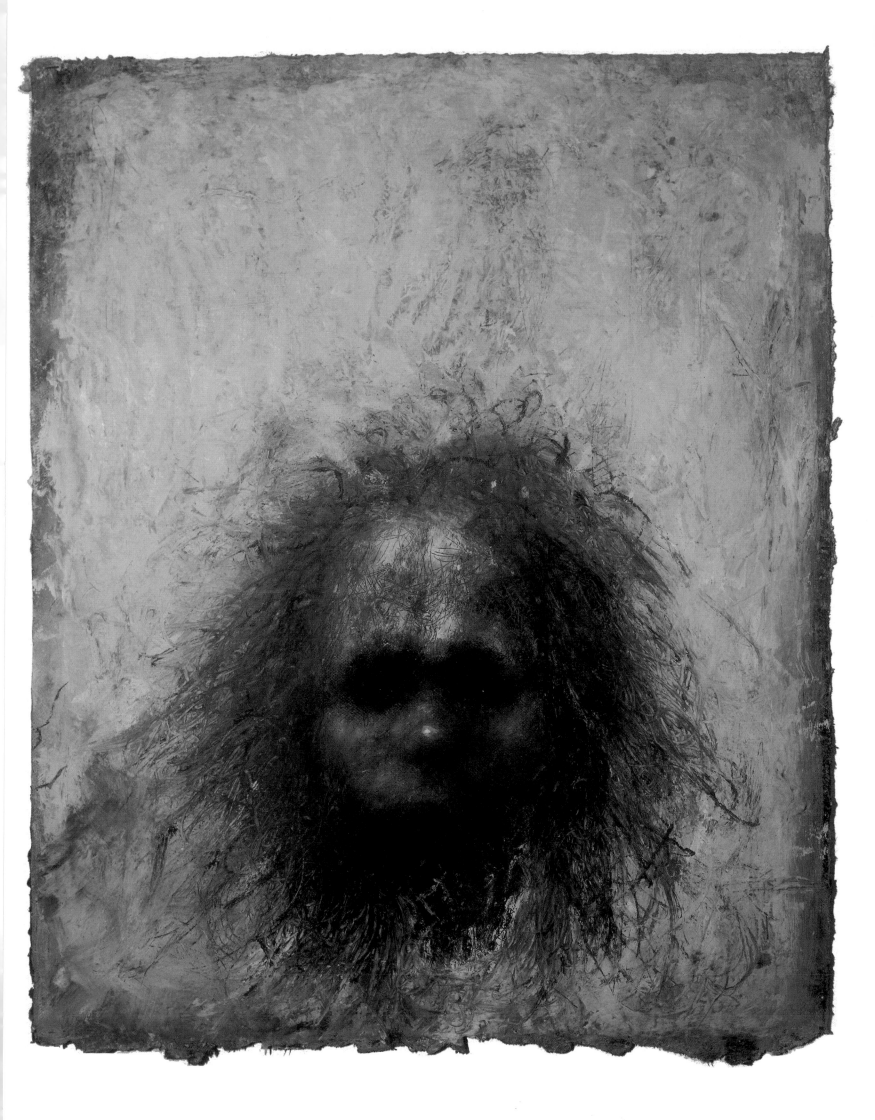

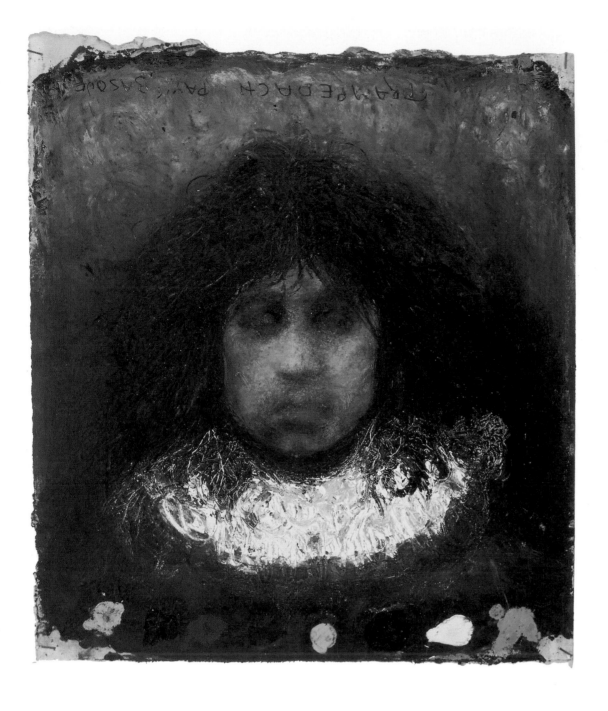

139
Portrait. 1985/86
Oil on paper,
pasted on canvas.
28 x 25 cm.
140
Boy with sheepskin
behind his head. 1985/86
Oil on paper,
pasted on canvas.
90 x 65 cm.

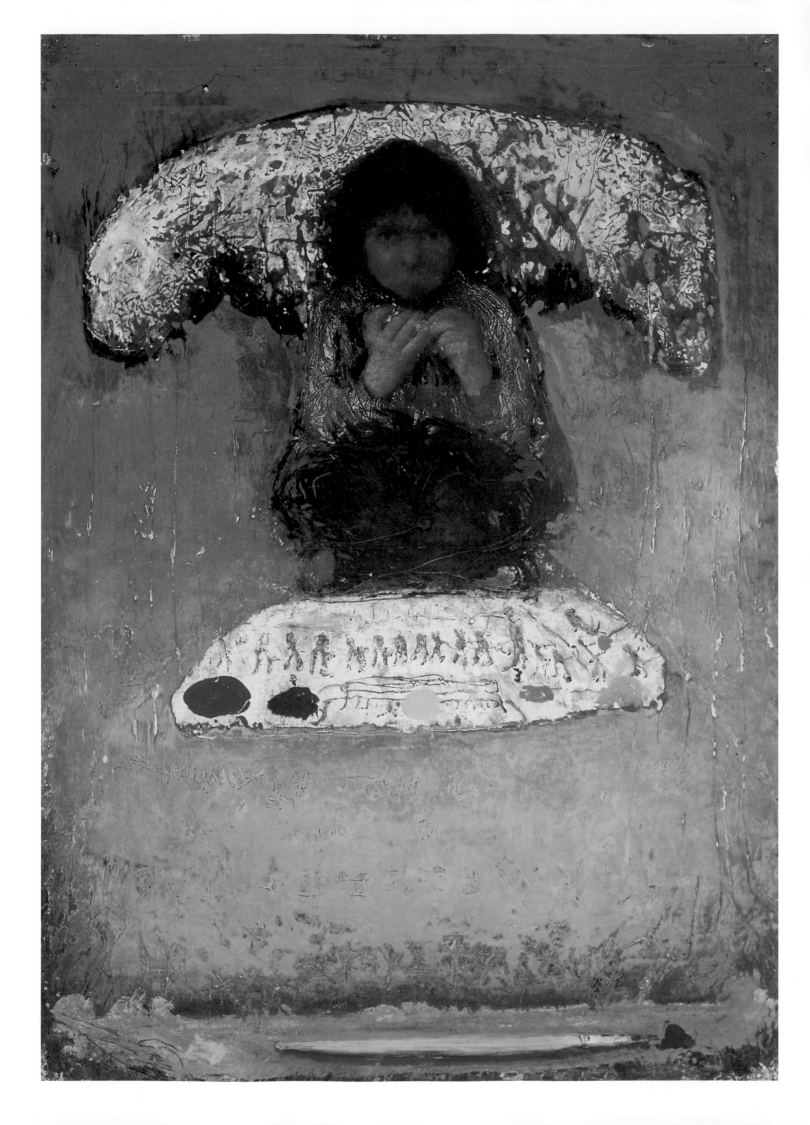

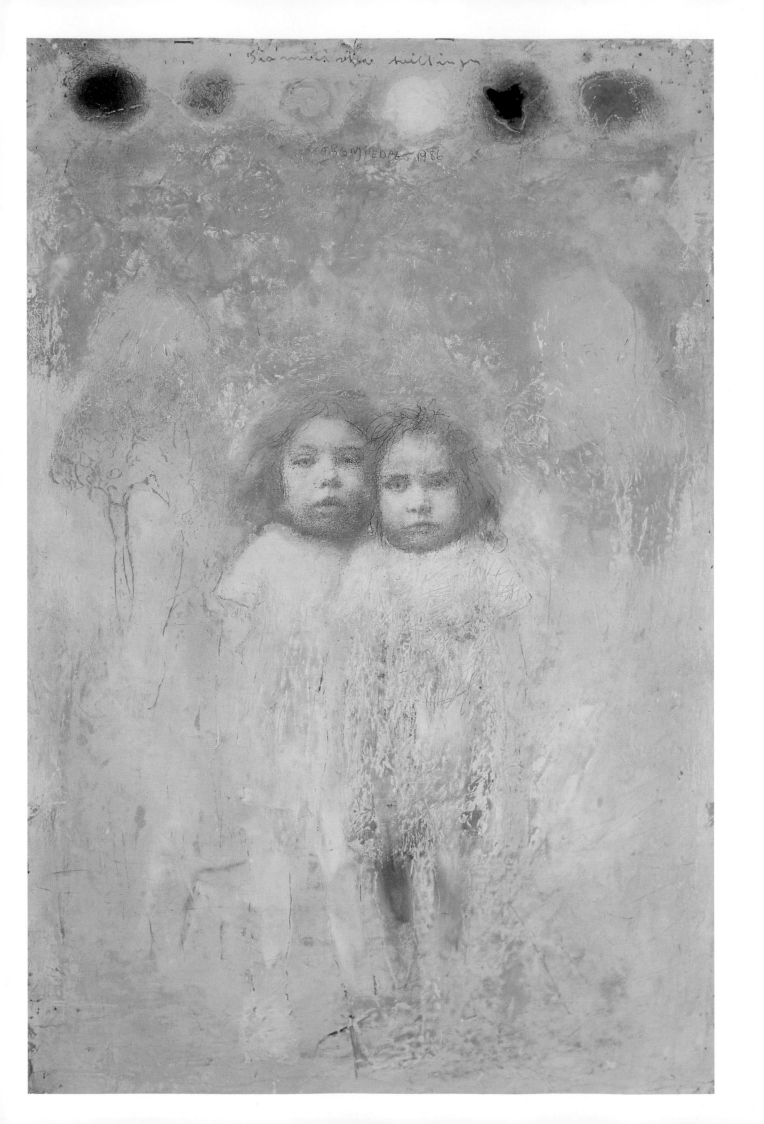

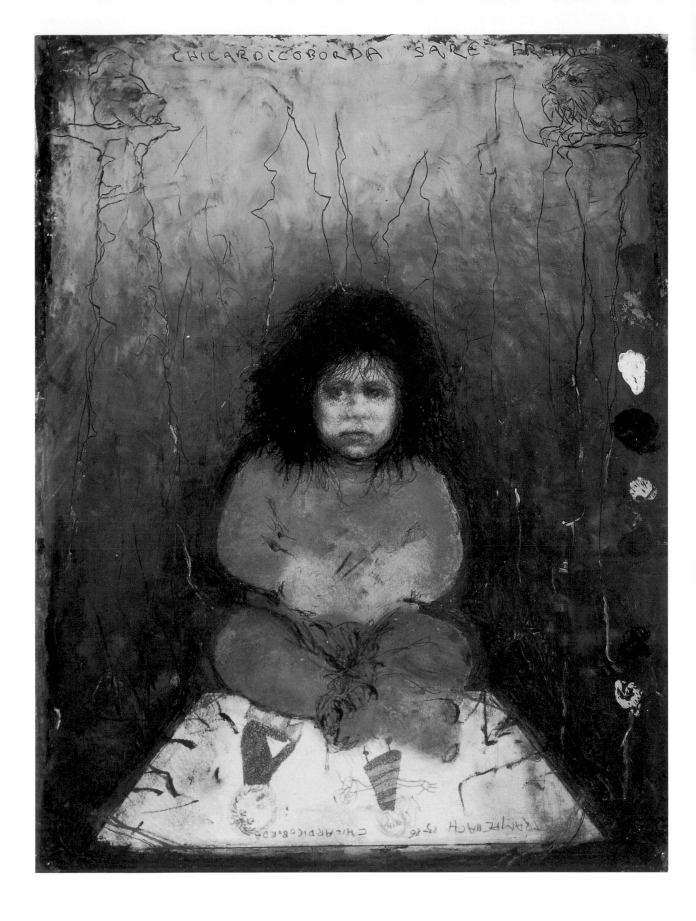

141

Siamese twins. 1985/86

Oil on paper, pasted on canvas. 65 x 35 cm.

142

Boy seated on a drawing. 1985/86

Oil on paper, pasted on canvas. 65 x 45 cm.

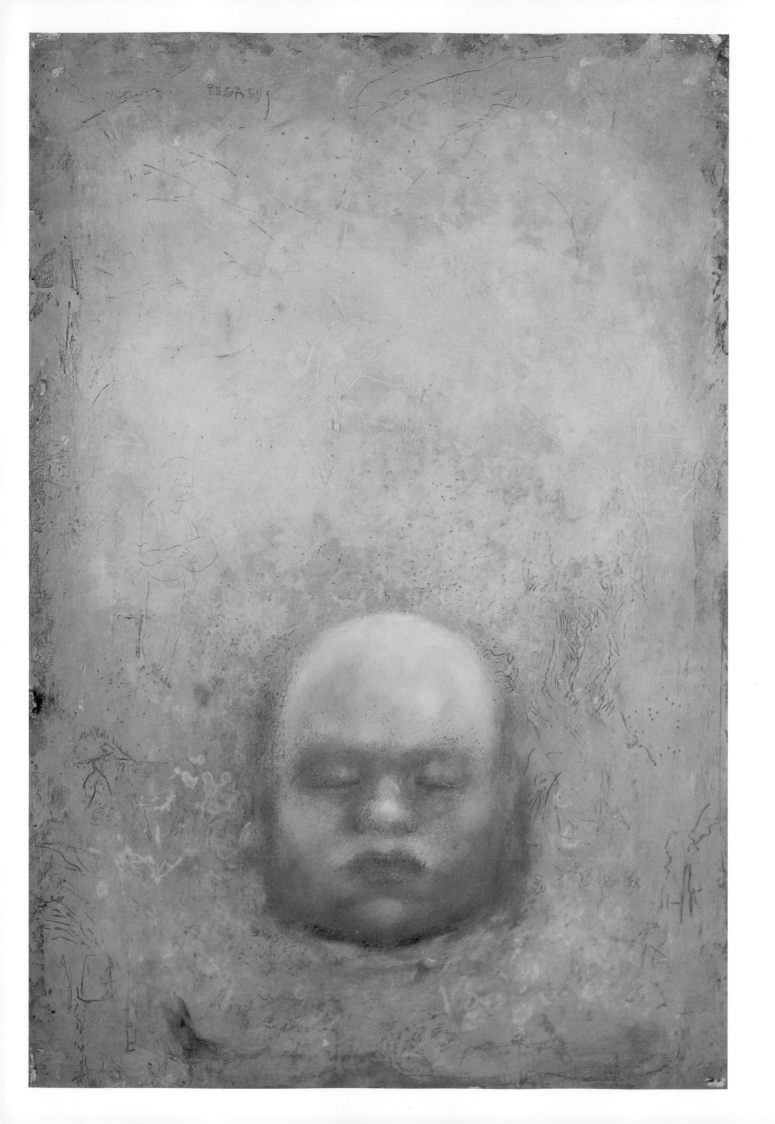

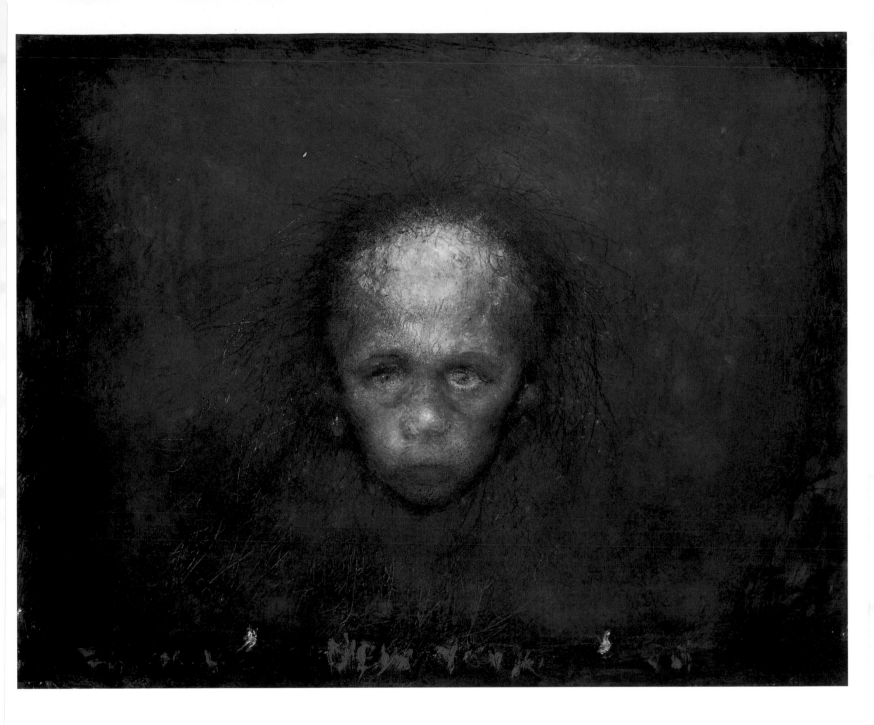

143
Head of child below Pegasus. 1985/86
Oil on paper, pasted on canvas. 65 x 35 cm.
144
Portrait on blue background. 1985/86
Oil on paper, pasted on canvas. 57 x 73 cm.

f o l l o w i n g p a g e s :

145
Head of woman between columns. 1985/86
Oil on paper, pasted on canvas. 72 x 58 cm.
146
Seated boy with his parents on his lap. 1985/86
Oil on paper, pasted on canvas. 100 x 62 cm.

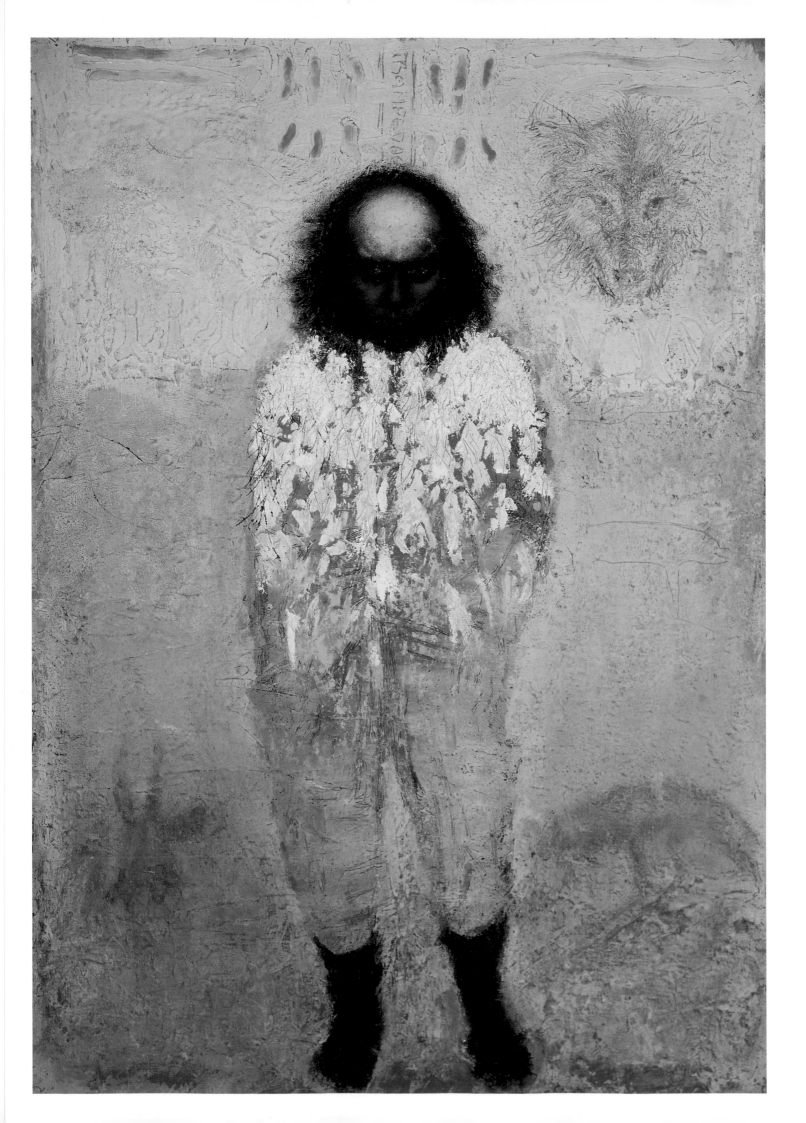

147

The Wolf Man. 1985/86

Oil on paper pasted on canvas. 120 x 80 cm.

148

Dog. 1986

Oil on paper, pasted on canvas. 60 x 78 cm.

f o l l o w i n g p a g e s :

149

Self-portrait as mummy. 1985/86

Oil on paper, pasted on canvas 80 x 120 cm.

150

The Escape to America. 1986/87

Oil on paper, pasted on canvas. 120 x 80 cm.

151

Little Painter. 1986/87

Oil on paper, pasted on canvas. 120 x 80 cm.

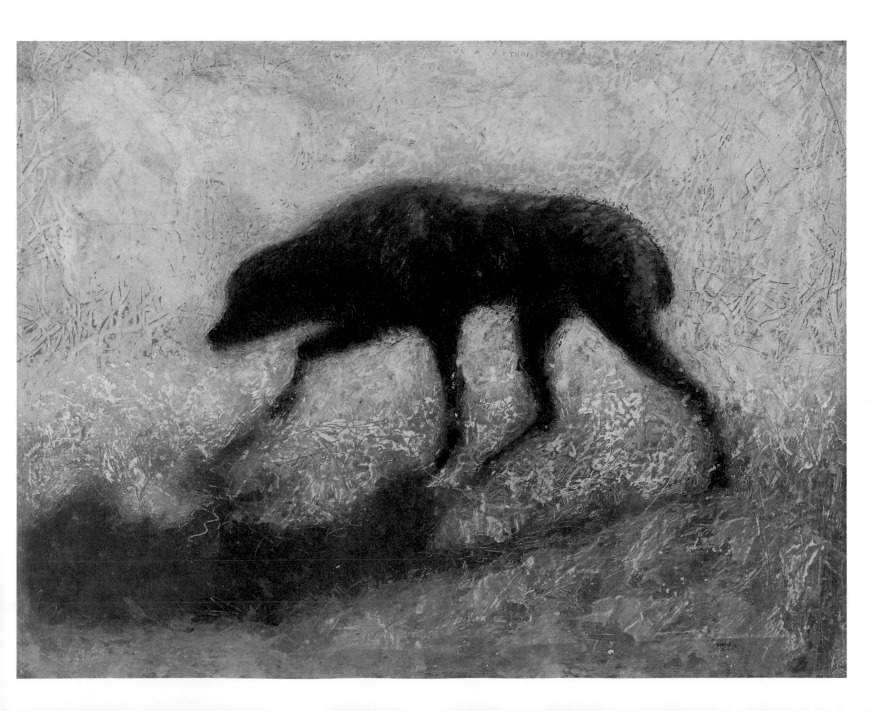

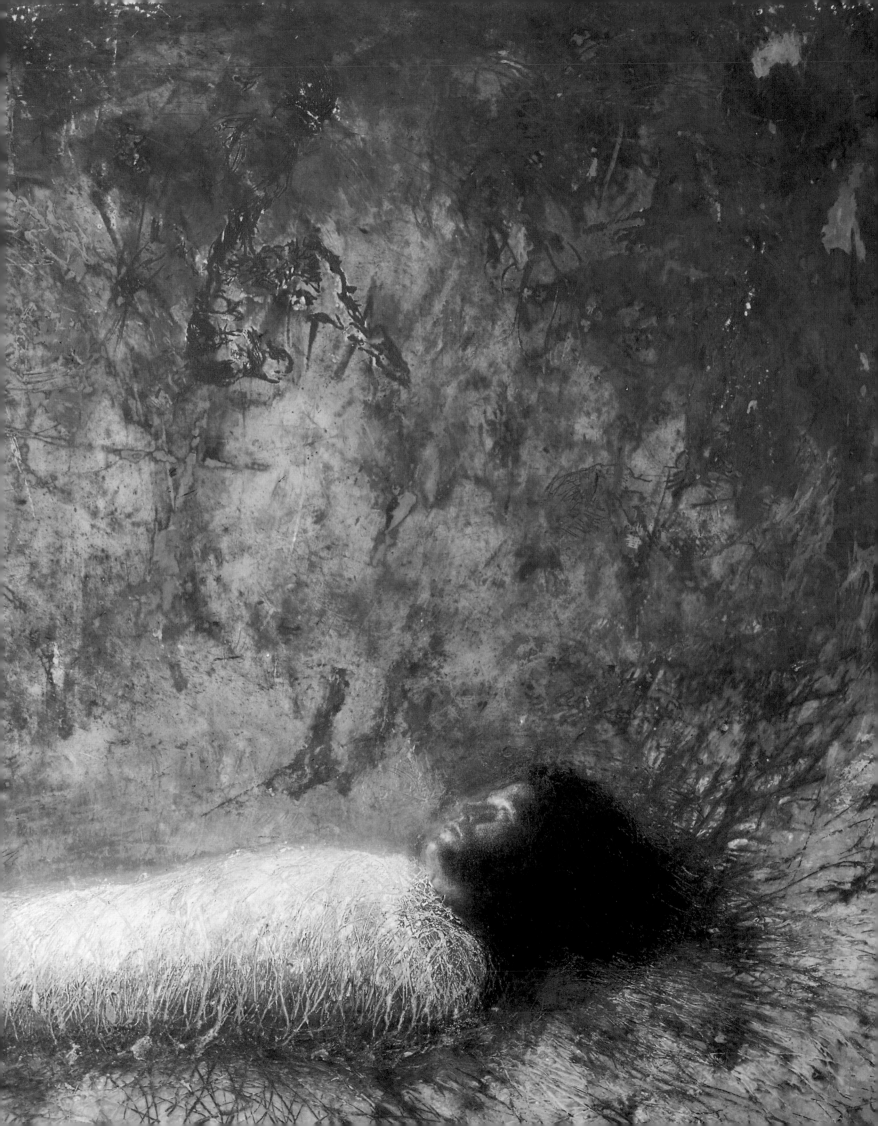

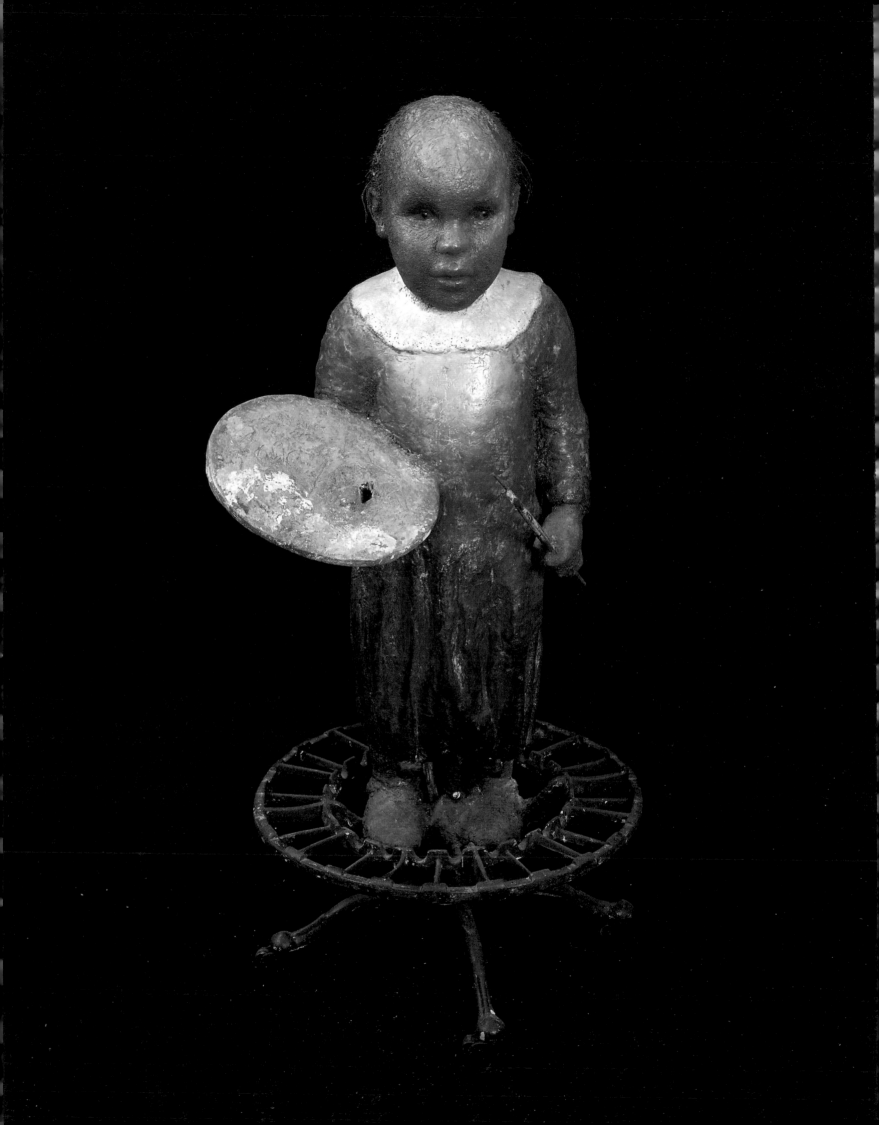

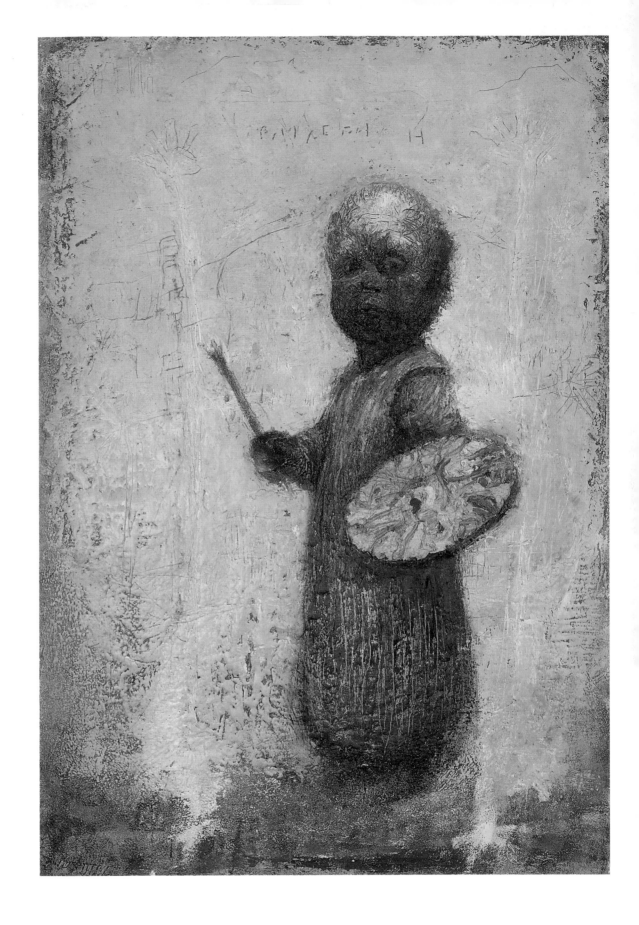

156

The Little Painter. 1988/89

Sculpture, mixed media. Height: 120 x 48 x 63 cm.

157

Little Painter, looking over his shoulder. 1988

Oil on paper, pasted on canvas. 110 x 76 cm.

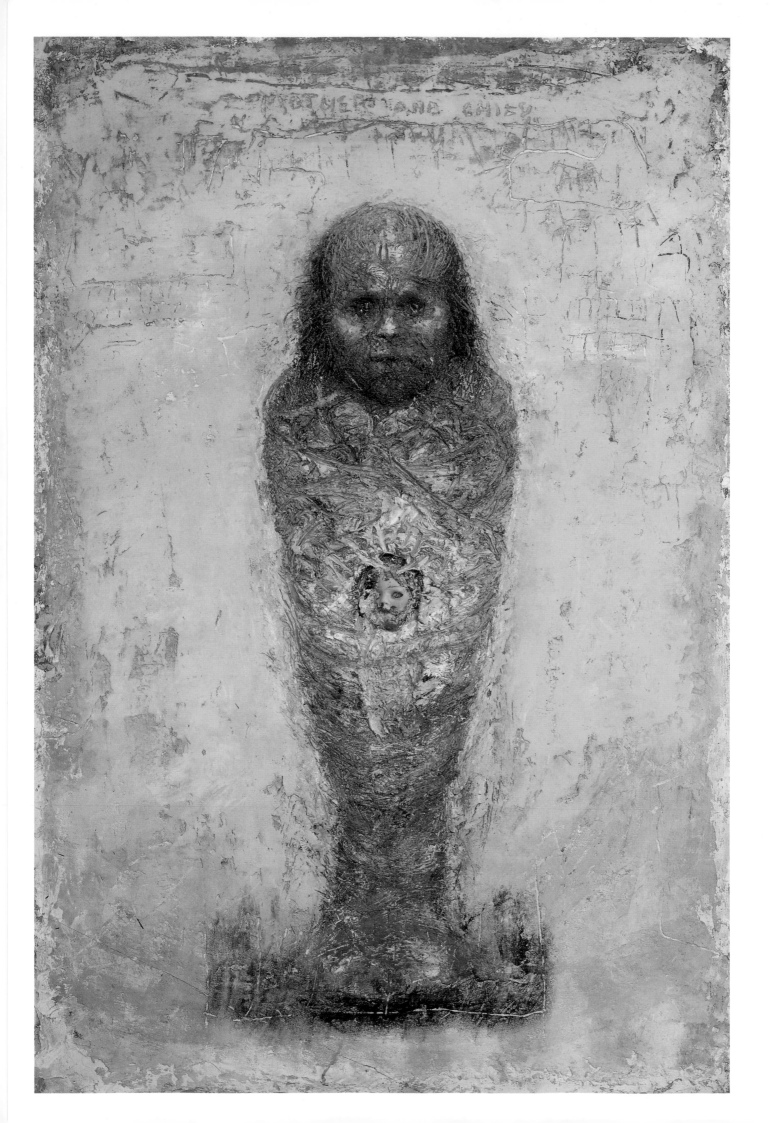

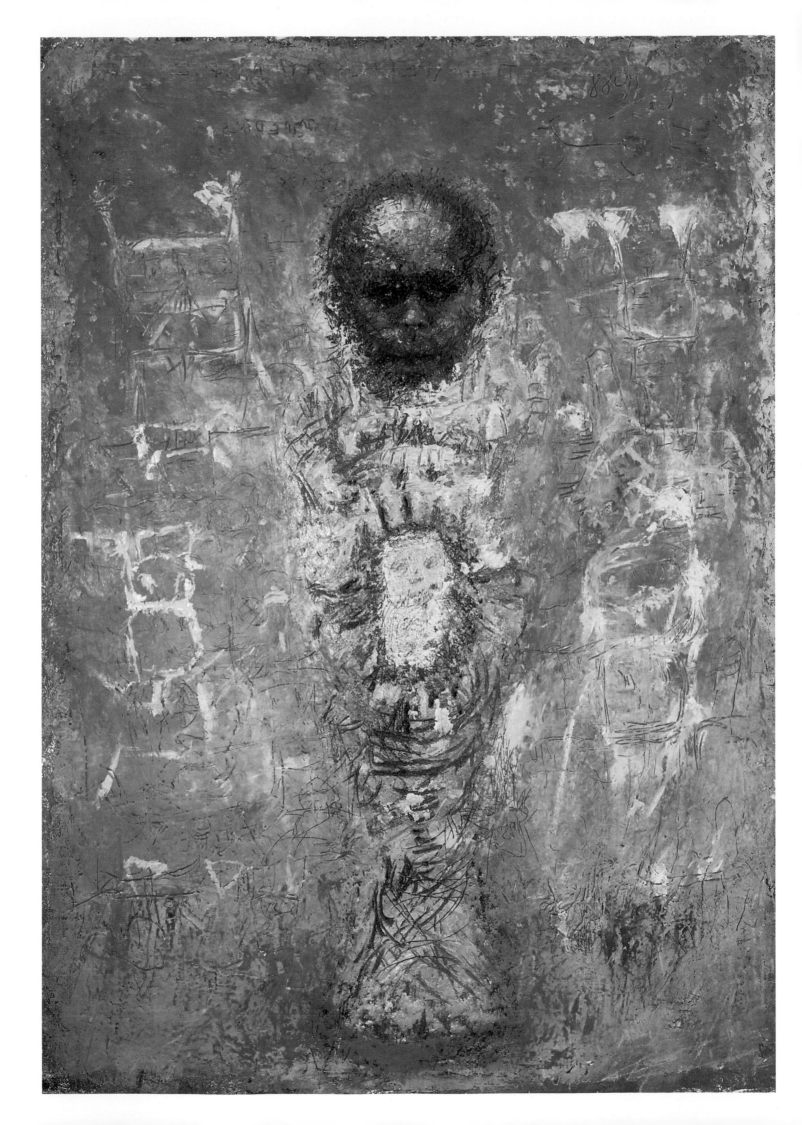

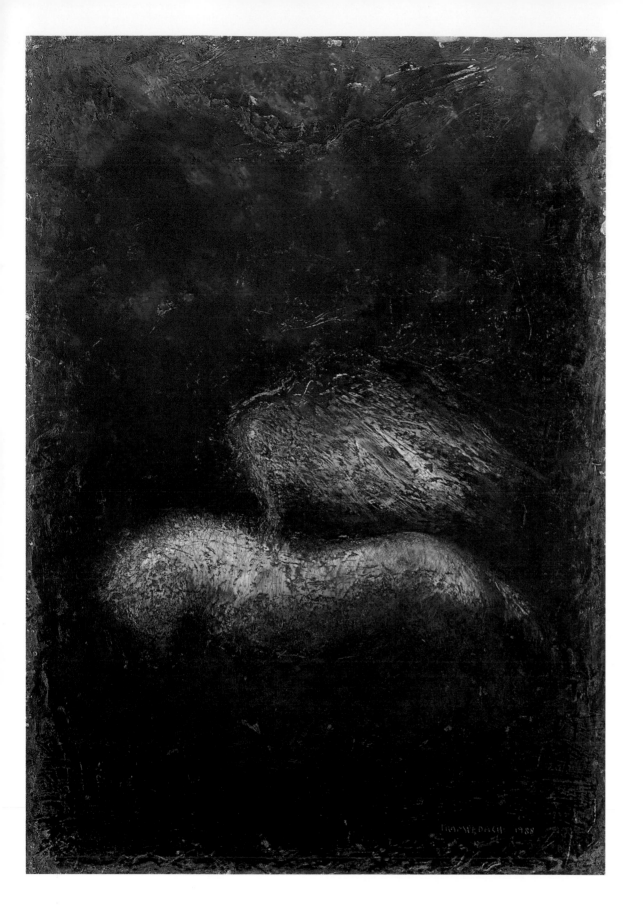

161
Pegasus. 1988
Oil on paper, pasted on canvas. 100 x 62 cm.
162
Little Painter below Pegasus. 1987/88
Oil on paper, pasted on canvas. 120 x 80 cm.

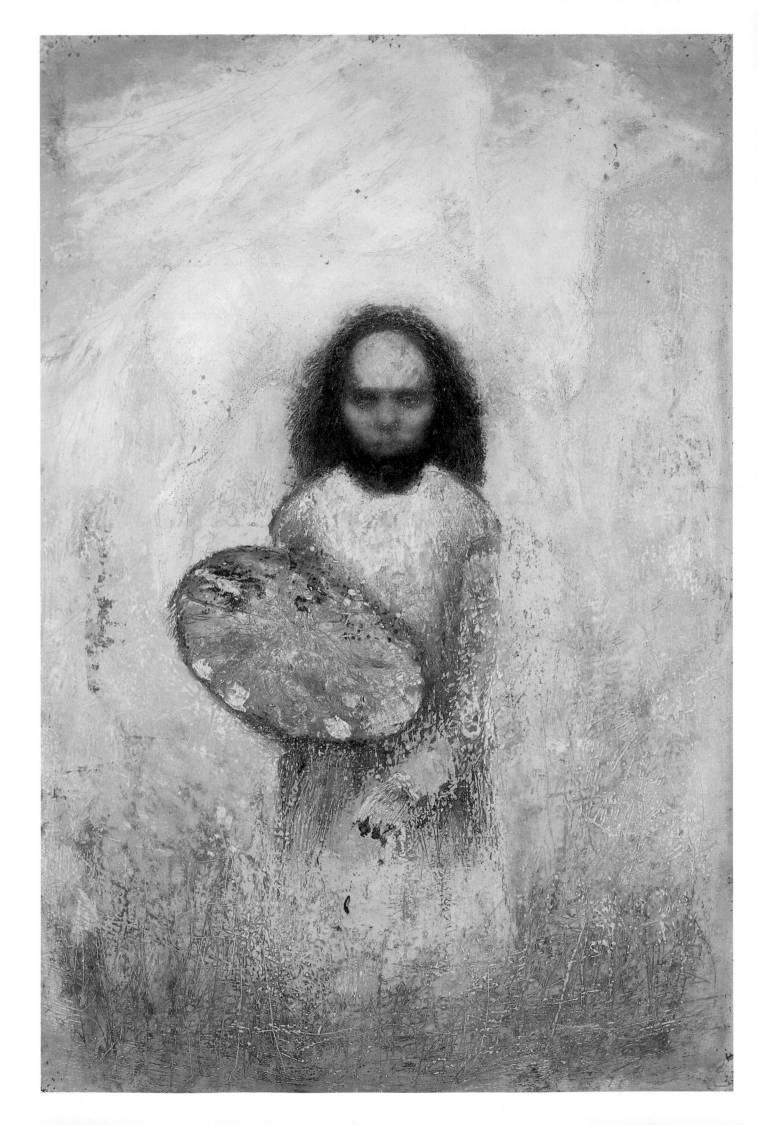

163
Self-portrait. 1991/92
Oil on paper,
pasted on canvas.
79 x 60 cm.

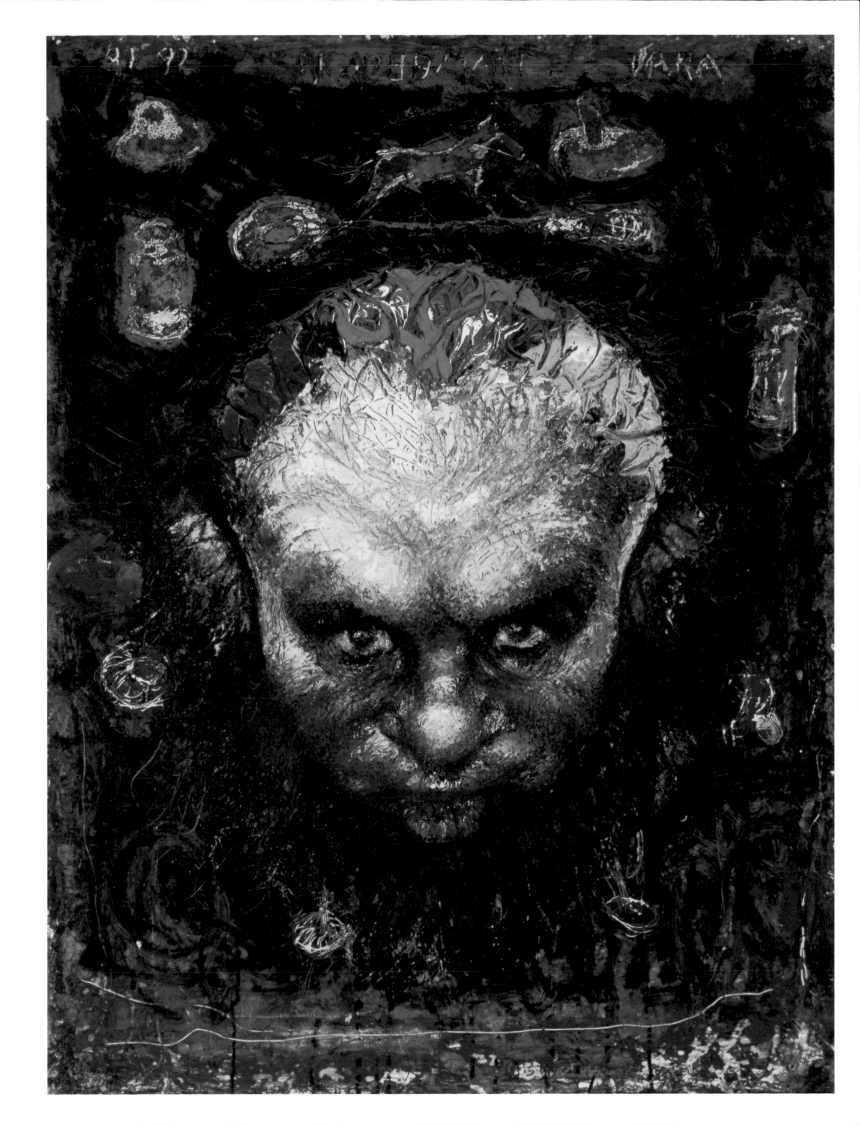

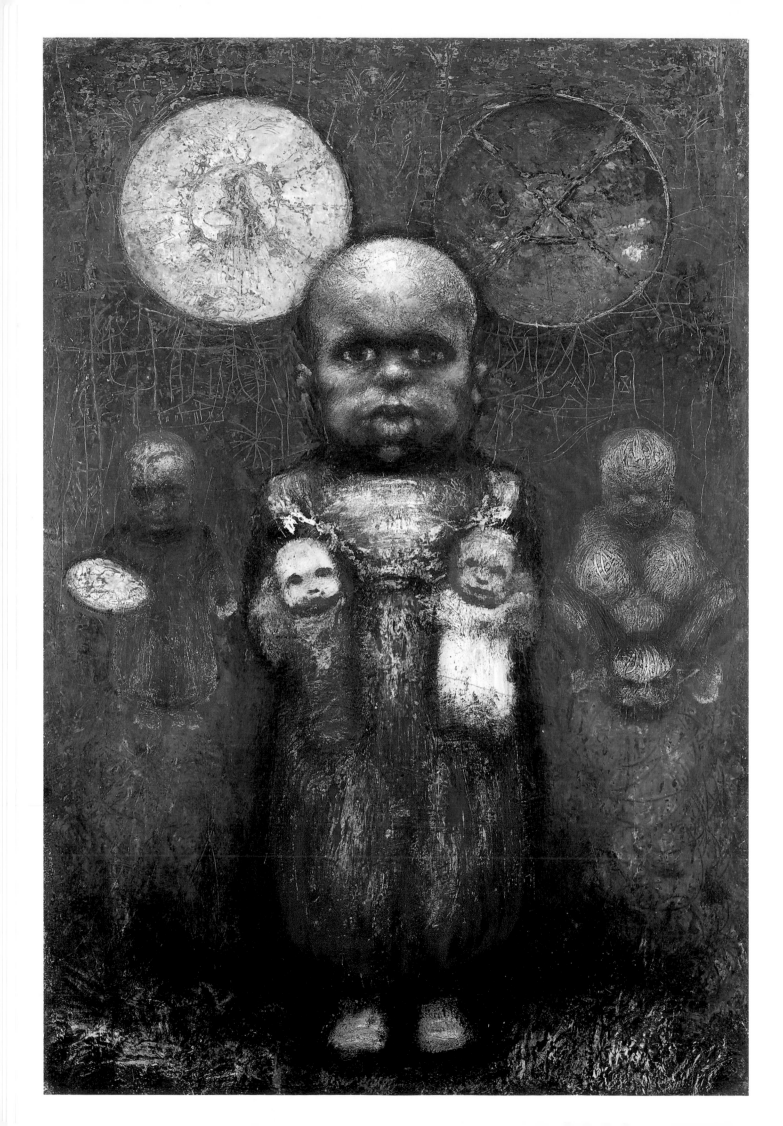

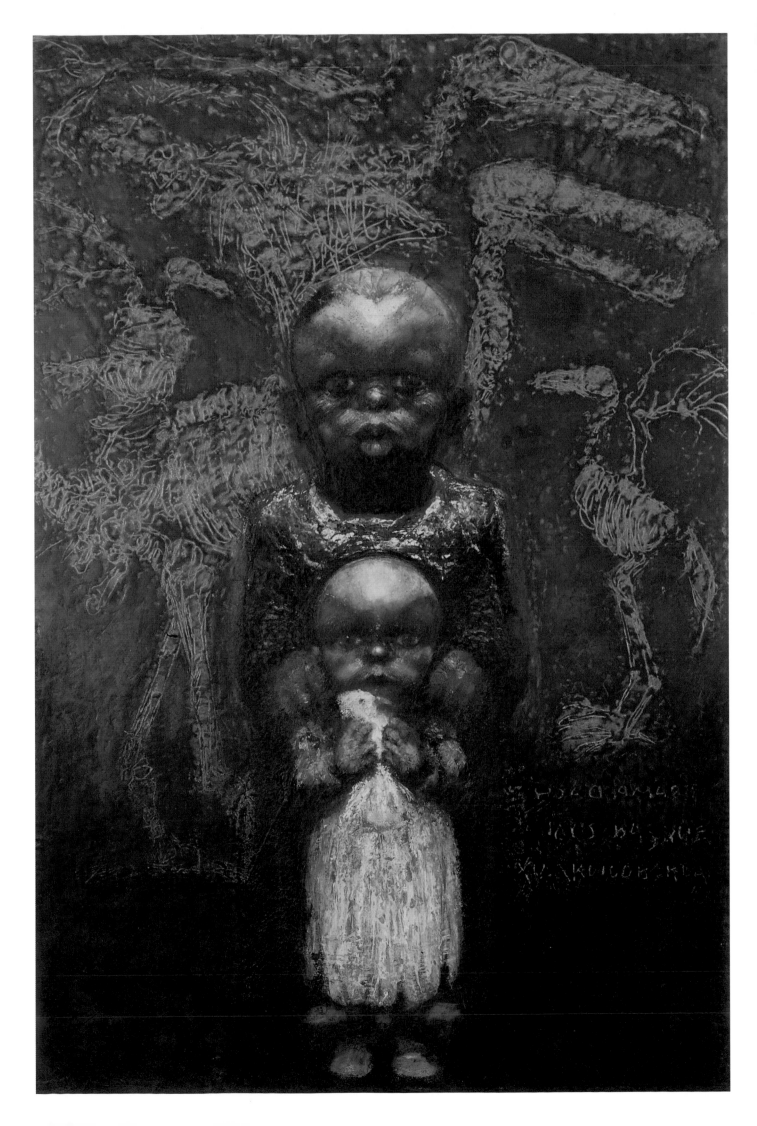

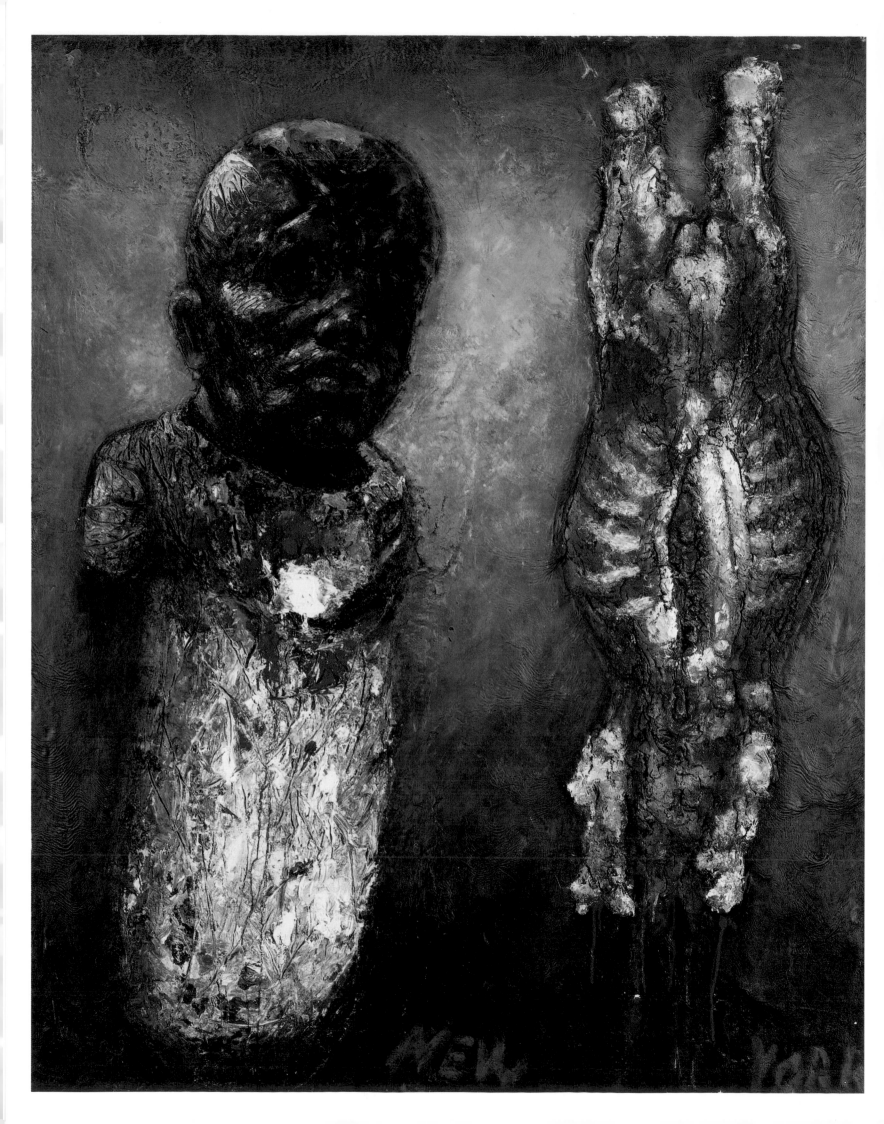

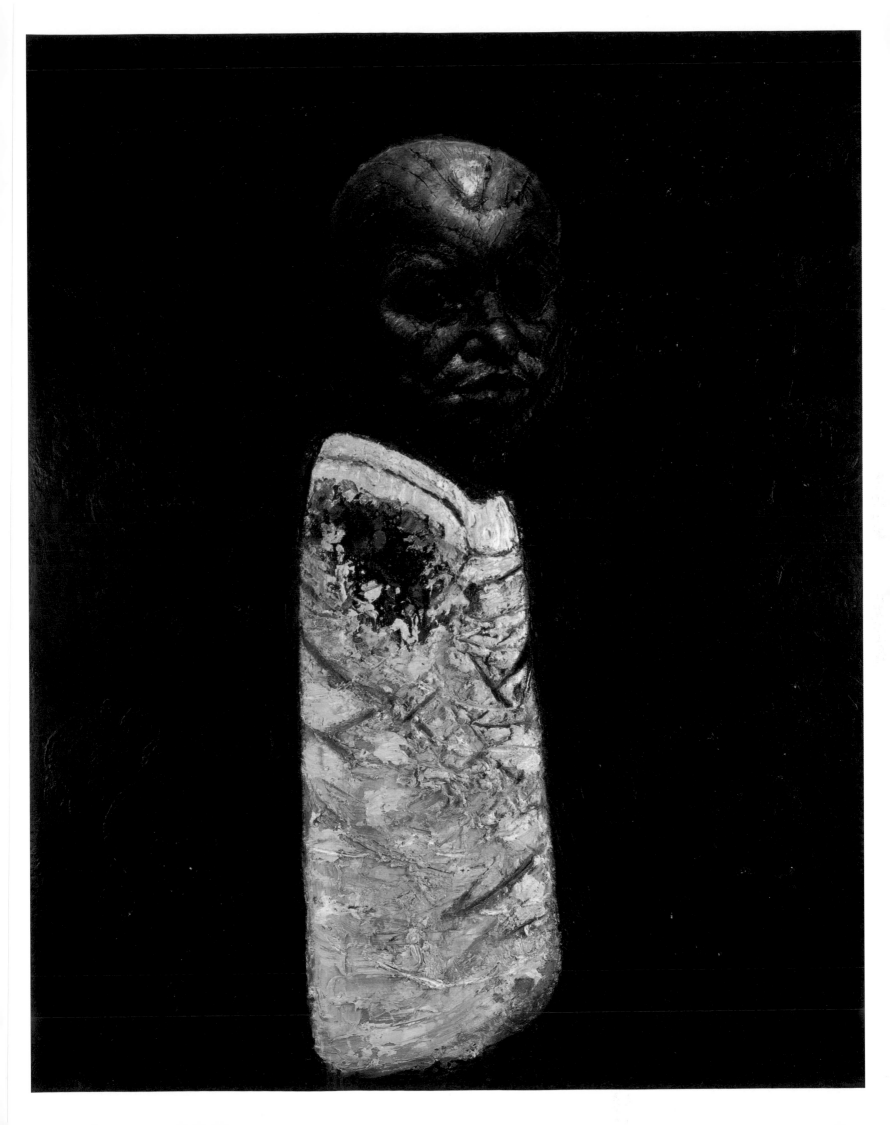

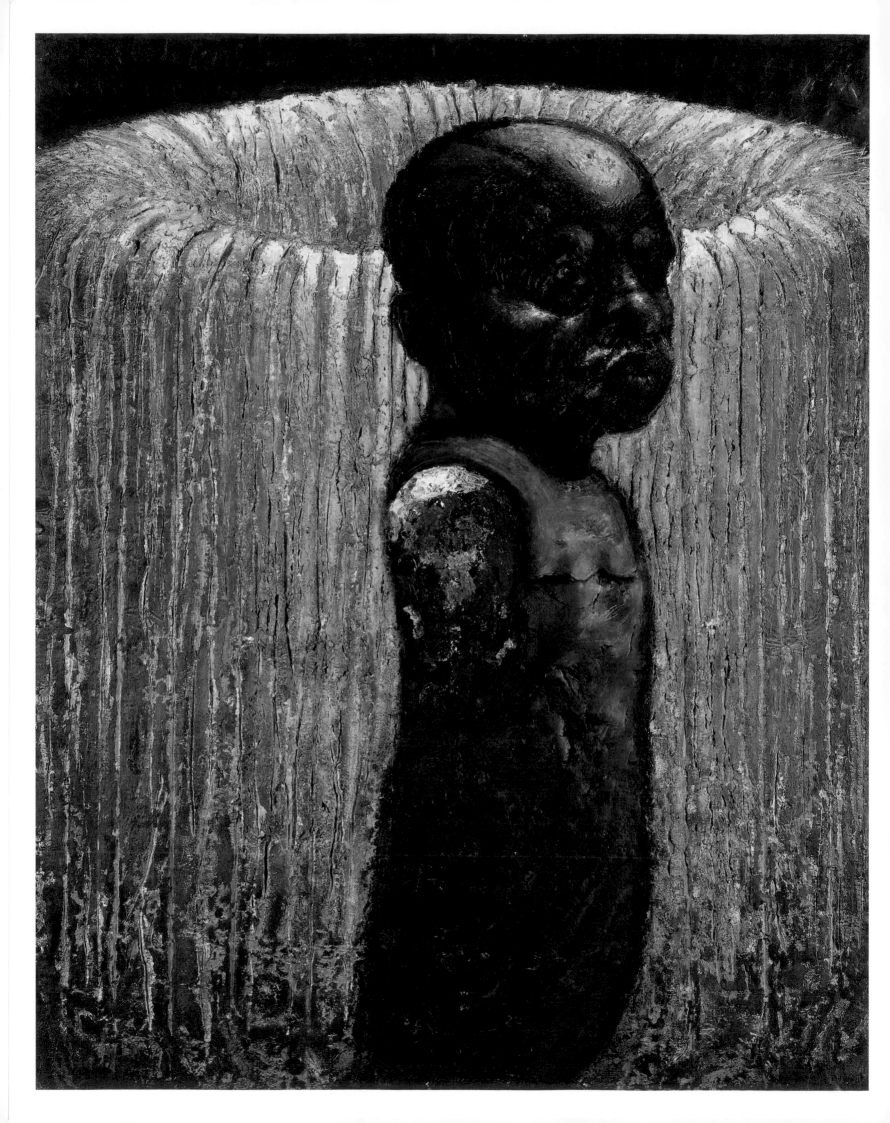

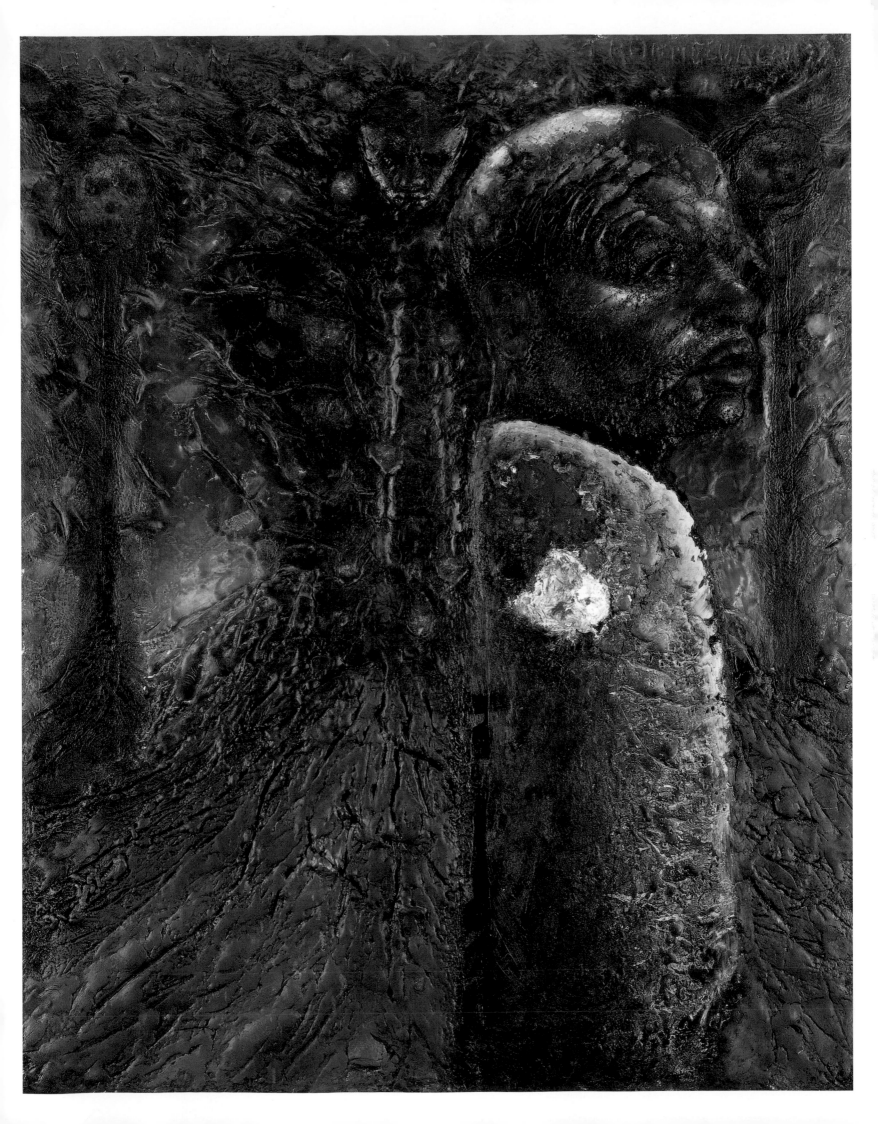

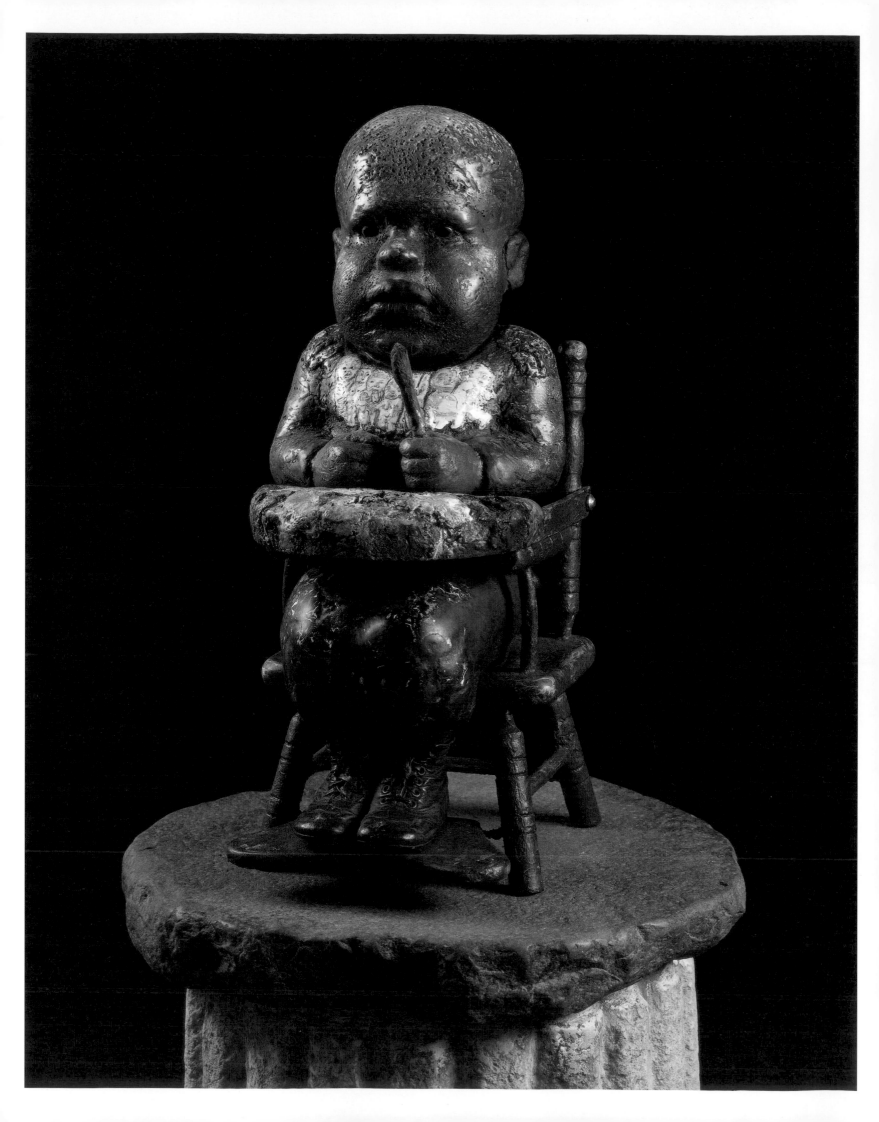

1943
Born on May 13 in Hillerød. Parents Knud
and Erna Trampedach-Sørensen

1962
Makes his debut at the Artists' Autumn
Exhibition, Copenhagen

1964
Completes apprenticeship as house-painter.
Sells his first picture to Statens Museum
for Kunst, Copenhagen

1964-1968
The Royal Academy of Fine Arts in
Copenhagen

1965
Marries Ella Clemens Ibsen. They are divorced
in 1967

1969
Awarded the three-year working grant of the
National Arts Foundation and *Dronning Ing-
rids Romerske Legat* and spends three months
at the Danish Academy in Rome

1970-1972
One-man shows at Galerie Jensen, Copenhagen

1971
One-man show at Fyns Kunstmuseum, Odense

1973
Marries Annette Aller. They are divorced in
1987. One-man show at Galerie Arnesen,
Copenhagen

1974
One-man shows at Galerie Leger, Malmö,
Sweden, and at the Stefanotty Gallery,
New York

1976
One-man show at Galerie Birch, Copenhagen

1977
Stage designs for *American Buffalo,* Bristol
Theatre, Copenhagen

1978-1983
One-man shows at Galerie Asbæk, Copenhagen

1978
One-man show at Nordjyllands Kunstmuseum,
Aalborg

1979
Buys the house Chilardico Borda in Sare in the
French Basque Country

1983-1990
Lives and works in New York, first with a
studio in Wooster Street and later in Broome
Street, SoHo

1984
Awarded the Eckersberg Medal by the Royal
Danish Academy of Fine Arts in Copenhagen

1985-1997
Represented in Denmark by Galerie Moderne,
Silkeborg

1987
First one-man show at the Allan Stone Gallery,
New York, which in future represents him
internationally

1990
One-man show at the Allan Stone Gallery,
New York

1995
One-man show at the Allan Stone Gallery,
New York

1997
Represented in Denmark by Galerie Provence,
Aalborg

1999
Marries Sofie Aller

2001
Retrospective exhibition at Sophienholm,
Lyngby and Randers Kunstmuseum, Randers

2002
Retrospective exhibition at Fyns
Kunstmuseum, Odense

The great majority of Kurt Trampedach's works are in private collections. A few are owned by museums or other public institutions. This applies to the following illustrations in this book:

4, 5, 14, 22, 44, 73, 168, 174. Statens Museum for Kunst, Copenhagen. 6. Royal Prints Collection, Statens Museum for Kunst, Copenhagen. 10. Aarhus Kunstmuseum. 15. Directorate of Culture, Frederiksberg Town Hall. 18. Nærumgaard School. 19. Askov Højskole. 37. Frederiksborg Upper Secondary School. 25, 98. Randers Kunstmuseum. 27, 74. Nordjyllands Kunstmuseum, Aalborg. 40, 52. Fyns Kunstmuseum, Odense. 53. Frederiksborg Byskole, Hillerød. 59. Bispebjerg Hospital. 57. Københavns Dag- og Aftenseminarium. 78. Trapholt Museum of Modern Art, Kolding. 72. Dagmar School, Ringsted. 80. Danish Maritime Authority, Copenhagen. 130. Odense City Council, Odense City Hall.

Dag Hansen
Kunsthallen, Copenhagen
Louisiana Museum for Moderne Kunst
Hans Ole Lund, Skive
Nationalmuseum, Stockholm
Ernst Nielsen, Information
Nordfoto, Copenhagen
Ny Carlsberg Glyptotek
Heine Pedersen
Thomas Pedersen og Poul Pedersen, Århus
Jan Persson
Polfoto, Copenhagen
Bent Rej
Bent Ryberg
Anders Schrøder
Statens Museum for Kunst, Copenhagen
Allan Stone Gallery, New York
Annette Trampedach
Sofie Aller Trampedach
Mikael Wivel

Museums

Antwerp, Open Air Museum Middelheim
Hillerød, Det Nationalhistoriske Museum på Frederiksborg
Copenhagen, Royal Library
Copenhagen, Statens Museum for Kunst
Maribo, Storstrøms Kunstmuseum
Randers, Randers Kunstmuseum
Skive, Skive Kunstmuseum
Sundsvall, Sundsvall Museum, Sweden
Tampere, Sara Hilden Art Museum, Finland
Aalborg, Nordjyllands Kunstmuseum
Aarhus, Aarhus Kunstmuseum, Aarhus